Gregory Curtis

THE CAVE PAINTERS

Gregory Curtis is the author of *Disarmed: The Story of the Venus de Milo*. He was the editor of *Texas Monthly* from 1981 until 2000. His writing has appeared in *The New York Times*, *The New York Times Magazine*, *Fortune*, *Time*, and *Rolling Stone*, among other publications. A graduate of Rice University and San Francisco State College, he lives with his wife in Austin, Texas.

ALSO BY GREGORY CURTIS

Disarmed: The Story of the Venus de Milo

THE
CAVE
PAINTERS

THE
CAVE
PAINTERS

Probing the Mysteries
of the World's
First Artists

Gregory Curtis

ANCHOR BOOKS
A Division of Random House, Inc.
New York

FIRST ANCHOR BOOKS EDITION, OCTOBER 2007

Copyright © 2006 by Gregory Curtis

Published in the United States by Anchor Books, a division of Random House, Inc., New York, and in Canada by Random House of Canada Limited, Toronto. Originally published in hardcover in the United States by Alfred A. Knopf, a division of Random House, Inc., New York, in 2006.

Anchor Books and colophon are registered trademarks of Random House, Inc.

Grateful acknowledgment is made to the following for permission to reprint previously published and unpublished material:

Abrams: Excerpt from *The Shamans of Prehistory* by Jean Clottes, translated by S. Hawkes (Abrams, New York, 1998). Published in French by Editions du Seuil as *Les chamanes de la préhistorie: Trans e magie dans les grottes* by Jean Clottes and David Lewis-Williams. All rights reserved. Reprinted by permission of Abrams, a division of Harry N. Abrams, Inc.

Laure Emperaire: Excerpt from *La Signification de l'Art Rupestre Paléolithique* by Annette Laming-Emperaire (A & J Picard & Cie, Paris, 1962). Reprinted by permission of Laure Emperaire.

Yanik Le Guillou: Excerpt from letter by Yanik Le Guillou. Reprinted by permission of Yanik Le Guillou.

Princeton University Press: Excerpt from *Prehistoric Cave Paintings* by Max Raphael. Copyright © 1945, copyright renewed 1973 by Princeton University Press. Reprinted by permission of Princeton University Press.

The Library of Congress has cataloged the Knopf edition as follows:
Curtis, Gregory B.
The cave painters : probing the mysteries of the world's first artists / by Gregory Curtis.
p. cm.
Includes bibliographical references and index.
1. Cave paintings—France. 2. Cave paintings—Spain. I. Title.
N5310.5.F7C87 2006
759.01'20944—dc22 2006040888

Anchor ISBN: 978-1-4000-7887-5

www.anchorbooks.com

Printed in the United States of America
10 9 8 7 6 5

For Vivian Curtis and for Vivian Curtis,
my mother and my daughter

CONTENTS

THE
CAVE
PAINTERS

The Naked Cave Man

This book began in 1995 when my daughter Vivian saw a statue she called "a naked cave man." For several days we had been riding on horseback across the Dordogne, the lovely area of river valleys, rolling hills, and thick forests in south-central France. It was late spring, just before the arrival of the swarms of rowers, hikers, and campers that descend on the region each summer. I did not know at the time that in eons past this appealing landscape had also attracted groups of the earliest humans. Their ancient campsites, usually found under the rock overhangs in the limestone cliffs that line the rivers, have kept archaeologists happily busy since they were first discovered more than 150 years ago.

As the archaeologists dig deeper, they find layer upon layer of occupation, the date of each layer receding farther into the past. Occasionally, in the upper levels, which can be 15,000 to 20,000 years old, these digs turn up tiny beads patiently crafted from ivory, an engraving of an animal on a rock, or some reindeer's teeth with a hole drilled at the root that were once part of a necklace. The people who made these delicate objects were the same ones who ventured into the caverns in the hillsides, sometimes crawling through narrow passages for hundreds of yards, to create

the paintings, engravings, and bas-relief sculptures that still touch the soul of everyone who sees them.

During our trip Vivian and I stopped at Les Eyzies-de-Tyac, a village on the banks of the Vézère River. We turned out our horses in a small pasture conveniently across the road from our hotel and went to visit Font-de-Gaume, then as now the only cave with polychrome paintings that is still open to the public. After a surprisingly steep climb, we arrived at the entrance—a narrow, upright gash in the rock near the top of a cliff where three or four other tourists were waiting.

In a few moments the guide to the cave arrived and unlocked the metal door that covered the entrance. We walked in single file down a tall, narrow passageway that proceeded roughly in a straight line despite a few slight twists and turns. A narrow metal grille placed in sections along the way protected the cave floor. There were rather dim lights hidden in the walls on both sides. The guide turned them on in a given section as we arrived there and then turned them off as we passed through. After about seventy yards, the guide stopped. Using a red laser as a pointer, she began talking about the first painting.

I was tremendously excited. The little I knew about prehistoric painted caves came from photographs in books and magazines. Now, some of the real paintings were right in front of me in all their glory. There were round, fat bison drawn in gentle curving lines. They had deep, expressive eyes and tiny legs. Mammoths with long, curved tusks stood placidly among the bison. Horses outlined in black, now partially obscured by natural concretions, galloped across the cave wall. Most impressive of all were two large reindeer facing each other. The one on the right, a female, was on her knees. The male on the left, whose antlers formed a magnificent long arc, had gently lowered his head toward her and had just begun licking the top of her brow. The grandeur of the

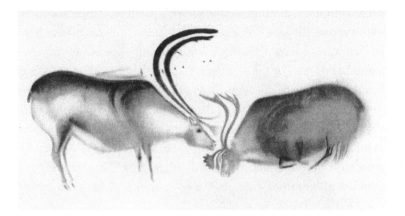

*This painting, where a male reindeer leans close to a kneeling female,
is rare among cave paintings because it shows a moment of affection.*
Font de Gaume

male and the delicacy of the female in this quiet moment, so intimate and tender, made the painting touching and irresistible.

Beauty in art or in nature or in a person is always surprising because it is stronger and more affecting than you could have anticipated. That's why, even though I was prepared for the paintings in Font-de-Gaume to be beautiful, seeing them was startlingly intense, like having a flashbulb ignite two inches from your eyes. I was reeling a little, since there was so much about the paintings I hadn't expected.

For one thing, they were punctuated with indecipherable signs. The simplest ones consisted of a horizontal line and a vertical one, like an upside-down T. Other signs had lines added to this basic shape. Some had slanted lines at the top and others had parallel vertical lines that made the sign look like a stick-figure house. And there were signs in different styles. Some were grids of straight lines inside a rectangle. Others were simply two circles below two arcs. They resembled a cartoon ghost peering above the horizon. Often the signs appeared alone, but they might also appear near or

even within a painting. They weren't writing, since the signs didn't repeat the way writing would. Instead they must have been an elaborate code, with each variation having a specific meaning— a number or clan or time of year. In fact, they could be anything. But the presence of the signs proves that the paintings meant more to the people who made them than the paintings alone could convey. The signs marked the paintings in some way. They classified them or ordered them or attributed them according to . . . what? It gave me a start to realize that for their creators, these paintings by themselves were not enough. They needed a gloss, elaboration, *captions!*

Also, I was astounded by the way the cave artists used the contours of the cave wall to enhance their work. This is a special quality of cave art that photographs rarely convey. The powerful shoulders of bison, for instance, are often painted over a bulge in the rock that makes the muscles of the animals seem to swell realistically and gives the work a dimension that would have been impossible on a flat surface. This happens so often that it's clear that the artists weren't simply taking advantage of the contours they happened upon as they painted. Instead they must have examined the wall closely first so as to find the places where the shape of the wall suggested animals or parts of animals before they began to paint. This meant that, at least some of the time, the cave artists had painted the animals suggested by the wall rather than imposing their own ideas onto the surface.

Photographs in books or magazines make the paintings look random, and even in the cave there isn't any apparent order at first. The animals seem lumped together according to whims of the ancient artists, and they are often painted one on top of the other in ways that are impossible in nature. The guide pointed out a red bison facing left that had a mammoth engraved over it facing right. The size of the two animals was roughly the same even though a

real mammoth would have been immensely larger than a real bison. And, with the exception of the male reindeer licking the female, the animals didn't seem to be doing anything. They were just there on the rock. Sometimes they faced each other head-on, but even then they stood stoically and without any sign of aggression. And the mix of animals—bison, mammoths, horses, and even a rhinoceros—seemed random as well.

That is, they seemed random until you looked a second time. We were in the cave only forty-five minutes that afternoon, but that was just long enough to begin to see some order despite the apparent chaos. Female animals are painted red, for example, although not every red animal is a female. When animals face each other, one is red and one is black. The black animal is on the right in the paintings nearer the entrance but appears on the left in the paintings farther in the interior. Late in the tour, I looked back at a frieze of bison that I had seen straight on a few moments earlier. Now the animals curved around the wall of the cave and appeared three-dimensional. Their legs were in perfect perspective, which added to the strong illusion that they were moving away down the corridor. Clearly the artist had planned for the painting to be seen from the spot where I stood.

That spot, provocatively, was before a tall but shallow cavity in the wall that is known as the Bison Cabinet. It was located in a spacious oval room that opened at the end of the long corridor we had followed from the entrance. The room reminded me of a nave in a small church. It even had a domed roof. And the Bison Cabinet, which was a curving recess, had the air of an adjoining chapel. As the name suggests, it is filled with paintings of bison. Five are well preserved and easy to see, but originally there were ten or more. The bison swirl about as if floating in the clouds. They face right, left, up, or down, and just below them is a wide horizontal fissure in the wall. Were they emerging from the fissure or were they being

sucked down into it? And wasn't there some connection between these bison in the Cabinet and the bison receding down the hallway that were best seen from a spot just before the Cabinet? Vivian had looked as long and hard as I had, and we both found ourselves put into a kind of emotional swirl by the experience. Happy but set slightly off-kilter by what we had just seen, we left the cave to visit the museum of prehistory. In the summer of 2004 the museum moved to a dramatic new building located just below the old one. But in 1995, the museum was still in an old château high in the cliffs behind Les Eyzies. The rooms were filled with polished wood-and-glass cases that seemed left over from the nineteenth century. Some of them held the tedious, repetitive displays of chipped stone tools—meaningless to a layman—that are inevitable in a museum devoted to ancient humans. But other cases contained rocks or pieces of antler with engravings of bison or horses. There were a few rocks with engravings of vulvas that were so faint it was a wonder that even archaeologists on the lookout for artifacts had noticed them. We wandered about listlessly. In Font-de-Gaume we had just seen the heights Ice Age civilization could reach. In the museum we were seeing the detritus of daily life.

At last we walked back outside. In front of the museum there was a long, narrow terrace with a white limestone statue of a Neanderthal in one corner. Perhaps seven feet tall, streaked and stained by wind and rain, he stared out of sunken eyes. His square head pushed down into his neck, he held his arms stiffly at his sides, and his face was contorted. Everything about his expression and posture conveyed tension, anger, and threat. He frightened and embarrassed my daughter, who declined to have her picture taken with, as she said, "a naked cave man."

Instead we turned away and looked out across the valley below. The village was just at our feet. In front of it, the Vézère River

made a long slow bend. Trees whose branches bent down to the water lined both riverbanks. Beyond them a wide, level valley stretched out until, in the distance, another wall of cliffs rose up. Gray clouds, threatening rain, covered the sky and made the valley look lush and green, and for just a moment everything I had seen that afternoon made sense.

If you looked at the landscape the way early humans might have, it became clear why they had made their homes in the cliffs where my daughter and I now stood. The overhangs gave shelter. The height of the cliffs prevented any approach from the rear by threatening animals or by other humans. The river below would attract herds of migrating animals and other game, and anyone living high in the cliffs could follow their movements for miles across the valley. Here was a safe place to live where food was plentiful.

But surely those practical reasons weren't everything. There was something else about the landscape before us, something that would have been surpassingly important to people who could paint masterpieces on the walls of a cave. The landscape was beautiful. Sometime long ago, hadn't our distant ancestors stood where we now stood and paused, as we did now, to relish the scene below, to revel in the trees by the river flowering in springtime, to watch the flight of birds or the patterns of animal herds crossing the valley, or to marvel as a storm front moved in over the distant hills, as one was doing now?

In that moment when the three of us—the angry statue, my daughter, and I—all looked across the same green, ancient, and seductive landscape, this book was born.

During my research, every time I entered a cave the same excitement I'd felt the day I first saw Font-de-Gaume with Vivian returned undiminished. It happened even when I revisited Font-

de-Gaume itself many times, often arranging to go alone with just a guide. The solemn mammoths, the tender reindeer, and the swirling bison in the Bison Cabinet never failed to make me pause in wonder.

But, as the caves became more familiar, I was also able to assume an investigative neutrality. As a result, I began to see much more. I would stand by a wall while the guide shone a light at oblique angles, and figures that had been invisible rose into view as if they had been summoned from the solid rock behind the surface of the wall. Sometimes these images were beautiful, but sometimes they appeared to be just doodling—strange animals, funny human shapes, or a line of red painted in a small crevice to make it look like a vulva. Such great variety in a single cave proved that many people had ventured inside for a variety of reasons. Not everyone who drew on the walls was a great master—although many were. And not everyone who entered the cave kept his or her mind on solemn thoughts. While some painted grand images of their society's history or myths, others seemed to have scratched their own private musings in the corners. Everything that's there—not just certain images or groups of images—must be considered in order to understand the meaning of the art in the caves.

This book contains two narratives, one considerably shorter than the other. The shorter one covers several million years as *Homo sapiens* arose in Africa, migrated out, and, about 50,000 years ago, pushed across Europe from east to west. Some groups went on clear to the Atlantic Ocean. But those who stopped short of the ocean and lived on either side of the Pyrenees were the ones who began to paint in the caves. Their work was the most impressive part of an outflowing of creativity by *Homo sapiens* that began about 45,000 years ago and has continued ever since.

The second, longer narrative covers only a hundred years. Although people had known of paintings in some of the caves for

centuries, no one had been able to figure out what they were until about 1900. But, once it was established that the paintings were the work of prehistoric people, and once the paintings became famous as both an aesthetic triumph and a marvelous historical record from the dawn of humanity, questions arose immediately. When were they painted? Who painted them? And, most important and difficult of all, what do they mean? During the last hundred years, four brilliant, driven, often solitary, sometimes difficult scientists devoted their careers to trying to answer those questions. Their lives, which occupy the center portion of this book, span the entire period from 1900 until today, and their ideas flow from one to another. It's impossible to approach the significance of the painted caves without understanding the inspired revelations in these scientists' work.

Art historians, poets, and other nonscientists who write about cave art tend to make sweeping statements that, if they are founded on anything, assume a kind of genetic wiring connecting us to those ancient artists, who are, after all, everyone's distant ancestors. The most common supposition, which was first expressed by the scholar Max Raphael, is that the paintings are the evidence of the moment when people began to conceive of themselves as different from animals: the very moment, that is, when we became human. That may even be correct, although it can never be proved, but it derives from the notion that we should be able to "read" the paintings by intuition alone.

Looking at the art that way is seductive, fun, and also dangerous, since it leads further into one's own imagination rather than further into the paintings. Consequently, with perhaps one exception, I've avoided trying to read the paintings by intuition and relied instead on what we can know by evidence and deduction. As for the moment when humans began to distinguish themselves from animals, I remain agnostic. But in any event, that is not why

the cave paintings are valuable. They represent the first time we know of that we humans summoned all our intellect and vision, all our knowledge and skills, and all our longings and fears and focused them on creating something that would last forever. What did our distant ancestors know that made all that effort worthwhile, that made it necessary? That is what lies there waiting in the caves.

Before beginning, I should say a word about technical language, which I have avoided almost entirely. Usually, using a common synonym rather than a technical term is all that's necessary. Thus I say "stone tools" rather than "lithic industry." But there are a few technical terms that the reader should know about and know what I have done to avoid them.

Archaeologists have divided the people who lived in Europe during the Ice Age into six basic groups. The groups are distinguished by their encampments, by the stone tools they used, and by the art they made, if any. They are the following:

1.	Mousterian	beginning more than 40,000 years ago.
2.	Chatelperronian	beginning 38,000 years ago. It and the Mousterian are both the creation of Neanderthals.
3.	Aurignacian	beginning 35,000 years ago. It is the culture of the first modern humans in Europe.
4.	Gravettian (or Perigordian)	beginning 27,000 years ago.
5.	Solutrean	beginning 22,000 years ago.
6.	Magdalenian	beginning 17,000 years ago.

The dates are approximate, of course, and each era is subdivided into early and late periods.

These distinctions arose during the twentieth century as archaeologists struggled to date the art and artifacts they were finding in caves and in the remains of open-air encampments. The two giant figures in cave art from 1900 to 1980, Henri Breuil and André Leroi-Gourhan, spent much of their careers constructing dating systems based on the discernible styles of cave art and assigning art in the caves to one period or another. The assumption was that art that appeared crude was older and art that appeared refined was newer and art that appeared in between was in-between.

Even after 1950, when radiocarbon dating became possible, cave art remained difficult to date because the paints usually have a mineral base and radiocarbon dating works only on organic material. But caves discovered during the 1990s, especially Chauvet and Cosquer, contained refined art that could be dated by radiocarbon and, to everyone's surprise, turned out to be quite old. While some of the paintings in Chauvet are 32,000 years old, making them Aurignacian, an archaeologist dating by their appearance would have said they must be Magdalenian and thus only 17,000 years old.

These discoveries made archaeologists question the distinctions among the time-honored cultures. The old assumption that cave art demonstrated an evolution from crude to refined has been proved wrong and has disappeared entirely. Consequently, I don't refer to the art or the people who made it as Aurignacian, or Gravettian, or by any of the other technical names, useful as those distinctions are to a specialist. Instead, I give dates for the art when it is possible, and usually it is.

I use a variety of names for the people who made the art—Ice Age hunters, Paleolithic artists, the ancient people, and so on—

and intend them to be interchangeable. In scientific writing the Stone Age is divided into the older Paleolithic and the newer Neolithic. The practice of painting in caves did not extend into the Neolithic. When I use the term Stone Age, I am referring only to the Paleolithic.

The Seductive Axe;
The Well-Clothed Arrivals

F ont-de-Gaume is one of almost 350 known caves contain-
ing art from prehistoric times. The art in these caves is the
creation of the first recorded civilization in history. It
appeared sometime between 30,000 and 40,000 years ago and
spread throughout Europe and Asia. As it moved across this great
expanse, the civilization preserved a basic unity, aided by what
must have been a surprisingly efficient network of communication
and trade. Because of that network, goods that were considered
precious during the Ice Age—obsidian or certain seashells, for
example—turn up in archaeological sites hundreds of miles from
their place of origin. Also, there was art everywhere in the form of
statuettes or engravings on stone, ivory, or antlers.

Within this broad similarity, however, the culture evolved dif-
ferently in different places, developing distinctive local customs,
styles, and traditions among many widely scattered societies. The
same might be said of Europe today, where each nation has
evolved as a set of local variations on the same overarching cul-
ture. Painting in caves was one such local development. Except for
a few widely scattered instances, the only people who painted in

caves lived in what is now southern France and northern Spain. Of course, in places like the steppes of Russia there were no caves to paint. But elsewhere, in Germany for example, there were plenty of caves, yet the people who lived nearby apparently neither explored nor painted them. It was the people who lived among the caves on either side of the Pyrenees who developed this powerful and enduring means of expression.

The oldest cave paintings yet discovered are in a cave named Chauvet in southern France. They are about 32,000 years old. The paintings show huge, vivid herds of animals spilling across the walls. In particular there are lions and horses all painted with an individuality and a dynamism that make them masterpieces. The lions are on the hunt and look fierce and wild-eyed. But cave bears were just as ferocious as lions, yet there is a wonderful, roly-poly bear with his head bent low as if he were sniffing flowers on the ground. The paintings there have all the refinement, subtlety, and power that great art has had ever since.

Having burst at once into full flower at Chauvet, cave painting remained much the same until it died out about 10,000 years ago. The changes that did occur were subtle. Lions and bears appear frequently in the paintings at Chauvet but become rare in the caves painted thousands of years later. Perhaps the change shows that those predators had become less of a threat as humans learned how to control or exterminate them. Styles changed subtly, too. Chauvet and, say, Lascaux were painted by different artists who had different visions. But the subtle differences only underscore the essential similarity, no matter what era or what place. Horses, bison, human hands, reindeer, and various repeated and consistent geometric signs—these images appear again and again in cave after cave. Horses, for example, are common at Chauvet and appear throughout the cave. At Lascaux, which was created 15,000 years later, horses are the dominant animal in the cave and constitute over half of the one thousand or so paintings and engravings.

There is also a strict consistency for 20,000 years in what is *not* pictured. Fish are rare, even though multitudes of salmon spawned in the rivers. With one or two exceptions, there are no insects, even though thick clouds of flies must have followed the herds of reindeer. There are no rodents, which were also common, no reptiles, and no birds except for a few owls. Sometimes the owls are shown front and back, implying that they had a special status because they appeared to be able to turn their heads 360 degrees. Also, many species of mammals were excluded, beginning with bats and extending to many larger, common animals, such as hyenas. The cave painters were not creating a bestiary or a zoological catalog. Nor were they attempting to re-create and record the world they saw around them in complete detail. Nor do the species pictured in the caves appear at the whim of the artists. Instead these prehistoric geniuses chose to paint animals that had a special place in their culture. Their work portrays the animals that their culture valued, not so much in a practical way—or else there would have been more fish, which were an important part of their diet—but in an aesthetic or mythological or spiritual way. Somehow the whole universe depended on the animals in the paintings.

There were other strict conventions about things that are not shown. None of the thousands of animals is shown in a landscape. There is never a tree or a bush or a flower. Nor are there rivers, lakes, cliffs, rocks, or caves. Sometimes a natural ridge in the cave wall serves as a ground line; but, for the most part, whether the animals are running, standing still, rearing, fighting, or even falling, they all do so in empty space. There's no sky either—no stars, no moon, and no sun. That's a peculiar, puzzling omission, since prehistoric people surely observed the sky closely in order to mark time and anticipate the coming seasons and migrations of the animal herds.

It's also surprising that the caves are very chaste. There are pictures of vulvas, penises that are occasionally erect, pregnant

women, and a variety of geometric shapes that suggest male or female genitals. But the animals are never actually mating and neither are the humans. (We call the first people to paint in the caves the Aurignacians. A frequently cited paper about them is titled "No Sex, Please—We're Aurignacians.") One small, flat rock has an engraving of a man and woman having sex, but that is the only such representation ever found from these prehistoric times. Apparently it was the work of the ur-pornographer. Nor are there animals giving birth except for a peculiar carving on a spear thrower. Even fawns, cubs, or other young are extremely rare.

The colors are consistent as well. The cave painters did have a wide range of colors in their palette, but the two that dominated everywhere were black obtained from manganese dioxide or occasionally charcoal, and red, obtained from iron oxide. The colored minerals were pulverized and then mixed with some fluid to make the paint. Often the fluid was water from the cave itself. It contained dissolved minerals from that particular place, which made the paint bind to that cave's walls more easily.

The artistic techniques remained identical during the many millennia that cave painting lasted. The artists chipped tiny, pointed chisels from flints to use as engravers. They sometimes used crayons of charcoal or paintbrushes made from animal hairs. More frequently they used wads of fur or perhaps moss and pressed them on the walls. Just as frequently they blew the paint onto the wall by using a hollow reed or bone pipe or by putting the paint in their mouths and spitting it on in a series of explosive puffs made with the lips. When blowing the paint, they used either their hands or a stencil of bark or hide in order to make the shape they desired.

This immutable similarity in themes, colors, and techniques shows that the cave paintings were the creation of artists working in a cultural tradition that survived for more than 20,000 years. For

that tradition to have endured essentially unchanged for so long, it must have been passed from generation to generation in a precise, clear, and, most of all, memorable way, since this whole expanse of time was well before the invention of writing. And as painting is both an art and a skill that must be learned, and as there was a single acceptable style to which the painters had to conform, the skills of painting must have been taught.

This is a startling idea, since, with painting being taught, it is very likely that to preserve the culture other skills were taught as well. Knowledge and beliefs would have been transmitted to a new generation in a way that was more formal and rigorous than telling tales around a campfire. One skill that might have been taught was music. Several archaeological digs in Ice Age sites have turned up flutes and whistles made from hollowed bone. Some people are natural musicians, but for most people, learning to play an instrument requires instruction. And with music there must have been dancing, songs, and chanting, too. It would have been ritual or stylized dancing and it, too, would have been passed through the generations. The songs and chants would probably have had a definite rhythm as well as the repetitions and stock phrases that characterize oral poetry everywhere.

But because there was no writing, the music, dances, songs, and elaborate mythology from the first civilization are gone forever. The beautiful carvings of animals on bone, ivory, and stones and the paintings in the caves are really all that remain from this cultural tradition that was so fulfilling and profound that it lasted more than 20,000 years. For people in the Ice Age, this art was their religion, their history, and their science. It made the world comprehensible, gave order and meaning to their lives, and informed their sense of beauty.

. . .

The cave artists poured all their genius into pictures of animals. When they did paint or engrave pictures of people, they did so with little care or effort; most of such pictures are stylized stick figures or simple line drawings of crude faces that look like cartoons or caricatures. The beauty and convincing realism of so many of the animal paintings show that the artists were so skillful that they could easily have created realistic paintings of people if they had cared to. They could even have painted realistic portraits—and how fortunate we would be if they had.

But creating pictures of people evidently did not interest the cave artists very much. Some scholars propose that there was a religious or social prohibition against human images in art, as there is in Islamic countries today and other cultures as well, but that explanation has never satisfied me. If there had been such a prohibition, there wouldn't be any human images at all, not even crude caricatures. It's more likely, I believe, that those stick figures are realistic in their way. They, together with the paintings of animals, show what people thought of themselves in relation to the world around them, a world ordained for animals and not for people.

Far from being the dominant creatures on the planet as is true today, people were insignificant, hanging on as best they could at the edges of a world that belonged to animals, teeming swarms of animals. Apparently the earth belonged to the animals by right. They seemed to understand it and have power over it. And the power, privilege, and dominance of animals are exactly what the cave paintings show.

Today it is almost impossible for us to imagine what a vast profusion of animals there actually was. Every species native to Europe today was there, along with species that are now extinct. There were hedgehogs, shrews, and moles, as well as rats, mice, and other rodents. The rodents had many predators, including

polecats of various kinds. There were minks, ermines, badgers, otters, wolves, jackals, foxes, and raccoons. Bats blackened the sky at evening, and there were numberless birds, including owls, partridge, grouse, and more exotic species. Seals lounged by the rivers, which during the spring spawn were thick with salmon.

Saber-toothed tigers were extinct in Europe by the time humans arrived, but plenty of ferocious cats still remained. Wildcats, larger than the ones today, and two varieties of lynx still roamed about, hunting rodents and rabbits. There were leopards that were peculiar-looking compared with the sleek cats of today. Like dachshunds, they had a small head, a long body, short legs, and an extremely long tail. And there were cheetahs, larger than today's version but just as fast. The most impressive cat was the cave lion. It was half again as big as lions today, although it did not have a mane. Cave lions also differed from most modern cats because they hunted in groups rather than alone. Their coordinated efforts were necessary because they hunted aurochs, bison, giant deer, elk, and other large game too formidable for a single attacker. The paintings in Chauvet show groups of lions on just such a hunt.

Modern humans began arriving at a time of global change, when the weather turned colder. Forests died out and were replaced by immense savannahs of open land, interrupted only by rivers and mountains. These grassy expanses were home to endless herds of reindeer and primitive horses, the two species that became the foundation of the humans' diet. The herds, surrounded by clouds of buzzing flies, gnats, midges, and mosquitoes, followed their migratory routes across the landscape that they shared with an array of other bovines and ungulates—aurochs, red deer, bison, elk, and the magnificent megaloceros, now extinct, whose antlers were thick as palm fronds and spanned twelve feet.

In fact, most of the animals in the Ice Age were larger than their modern counterparts. There were three kinds of hyenas, including the terrifying short-faced hyena, which was as big as a lion. Wolverines lurking in the bogs were more dangerous than the packs of wolves. In order to attack a large animal, a wolverine would leap from a tree onto the back of its prey, dig in its claws to keep from being bucked off, and then rapidly chew through the victim's neck until its bones were severed.

Cave bears, although exclusively vegetarian, were so huge that they would dwarf a modern grizzly. They would have been perfectly capable of grabbing a grizzly's head in their jaws and crushing it. Their range was confined to Western and Central Europe and they didn't wander far from the territory where they were born. Humans must have been careful not to enter a cave while a bear was in it and didn't hunt them much either—cave bears were ferocious and difficult to kill, while horses and reindeer, which were far less dangerous and much more vulnerable, abounded.

Late in the fall the bears dug out large round cavities in cave floors, where they hibernated. The floor of Chauvet is pockmarked with these holes, and another cave, Rouffignac, has thousands upon thousands of them, some more than half a mile into the cave. Each of the cavities represents one year, since only one bear hibernated in a cave each season. The bears marked their path into the black depths of the cave with urine and with scratches on the walls. Then in spring they could find their path out through the darkness by scent. Occasionally they were injured or killed during hibernation by rocks falling from the cave ceiling. Fractures are common in their skeletons. In males even the penis bones are often broken, possibly as a result of fighting over females after awakening from hibernation. Cave bears seldom lived more than twenty years, and their skeletons show rheumatism, arthritis, and other plagues that come with age. Most of them died during hibernation

when either the inexperience of youth or the infirmities of disease or old age prevented them from building up enough fat during the rest of the year to survive their long sleep.

Among all the species that thrived and multiplied during this fecund era, the largest by far was the woolly mammoth. These animals, with their long, curved tusks, appear frequently on the walls of the painted caves and in engravings on bone and ivory. Restless, constantly foraging, they covered the entire northern hemisphere from Europe, across Asia, and into North America.

These lumbering giants weighed six tons yet had such delicate musculature at the end of their trunks that they could sort through different blades of grass to decide which ones to eat. They also had tender sensibilities and would aid and protect members of their herd who were sick, injured, or in danger. Eating only grass, branches, and bark, they had to graze as much as twenty hours in order to consume the four hundred pounds of food they needed each day. They were not mature until they were more than fifteen years old. Their gestation period was two years; calves were born one at a time; and a female would not get pregnant again until three or four years after giving birth. And yet the environment was lush enough to support their immense appetites, and, despite an agonizingly slow rate of reproduction, they multiplied into numbers that defy belief.

Several archaeological sites give indirect evidence of just how many mammoths there really were. On the Russian steppes about 15,000 years ago, people made huts from mammoth bones that were linked together intricately as jigsaw puzzles. Each hut needed twenty-five skulls for its foundation, as well as twenty pelvises. On top of them the builders arranged twelve more skulls, fifteen pelvises, and other bones. Hides were stretched across the top and held down by thirty-five tusks. Then came an outer wall with ninety-five interlocked lower jaws. A single hut could contain

almost four hundred bones that in total weighed over twenty-three tons. A single settlement might have five such huts, each of them a testament to ingenuity and hard work.

It is unlikely that the people who lived in the huts killed any of these mammoths. Instead they scavenged the bones from what must have been the remains of thousands of animals lying about the landscape. In fact, such bones are still part of the landscape in remote areas. There are villages in Siberia where carving mammoth ivory into delicate figurines and filigreed boxes is a cottage industry even today. One naturally assumes that such ivory is rare, but it comes from the remains of millions of mammoths still frozen beneath the Siberian wastes.

About 40,000 years ago *Homo sapiens* walked into this vast domain where animals ruled. The new arrivals were identical in every respect to modern people except that they were probably slightly taller on average than people in the West today. And they behaved like modern people. They had powerfully developed intellects and a rich imaginative life. They cared about appearances and decorated their bodies and their clothes with signs of wealth, rank, and kinship. And they spoke a complex language. The old cliché is actually true. An Ice Age couple with the man wearing a coat and tie and the woman a contemporary dress would be indistinguishable from their fellow passengers on the New York subway or Paris Metro, and, given enough time to become accustomed to the modern world, the couple would get along as well as anyone else.

The new arrivals appeared only after many generations of migration up from Africa, through the Levant, and then, always moving east to west, across the Balkans and the rest of Europe until they reached the Atlantic Ocean, an insuperable barrier to any further westward migration. Only then, after they had arrived

at the end of the trail in what was at that time an isolated corner of the world, did the painting in caves commence.

The word "migration" is misleading because there weren't many people. The population of *Homo sapiens* was minuscule. Forty thousand years ago there were probably no more than five thousand people in all of what is present-day France.

These new arrivals were, like every other animal, the result of millions of years of evolution. The long saga of human evolution is filled with subtleties, uncertainties, and yawning abysses in our knowledge. Fortunately, though, for understanding the cave paintings, the saga can be summarized using just five approximate but important dates. The first is somewhere between 5 and 7 million years ago. That is the last time that humans and chimpanzees—our closest relative among animals living today—had a common ancestor. At that time a species of ape living in Africa south of the Sahara desert exhibited an abrupt evolutionary change and became the first hominid—a term for a group of species related to but distinct from apes. This first hominid still looked like an ape and probably spent much of its life in trees as apes do; but when it was on the ground, it walked upright on two legs. The erect posture freed the hands for carrying food, but otherwise no one knows exactly why walking upright was an evolutionary advantage. Early theories that walking upright required less energy or exposed less body area to the sun have been disproved, and later theories have not attracted much interest or support.

Whatever the reason may be, walking on two legs was an evolutionary advantage or we wouldn't be here today. And its success was evident even in those remote times. As millennium after millennium dragged on, other species of hominids appeared in central and eastern Africa until one of these species that lived in what is now central Ethiopia began making crude stone tools—and this is the second crucial date—about 2.5 million years ago.

These oldest known tools were found conveniently deposited in a layer of volcanic ash that was easy to date precisely, but there were no hominid bones along with the tools. Consequently, it's impossible to tell which species made this brilliant breakthrough. It may well have been one still unknown to science. But one thing is certain: the species that made the tools is our distant but direct ancestor.

These stone tools were not very impressive, being nothing more than chips cobbled by knocking one stone against another. Still, making even these rudimentary tools required some judgment about where to strike the stone to obtain a flake. The need for such judgment put making stone tools beyond the ability of any ape or chimpanzee, as modern experiments in trying to train chimps have shown. In general the toolmakers put a long edge on large, hefty stones and used them for smashing bones or ripping apart a carcass. And they chipped off flakes of quartz or lava and used them to cut into hides, something the flakes did surprisingly well. The appearance of the long-edged stones or of the flakes hardly concerned their makers at all. They were concerned only with creating an edge. These tools, once invented, did not improve—or even change—for a million years. Our lost and distant ancestor who began making tools apparently had one very good, revolutionary idea, and that was all.

After many years of sameness, a change came at last about 1.5 million years ago—the third important date. That was when the hand axe first appeared. Its inventor, a species of hominid whose scientific name is *Homo ergaster*, had first appeared 1.8 to 2 million years ago. The brain of *ergaster* was small compared to ours, but it was half again larger than the brain of any previous hominid. Except for the size of the brain, *ergaster* looked eerily like us. Unlike its forebears, it was more human than ape. Its arms were shorter than its legs, which must mean that it lived always on the

ground and not in trees. Its pelvis and hips had developed to enhance the ability to walk upright, and anthropologists speculate that *ergaster* was the first primate to have a nearly hairless body. Its nose, instead of being flat and internal to the skull like an ape's, stuck out like a human's.

We call *ergaster*'s signature tool the hand axe, but that simple name hides a nagging uncertainty. We don't know what hand axes were used for. Inevitably described in anthropology textbooks as "tear shaped," hand axes had a curved top and two straight sides that ended in a point. They were flaked to an edge on both sides and the sharp edge usually ran all the way around the perimeter of the tool. This means that a man who used such an axe to chop something would cut his own hand in the process. Nor would hand axes have been much good for hunting. If thrown, the axes would have been little more than an annoyance to a game animal, and the technological advance of putting a shaft on a point was still more than a million years in the future. In addition, all the tasks hand axes might have been used for—chopping, cutting, slicing, and so on—can be accomplished by simpler tools that require far less time to make. Why should our ancient relatives have, as it were, overinvested their time in hand axes? Some sites have hundreds of hand axes with no signs of wear, while other sites have just two or three well-worn axes. Some sites have no hand axes at all, while other sites in the vicinity from the same time and the same culture do have them. All these anomalies led two well-regarded scholars, Marek Kohn and Steven Mithen, to propose in 1999 that hand axes weren't really tools at all but were created and horded by males as a kind of sexual display.

That theory, which cannot be proved or disproved, is at least in keeping with the significance of the hand axe for us. Previously, as we have seen, tools had a random appearance depending on how the chips broke off the rock. But to make a hand axe, *Homo ergaster*

must have had the classic tear shape in mind before beginning. Then he shaped the rock until it conformed to that image. This brilliant leap, a million years in the making, was even more revolutionary than the original idea of making tools at all. The purpose of the hand axe may be confusing to us, but its shape is not. Symmetrical, classical in that it combines a curve with straight lines in a simple composition, a well-made hand axe is as aesthetically pleasing to us today as it must have been when it was made. In fact, if Kohn and Mithen are right in their conjecture, the aesthetics of hand axes were their whole value and purpose. The shape of the hand axe was an abstract idea. In all history, the hand axe itself was the first abstract idea to be made real. And humble *Homo ergaster*, who looked like us but had a much smaller brain, was the first living being to transform a vision into an object.

The last two dates necessary for understanding the art in the caves are 150,000 and 47,000 years ago. They are more precise than the previous three dates because there is more archaeological evidence associated with them. If only that made things simpler! Instead there is continuing controversy about what the evidence means.

As befits a visionary, *ergaster* was the first hominid species to migrate out of Africa. Starting no later than 1.8 million years ago, members of the species spread from the Horn of Africa across to Asia, where their descendants were a species known to us as *Homo erectus*, which includes the famous Java man and Peking man. *Ergaster* also moved up through what is present-day Egypt to Israel and far beyond into Europe, where *ergaster* and its descendants survived until 150,000 years ago. Their hand axes are found as far north as the British Isles. The descendants of *ergaster* in Europe eventually evolved into the Neanderthals.

In Africa the descendants of *ergaster* developed increasingly large brains until about 150,000 years ago, when the first modern humans, *Homo sapiens,* finally appeared. No one knows exactly where or how this occurred. East Africa is one likely setting for this momentous event because at the time it had a varied terrain with cul-de-sacs and cutoff regions that could have created the isolation necessary for a small population of one species to evolve into another. We may never find any evidence of the first true humans, since the original breeding population could have been very small—fifty people or even fewer—so that evidence of their existence might not have survived.

The appearance of these early *Homo sapiens* should be comforting, in a way. Here at last, after millions of years, we see ourselves present in the world. Instead the early *Homo sapiens* seem peculiarly distant from us. These early humans, who were anatomically identical to us, did not act like us. They were like characters in a science fiction novel whose souls have been leached away by some alien power, leaving them mere automatons.

They were cleverer than any of their ancestors. They had better tools, they could successfully hunt a wider variety of game, and they even on rare occasions made decorative objects or grooved a pattern of lines on a rock. But according to the evidence, they didn't think, create, or imagine as we do. Instead, apart from the most rare exceptions, everything they made was simply utilitarian.

Then, about 47,000 years ago, *Homo sapiens,* who had always looked like us, now began to behave like us as well. After that time, their sites are flush with carvings, figurines, and other art. They performed elaborate burials. They decorated their bodies and clothes with shells, beads, and the teeth of animals. All of this implies a rich culture, a focused intelligence, and a probing, seeking imaginative life, none of which had been present before.

There is no apparent reason for this sudden change. Richard G. Klein of Stanford University believes that the change was the result of a neurological change in the brains of *Homo sapiens* that occurred about 47,000 years ago. Specifically, he believes that this sudden neural alteration created the ability to speak a complicated language. Without language, symbolic thinking would have been impossible. With language, people did begin to think symbolically, and all our art and culture, our music and myths and tales, and all our religions are the result.

Of course, a change inside the brain could not and did not leave any archaeological record. Klein's theory will always remain an informed speculation, and Klein believes in it almost by default, thinking that nothing else but the sudden appearance of language could account for such a radical change in behavior.

Scientists who disagree with Klein say that there was no sudden change and that the symbolic behavior was present from the moment modern anatomy appeared. However, these arguments depend on a handful of carved or engraved objects in a few sites widely separated by time and space. Accidents of nature, rather than human hands, may have created some of the supposed symbolic objects. Even if all the objects are real human artifacts, they are so rare compared with the symbolic richness of sites after 47,000 years that they could be mere anomalies rather than the precursors of a revolution. Thus the debate over human origins has become distilled to unpersuasive arguments versus Klein's unprovable hypothesis. Welcome to modern anthropology.

However this came to be, by 47,000 years ago *Homo sapiens* had abilities beyond those of any other hominid then living. Numbers of them began to leave Africa looking for new territory, and they fanned out across the globe. Some moved north through the Levant, and then farther north to Eastern Europe. Some then turned west across central Europe and continued west until they reached

the valleys of the Pyrenees. All along their westward journey they encountered another hominid, distinct in both appearance and behavior but still uncomfortably similar, who had been living in these territories for at least 100,000 years. This must have been one of the most dramatic confrontations in all history, the moment when modern humans who arrived in Western Europe laid eyes on the Neanderthals. And, of course, that same moment was when the Neanderthals of Western Europe, isolated and unsuspecting, laid eyes on us.

Scholarly writing by anthropologists is supposed to be scientific and therefore completely unemotional. But during the last thirty years or so, papers in the leading journals have often been infused with sentimentality about the Neanderthals. Throughout the nineteenth century and the first half of the twentieth, Neanderthals were considered to have been thick, hairy, brutish creatures that walked in a stooped shuffle. Their short foreheads and large, jutting jaws made them look like the cretins they were thought to be. That image turns out to be completely wrong, and careful scholarship and inspired rethinking have been able to correct it. But now the view threatens to become just as misleading in the opposite way. Papers keep appearing in which the slightest wisp of evidence is paraded as proof of the Neanderthals' compassion, tenderness, and intelligence. One scholar, evidently enthralled by his visions of Neanderthals dancing hand in hand in a circle, described them as "the first flower children."

In most cases the sentimentality is more muted than that, but there is a subtle reason why it persists. It is not simply a matter of the pendulum's swinging too far in the effort to correct the mistaken brutish image. Anthropologists study indigenous people around the globe, especially those who may still be living in Stone Age

societies and who are often treated badly by the governments and other institutions that are more powerful than they. Anthropologists are hardly the only ones who are sympathetic toward these unfortunate people and accurately see them as victims. And, consistent with the political climate in universities for the past thirty years or so, there is an emphasis on seeing a pattern of exploitation and even extermination repeated again and again, beginning with Columbus arriving in the Americas and continuing through the nineteenth and twentieth centuries as Western imperialists advanced around the globe.

With such a view of the modern world and of recent history, it is inevitable that some researchers would come to see the Neanderthals as victims, too—to see them, in fact, as the very first victims of imperialism and to see our ancestors, the advancing modern humans, as history's first merciless and greedy conquerors.

It soon becomes clear that this analogy with imperialism is an attempt to fit a template from the modern world over the remote past, a mistake anthropologists usually recognize and reject. There were no empires in the Stone Age; neither did the new arrivals have an overwhelming advantage in arms and technology. Their contact may even have been friendly or, more likely, rare to nonexistent, since the two groups coexisted in the same territory for thousands of years before the Neanderthals finally disappeared. And that territory—the place where the Neanderthals and the modern humans lived together the longest—was in southern France, precisely where today we find the painted caves.

Hominids are by origin and by nature best suited for tropical and temperate climates. But the Neanderthals survived for 100,000

years or more in Europe in a climate that varied in intensity as the cons rolled on but was basically very, very cold.

Isolated in their forbidding world, they evolved, adapted, and survived. Neanderthals were short, and they had stout legs, hips, and arms, along with a tremendous round chest. Their bones were thick and heavy enough to withstand tremendous tension and to support an immense muscle mass. Consequently, they were unimaginably strong. In a wrestling match, a Neanderthal could crush even the strongest person of today simply by breaking his back with a bear hug. Lifting a 250-pound opponent would not have strained a Neanderthal in the least. Also, their hand was constructed in a way that gave the thumb tremendous leverage when it pressed in opposition to the fingers. That meant their grip was unbreakable. Once caught, our modern wrestler could never escape.

A ridge of bone went across their forehead just above the eyes. The rest of their face slanted forward toward a protruding jaw with practically no chin. Their teeth were generally worn to the nub, even in adolescents, as fossils show. Perhaps they chewed hides to soften them or perhaps they held one side of a hide in their teeth and then used a hand to pull the other side, thus holding the hide taut for scraping. That would have worn down their teeth and would fit with the way their jaws were pushed forward.

All in all, their heads were quite large and had a bony knob on the back. Their brain capacity was one hundred cubic centimeters larger than ours, and apparently they could plan for the future concerning food and shelter. There is little proof—and what proof exists is disputed—that they had any intellectual abilities beyond that.

Most Neanderthals died before they were thirty, and, by evidence of the skeletons that have been found, none lived past forty. Those skeletons also show that the Neanderthals often went hun-

gry. By contrast, the life expectancy of the modern humans who lived at the same time was fifty years.

The Neanderthals lived in small groups, moved camp often, worked incessantly, and seldom encountered Neanderthals in other groups. There are fossil remains of Neanderthals who lived for several years with crippling disabilities. For those cripples to have survived, others in the group must have shared food with them and helped them move from camp to camp, clear evidence of pity and affection, so they did have an emotional life.

Though sometimes they might have the good luck to be able to drive game over a cliff, their best weapons for hunting were wooden spears that they smoothed and sharpened with stone tools. The spears couldn't be thrown effectively. Instead the Neanderthals thrust them into their prey at short range. Contrary to past opinion, which held that they preferred to attack animals that were injured, sick, old, or very young, it now appears that they liked to target prime adults, which made hunting at such close quarters very dangerous. Neanderthal bones contain so many healed fractures, particularly around the head and neck, that one influential paper compared the pattern of Neanderthal injuries to that of modern rodeo cowboys and found that they were remarkably similar. The authors of the paper concluded that the similarity implies that Neanderthals, like cowboys, had "frequent close encounters with large ungulates unkindly disposed to the humans involved."

The Neanderthals' great muscle mass, while an advantage in many ways, took constant effort to maintain. Their muscles required so many calories each day that they would have needed to stuff themselves with animal fat, bone marrow, brains, and the like. Their clothes and shelters were apparently rudimentary, so just staying warm, especially at night, meant keeping all those great muscles in constant motion to generate heat. So much in-

tense activity might explain why they died so young. They simply wore out.

We don't know with certainty whether they could speak or not, but their society remained primitive. In their camps they never marked off any area for ceremonies or social occasions. The routine of their life—hunting, dressing meat, building fires, making tools—never varied, and there is little or no evidence that they had ways of symbolizing such activities or making them part of a rite or tradition that would add a meaning beyond the repetition that was necessary just to stay alive. Their groups remained small, probably because they didn't create the cohesive cultural patterns that make large groups possible—notions of authority and status, a respect for extended kinship, the ways of dressing and acting that show an individual's membership in the group as well as rank and status. The Neanderthals were hominids, but they did not act in ways we think of as human.

Except in one way. They buried their dead. Usually they dug a grave in a cave or under an overhanging rock and placed the body on its side with the knees drawn up to the chest in a fetal position. The burials are the reason why so many Neanderthal bones survive.

But the bones are all that do survive. The grave seldom contains anything but the corpse. There are no offerings or special preparations or even sentimental gifts for the departed one, so these burials aren't evidence of a developed culture or of religious beliefs, except in one unique case. A grave in a cave named Shanidar in Iraq contained clumps of flower pollen. The pollen could mean that the corpse had been decorated with flowers, and that in turn would imply a religious ritual preparing the dead for an afterlife. The Shanidar burial inspired the notion of the Neanderthals as the first flower children. Unfortunately, it's just as likely that rodents brought in the pollen, since the grave was lat-

ticed with their burrows. Unless someone should discover a similar burial site, the meaning of the Shanidar cave can never be determined.

But all Neanderthal burials, even without special offerings, do prove that the Neanderthals had just enough feeling for one another and had developed just enough of a social structure to want to recognize the death of a member of their group. They took the time to carry the body to a cave and dig a hole even though all they had to dig with were their hands, rocks, and sticks. Then they laid the body carefully inside the hole before covering it with dirt and rocks. Their careful burials reveal a glimmer of the potential the Neanderthals had for a richer life, a potential they began to realize after the humans arrived in their territory.

Jean-Pierre Bocquet-Appel and Pierre-Yves Demars are two French researchers who published a study in 2000 in the British archaeological journal *Antiquity*. Three sets of maps are the core of the paper. The first set begins with a map showing those places where there is evidence of Neanderthals from 40,000 years ago. The next map shows the places with evidence of Neanderthals from 37,500 years ago. The sequence continues with a new map for every 2,500 years down to 27,500 years ago. The first map shows the Neanderthals spanning Europe from Iberia to the Balkans. In the second-to-last map, they have disappeared from everywhere but a sliver at the foot of the Pyrenees in southern France and a toehold in the far southwestern corner of Spain. In the next map, the final one in the first set, from 27,500 years ago, they have disappeared completely.

The second set of maps covers the same period of time, but instead of tracing the Neanderthal contraction, it shows the spread of modern humans east to west across Europe until they—we— had spread all across the continent from the Balkans to Spain, advancing as the Neanderthals retreated.

The third set of maps shows the areas where humans and Neanderthals lived in the same place at the same time. This set of maps proves that it would be a mistake to assume that the modern humans were swooping down on the Neanderthals and driving them relentlessly west into the Atlantic. First of all, there were so few people and so few Neanderthals in such a vast expanse of land that the times when they actually saw each other were probably rare. It's also possible that when the modern humans saw Neanderthals, they avoided them and simply pressed on to new territory. There was plenty to go around. In fact, the third set of maps shows that there was only one area where the Neanderthals and modern humans coexisted for an extended period of time. From about 35,000 until 27,500 years ago they lived together between the foothills of the Pyrenees and the valley of the Vézère River in southern France—exactly the area where the cave paintings first appeared.

And here, too, the first few seeds of Neanderthal creativity bloomed for a short time even as the Neanderthals themselves diminished in number and finally disappeared. Why did they disappear?

One theory holds that the Neanderthals did not become extinct at all. Instead they interbred with humans and became part of our ancestry. This idea is part of the "multiregional" theory of human origins. The theory rejects the view that modern humans originated in Africa and migrated out from there into the rest of the world. Instead, it holds that modern humans evolved more or less simultaneously in many regions across the globe from the existing populations of older hominids. The multiregional theory is the minority opinion, but it has not been refuted entirely and it is buttressed by the archaeological record, such as it is, of hominids in eastern Asia, Australia, and the Pacific.

But the multiregional explanation that the Neanderthals

melded into modern humans appears to be mistaken. In 1997 an international scientific team managed to extract a small sample of DNA from the first Neanderthal skeleton ever found. In 2000 a different international team recovered a second DNA sample from the skeleton of an infant Neanderthal. Analyses of the two samples yielded identical results that proved there is no trace of specifically Neanderthal genes in our DNA. Perhaps modern humans never or rarely had sex with Neanderthals, despite living close to one another for thousands of years, because of a social taboo on one side or the other or both. Or perhaps individuals from the two groups did have sex but could not conceive. Or if Neanderthals and humans could conceive, then their mixed-species children must have been sterile. Either way, the fact remains that Neanderthals did not become our ancestors and that means they must have faded into extinction.

Until well into the twentieth century, the assumption was that we—modern humans—had killed them off and it was a good thing that we had. In 1921 the popular novelist H. G. Wells published *The Grisly Folk,* whose theme was exactly that. But, battered as Neanderthal bones often are, there is no hard evidence of violence inflicted by either humans or other Neanderthals. One skeleton does reveal a stab wound, but it wasn't fatal and could have been the result of a hunting accident. And if the humans were so bloodthirsty toward the Neanderthals, how could the two groups have lived together in southern France for more than seven thousand years?

In recent years the fate of the Neanderthals has inspired a blizzard of new theories. With one exception, they all have a common undercurrent. Just as the last couple of decades have seen a wide streak of sentimentality about the Neanderthals in scholarly work, there has also been a corresponding tendency, unstated but obvious to anyone who wades through the scientific literature, to

absolve any lingering guilt we might feel over the way we may have treated the Neanderthals. According to the new theories, we had little to do with the Neanderthals' sad fate. Or, even better, maybe we had nothing to do with their demise at all.

Some papers, filled with careful mathematics, show how even a slight difference in birth rate or life expectancy could have destroyed the Neanderthals in less than a thousand years without any overt action by the modern humans. Even if the Neanderthals simply took longer to wean their children, that slight advantage multiplied over generations would have ensured that the modern humans would prevail. Another theory is that we had a broader diet than the Neanderthals and thus survived. A number of large mammals died out about 30,000 years ago, and perhaps the Neanderthals were merely one such species. Or, when the climate grew more severe, as it did around 30,000 years ago, modern humans were able to adapt because of our larger, more efficient, and more cohesive communities, while it may be that the Neanderthals in their small bands could not.

The trouble with these theories is that the Neanderthals had survived in Europe for more than 100,000 years, weathering every swing in the climate from bitter to benign to bitter again, no matter what their birth rate and whatever the size and complexity of their communities. They faltered only after we arrived. Something we did, either intentionally or unintentionally, sealed their doom.

And certainly some of it was intentional. Certainly some of it was violent. Throughout history there has been violence whenever a stronger population on the move finds a weaker group living on desirable land. It is naive to suppose that in prehistory violence seldom occurred or that it had little overall effect on the extinction of the Neanderthals. Azar Gat of the University of Tel Aviv had the courage to publish a paper in 1999 that said as much, but he stands alone in the great debate.

It's true that there wasn't a great difference between the weapons on either side, and that the Neanderthals were physically stronger and had the initial advantage of complete familiarity with the territory where they lived. But the newcomers, or perhaps we should even call them the invaders, were able to organize. We know from observing hunter-gatherer societies that still survive that no matter where they live, whether in the desert or tropical forests or the arctic ice, they have family groups of 10 or 20, then associated groups of 150 to 175, and then a larger regional group of about 500 individuals. It's reasonable to assume that the first modern humans lived in a similar family and social organization of about the same size, especially since the archaeological evidence is consistent with that assumption. The Neanderthals, meanwhile, lived in their small groups of maybe 15 to 30. Strong as they were, 30 poorly organized Neanderthals would have been no match for 150 to 500 humans who were organized enough to cooperate in a fight.

There must have been attacks. Presumably the Neanderthals fought back. But much more often the Neanderthals probably just retreated and that is why no evidence of violence remains. Among the surviving hunter-gatherers, as among the tribes in North America before the arrival of Europeans, intimidation, threats, and boasting displays are much more frequent than actual combat. The invading humans would quickly have learned that a threatening display of their superior numbers would make the Neanderthals flee into the far distance.

The Neanderthals spent their last 7,500 years mostly around the Pyrenees and elsewhere in northern Spain and southern France. It's a land cut by hills, mountains, and river valleys into small sections that are isolated from one another. That meant the Neanderthals and modern humans could each occupy different territories and live without much contact with one another, especially since the population of both groups was so small. Still, there

must have been at least some occasional contact, and it produced the Neanderthals' most poignant legacy.

It was most likely clear to them that nearly everything the new humans had was better than what they had—better tools, better clothes, better camps and shelters, better hearths, and better methods of hunting. Also, the newcomers had things like jewelry, beads, and carved pendants. Seeing that there was, somehow, a better way, the Neanderthals began to copy, or try to copy, their rivals.

Neanderthal remains in France, especially at a site named Arcy-sur-Cure in Burgundy, include these first desperate efforts to transform themselves. There are awls, pins, and other artifacts carved from bone and ivory, materials only the modern humans had used before. These Neanderthals painted bones and made notches in them, perhaps their first rude efforts at decoration. They made ivory rings and they carved grooves at the base of teeth from wolves, foxes, reindeer, hyenas, and other animals and presumably hung the teeth from their necks or garments. And they carved grooves in long bones for some lost, unknowable reason of their own.

There are 125 sites containing such remains in France and northern Spain. Although they date from the same epoch, they are distinct from the modern human sites in the same area—another proof that in all the time Neanderthals and modern humans lived closely together, they never merged. The Neanderthals were forced into ever more remote and unproductive places as their numbers dwindled. They lasted the longest in a rocky wasteland in southwestern Spain.

Since an individual Neanderthal would have been formidable to a single human, it's easy to imagine—and imagining is all it is— the modern humans warning their children against these strange neighbors. Their warnings would have come from real concern,

but it is an easy step from there to using the warnings as a disciplinary tool—"The bogeyman will get you if you don't watch out." In many different Western cultures the belief in ape-man monsters like Big Foot or the Abominable Snowman stubbornly persists. It recalls what our distant ancestors may have felt during moments when they watched a band of their muscular neighbors make their way across a ridge in the foothills of the Pyrenees, a few hyena teeth hanging on rawhide cords around their necks.

CHAPTER 2

A Skeptic Admits His Error; The Passion of Miss Mary E. Boyle

On the western edge of Les Eyzies, the village where Font-de-Gaume is located, there is a small rock shelter formed by a low overhang of a cliff. It is tucked behind a large, two-story house covered with vines. To the right of the shelter, a sagging, aged barn leans against the cliff. A low stone wall runs in front of the shelter. It has a rusted metal gate that hangs open at an odd angle. Apparently no one has bothered to close it for decades. Although both the main street of the little town and the train station are just a few yards away, this shelter is quiet, leafy, and forgotten. There aren't even any signs that point the way here. But there was a time when the attention of all Europe was focused on this tiny spot, which was the site of a discovery that rocked the intellectual community, horrified the church, and gave a new phrase to languages around the world. These events are commemorated—or at least quietly noted—on a steel plaque bolted to the overhanging rock directly above the open gate. It announces that this place, known for generations before the skeletons were

43

discovered as the Cro-Magnon shelter, gave the common name to the first humans who arrived to occupy this land 35,000 to 40,000 years ago: Cro-Magnon man.

It was March 1868 when construction workers discovered five human skeletons beneath the overhang. Unfortunately, the workers mixed up the bones as they uncovered them, but Louis Lartet, a capable archaeologist, soon arrived to excavate the site according to the best practices of the time. Apparently the bones were from three male adults, one female adult, and an infant. Their anatomy was identical to that of modern people, and the skeletons were soon taken to be remains of the direct ancestors of the people then living in the area around Les Eyzies.

The first skeleton, known as Cro-Magnon 1, or the Old Man, was a male who was about fifty years old when he died. His skull was deeply pockmarked across the cheeks, the result of a painful and disfiguring viral infection. Other skeletons had fused vertebrae in their necks that must have come from terrible injuries. The female skeleton had a fractured skull, although that was not the cause of her death. She had survived with the fracture for several years. The lives of these ancient people were obviously filled with duress, but they were tough enough and canny enough to live to be fifty or even older.

Lartet concluded that the skeletons had been buried deliberately. His digs revealed a fine array of stone tools as well as artistic treasures such as carved antler, carved ivory, and pierced seashells apparently for stringing on clothes, necklaces, or bracelets. These attractive relics were identical to those found in several other sites nearby that had not contained skeletons. Lartet made the obvious assumption that these other relics must also have been made by the Cro-Magnons, who in the tenor of the times came to be described as the Cro-Magnon race. Since the first recognized Neanderthal skull had been discovered in 1856 in the Neander Valley near Düs-

seldorf, the French took some nationalistic pride in the Cro-Magnons. *Their* ancestors — that is, the ancestors of the French—had been this sophisticated, attractive, modern-looking race, while the Germans must have descended from the short, thick, dense Neanderthals.

It was a confusing, impassioned period. Even those nationalistic overtones were faint background noise compared to the wrenching debates between science and religion and among the scientists themselves. Charles Darwin had published *The Origin of Species* in 1859, just three years after the discovery of the Neanderthal skull. The book was circumspect about the origin of humans, although the implication that we had descended from apes was clear. The ambiguity didn't last long. Darwin's disciple Thomas Huxley published *Evidence as to Man's Place in Nature* in 1863, and Darwin himself followed with *The Descent of Man and Selection in Relation to Sex* in 1871. These books not only made quite clear Darwin's ideas about the descent of humans from apes—specifically chimpanzees and gorillas—but also argued that humans must have originated in Africa because that was where chimpanzees and gorillas lived.

This is where the conflict between religion and science about human evolution began. That conflict was just as virulent and politicized in the nineteenth century as it is today, or perhaps even more so, since Darwin's ideas were new then and more easily ridiculed. And there were many serious and thoughtful people in the scientific community who were as confused and belligerent about the question of human origins as the church. Not every scientist accepted evolution. Rudolf Virchow, a German who was the founder of scientific pathology, attacked evolution virulently at every opportunity. Even among those who accepted evolution there were constant battles over what exactly it meant.

The nineteenth century was obsessed with trying to define,

describe, and rank human races. Darwin's theory provoked endless arguments about whether the various races had had a common ancestor or different ones among the apes. Much depended on the answer because if the different races had different ancestors that would help explain the supposed superiority of some races over others. Everything about this debate sounds ugly to a modern sensibility.

There was another assumption among scientists of the time that is less grating but was no less misleading. Today science holds that evolution is neutral and certainly amoral. Evolution does not yearn for perfection but merely for survival. But scientists in the nineteenth century believed that evolution also meant progress, which is why many of the earliest scientists to adopt evolutionary views were also political progressives or radicals.

The brilliant Gabriel de Mortillet in France had such extreme politics that he had to live in exile for fifteen years. He believed in what he called "the law of progress of humanity." His influence was pervasive. He thought that evolution not only caused humanity to improve physically over time but also caused humanity to improve culturally as well. Neanderthals were slow-witted brutes; Cro-Magnons were a definite improvement, but their culture, those carvings on ivory and pierced seashells, was nothing more than a crude beginning that with thousands of years of evolution would eventually flower in ancient Greece, Renaissance Italy, or, for that matter, nineteenth-century France.

As new discoveries appeared, a varying mixture of science and aesthetics was often used to classify them. The theory was that just as a skeleton that had some features like those of apes must be older than a skeleton with only human characteristics, which is true enough on the whole, crude, unsophisticated tools or art must be older than sleeker, better-designed artifacts, which it turns out may or may not be true. De Mortillet's idea that culture evolved

just as species evolved led to the belief that early humans such as the Cro-Magnons made only crude tools and crude decorations because they were not capable of doing anything better. According to de Mortillet, people in the Ice Age developed their tools only in response to specific needs. They had not evolved enough to think abstractly outside this simple cause-and-effect relationship. Since they couldn't think abstractly, they could not have had religion, and without religion they could not have had art. In particular, they couldn't have made the paintings that had been found from time to time in caves.

Caves with prehistoric paintings were known and had been visited repeatedly over many centuries. They were not misunderstood, exactly; better to say they were not comprehended. In fact, the paintings in caves were bewildering, completely unintelligible, frightening. In 1458 Pope Calixtus III, who was from Valencia, condemned Spaniards living in the northern mountains for performing rites in the "cave with the horse pictures." (The Pope's phrase leads to the tantalizing speculation that some remnants of Ice Age religion survived until the mid-fifteenth century.) At Rouffignac, a cave in the Dordogne with marvelous paintings on a large, low roof, graffiti are mixed everywhere among the paintings. Many of the graffiti have eighteenth-century dates, including a cross drawn by a priest who had been brought in to exorcise demons and sanctify the room. Niaux, a beautiful and important cave at the edge of the Pyrenees, has numerous graffiti where visitors over the years have scratched or painted their names. One of the oldest is "Ruben de la Vialle," the name of a man who left his mark in 1660. His inscription is only a yard away from large, well-preserved images of bison and ibex. In 1864, two hundred years after de la Vialle's visit, a scholar named Félix Garrigou, who was himself a prehistorian, visited Niaux and later wrote in his notebook, "There are paintings on the wall. What can they be?"

The paintings were seen by these people and many others, but except for a line or two in a notebook or in an occasional letter, they were never written about. Since the visitors in the caves could not even begin to understand what they were, the paintings might as well have been invisible. The teachings of the church couldn't account for them, while the teachings of science, especially de Mortillet's doctrine of cultural evolution, couldn't account for them either. If mentioned at all, they were dismissed as frauds, as the work of Roman soldiers, or with some other fanciful explanation.

Mistakes taint science; they also cause tragic lives. Eventually science corrects its mistakes, but tragedy can't be undone. The first victim of the belief in cultural evolution was an estimable Spanish scholar and aristocrat named Marcelino Sanz de Sautuola. Events would prove that he was not only a talented intuitive scientist but also a visionary. His life was blessed and cursed because in 1879 he discovered on his family's land the beautiful painted ceiling in the cave known as Altamira. near Spain

Sautuola had earned a degree in law, but he had an amateur's scientific interest in the natural history of his ancestral lands and the neighboring countryside in northern Spain. He read and explored, and he added to his collection of local insects, minerals, and fossils. In 1878, just a year before his fateful discovery, Sautuola traveled to Paris to attend the World Exposition. Once there, he was particularly attracted to an exhibit of prehistoric tools and small objects of art that had been found in France. The experience thrilled and inspired him, particularly since he was able to meet Édouard Piette, who was then one of the luminaries of French prehistory and a fervent collector of prehistoric artifacts. Sautuola had long conversations with Piette about the artifacts and the proper ways to excavate a site.

Once home, he began excavating around the countryside, particularly in various caves in the region. His sole intent was to find prehistoric objects like those he had seen in Paris. That was how in November 1879 Sautuola came to be digging in the floor of Altamira. The story of that afternoon is now famous. Sautuola was forty-eight at the time, a slender, balding man with thick, curly sideburns connected by a luxurious mustache. He had a young daughter named Maria whom he had brought to the cave with him. As her father concentrated on his excavations, Maria ran playfully in and out of the cave and here and there in the large, low room where her father was working. For no particular reason she looked up and saw what she later called "forms and figures" on the roof. "Look, Papa," she cried. "Oxen!"

Papa looked up and there was Altamira's great painted ceiling. Over twenty yards long, it is covered with vivid yet delicate paintings of bison, almost fully life-sized, that appear to be tumbling across the sky as if they had been tossed by some giant hand. Sautuola was so dumbfounded that he burst out laughing. He must have recognized the absurdity of his intense focus on his careful excavations when rich treasures beyond his dreams were in plain sight only a few feet above his head. Finally his enthusiasm overwhelmed him and he could hardly speak.

I like to think that it was at this precise moment that Sautuola made the brilliant deduction that the paintings came from the Stone Age, that they were made by the same people who had made the tools, carvings, and other objects that he was finding in the floor of the cave and that he had seen in the World Exposition. That deduction earned him the respect of history and little but contempt during his lifetime. Even if his superb intuition only crystallized into words somewhat later, after he had recovered his composure, Sautuola must have seen those paintings from the first moments without any clouds of prejudice or even confusion. He knew what he was seeing in a painted cave when no one before him

Don Marcelino Sanz de Sautuola, who discovered the paintings in Altamira, had a brilliant moment when he realized the paintings were the work of prehistoric people. His deduction earned him the respect of history and little but contempt in his lifetime.

had. That day in November 1879, as Marcelino Sanz de Sautuola stood speechless below the painted ceiling of Altamira, was the first time we know of that an artist from the distant Stone Age touched the soul of a modern person.

Sautuola approached Juan Vilanova y Piera, the leading paleontologist in Spain, who had the good sense to visit the cave in person, something Sautuola's most vehement detractors rarely bothered to do. Vilanova quickly concluded that the paintings were indeed the work of prehistoric people and gave a lecture saying so. That carried the news across Spain and created a rush of visitors similar to the excitement that would follow the discovery of Lascaux sixty-one years later. The king of Spain himself came to see the marvels.

These expressions of local support and acceptance were the last happy moments for Sautuola. Only a few months later, in early 1880, he published a cautiously written pamphlet titled *Brief Notes*

on Some Prehistoric Objects from the Province of Santander. He was well aware that claiming the paintings were the work of Stone Age people would expose him to controversy and that he would be a mere amateur confronting the orthodoxy of the scientific world. Since he wanted to avoid trouble if he could, he began his pamphlet with the dullest information—technical analysis of stone tools, ornaments, and remains of food—before turning to the paintings. Here he was more tentative still. He wrapped his assertions about the validity of the paintings in prose so convoluted that it's nearly impossible to follow what he is saying and so tortured that his internal anguish practically moans behind every word: "It is doubtless that by repeated discoveries, which cannot come under any doubt at all, that the present has proved that already man, when still not possessing more room than caves, produced, and with similarity, upon horns and elephant trunks, not only his own figure, but also the animals he saw, it would not be adventurous to admit that if, in that epoch, such perfect reproductions were made, engraving them upon hard surfaces, then there is no founded motive for completely denying that the paintings are also of such an ancient procedure." (Translation: Since it's been proved that Stone Age people engraved realistic pictures of animals on hard surfaces like horns, there is no reason to doubt that the paintings are just as old.) This passive, cumbersome, frightened, almost incomprehensible sentence ruined Sautuola's life.

Tortured and tentative as he was in his writing, Sautuola in person confidently stood by his conclusions. A few months after the publication of the pamphlet, he and Vilanova attended the International Congress of Anthropology and Prehistoric Archaeology in Lisbon, with every august presence in European prehistory in attendance. Vilanova made a formal presentation. When he displayed drawings of some of the paintings in the cave, the disbelief was palpable. Émile Cartailhac of France, the most respected per-

sonage in prehistoric archaeology, pointedly walked out of the lecture, making no effort to disguise his disgust.

His response was foreordained, since Sautuola had sent Cartailhac a copy of his pamphlet only to receive a contemptuous reply that these paintings pretending to be of prehistoric wild cattle looked nothing like the real thing. (Sautuola could have responded that they don't look like cattle because they are bison.) Then, to make matters worse, de Mortillet warned Cartailhac that some Spanish Jesuits were behind a secret plot to embarrass prehistorians at the International Congress as a way of attacking evolution. The paintings at Altamira were nothing but clever forgeries that were part of the plot. No Stone Age artist could have painted with such skill. Someone had duped Sautuola, or perhaps he was himself part of the conspiracy. Cartailhac said it was all "a vulgar joke by a hack artist" and refused an invitation from Vilanova to visit the cave. He had taken a personal dislike to the two Spanish gentlemen because they persisted in pressing their case at other meetings during the congress. The official report of the event does not mention Altamira at all. Sadly, this atmosphere of intrigue, jealousy, mendacity, and paranoia contaminated the world of prehistorians between 1880 and 1900 and, with somewhat less intensity, still does today.

Cartailhac was only thirty-five. He was a thin, slight man with very thick, wavy hair that was black as onyx. A thin mustache and beard spread in tiny curls around his jaw. There were thick, dark circles under his eyes, which were unusually deeply set. He tended to regard the world with a faraway gaze.

Cartailhac had risen rapidly to his eminent position and he combined the certainty of youth with a reputation that made him immune to challenge, something that usually comes only with age. Sautuola had annoyed him so much that he could not confine his vindictiveness to the congress. Several months later, in 1881, he

dispatched a man named Édouard Harlé to visit the cave and report on what he found. Harlé dutifully wrote that the paintings were obvious forgeries. He claimed they were too skillful and the paint was too new for them to be genuine. But the point that clinched his argument was that prehistoric people could have lit the cave only with torches but there were no traces of smoke on the walls or ceiling of the cave. The paintings must have been made with modern artificial light that produced no smoke. Cartailhac gleefully published Harlé's paper in the influential journal he edited. Now other mocking papers about Altamira began to appear, not only in France but—painfully for Sautuola—in Spain as well.

Still, Sautuola and Vilanova persevered. They presented papers at the French Congress for the Advancement of Science in both 1881 and 1882 and at an international congress in Berlin in 1882. No one listened. Cartailhac published his study *The Prehistoric Ages in Spain and Portugal* in 1886. It did not mention Altamira. By now Sautuola was a broken man. The attacks on Altamira were often personal, but even when they weren't openly personal, he took them as attacks on his honesty. He believed he had offered the world a great treasure and the world had responded by calling him a liar and a scoundrel. Marcelino Sanz de Sautuola, the man who was the first to understand what the cave paintings were, the man who was the first to comprehend that they had been made by prehistoric people, the man who was the first to experience their power as art—that man died prematurely at fifty-seven in 1888, distraught, miserable, unvindicated.

Sautuola's vindication would come, but fourteen years too late to help him. All along there had been a few—a very few—enlightened scholars who believed that the Altamira paintings were genuine. One was Édouard Piette, the distinguished prehistorian who had befriended Sautuola at the Paris World Exposition in 1878. He

was building an impressive personal collection of small engravings, statuettes carved from ivory and antlers, and particularly well-made tools, and he believed that people capable of creating these beautiful objects would also be able to make beautiful paintings on the walls of caves. Piette, a kindly man, eventually wrote Cartailhac endorsing the paintings at Altamira, but to no effect.

What did have an effect on Cartailhac, years later, was the evidence of his own eyes, but only after so much evidence had accumulated that he could no longer equivocate about what he was seeing. During the 1890s several ardent amateurs were exploring and making archaeological digs in caves in southern France. One was Léopold Chiron, a small-town schoolteacher and amateur archaeologist from the Ardèche region in southeastern France. While digging at a local cave named Chabot, he noticed a swirl of engraved lines. He was certain the engravings were ancient because they were covered by a film of calcite that could come only with age. The engravings at Chabot are filled with disconnected lines and are notoriously difficult to decipher. Mistakenly, Chiron interpreted the drawing as groups of people and birds with open wings. But he did make tracings and even took photographs. More important, he connected the engravings with the stone tools he was finding on the cave floor and concluded that both were made at the same time by the same people. Chiron announced this conclusion in a paper he published in 1878 in the *Revue historique, archéologique, littéraire et pittoresque du Vivarais,* a provincial journal that didn't carry much weight in the leading circles of the day. Chiron even wrote the great de Mortillet, who never bothered to reply. De Mortillet was certain of his theories. Why should he bother with the strange, rather challenging ideas of a small-town teacher? Chiron, however, was not intimidated. For the next fifteen years he continued to present his discoveries at meetings of provincial scientific societies, where he discussed both Chabot and the engravings he had found in other caves nearby.

In 1895 the owner of a cave named La Mouthe in the Dordogne region dug away an ancient rockfall and exposed a new gallery. Some local boys explored farther into the cave and found engravings. Scientists rushed to the cave, and one found a flat stone with a shallow indentation scraped at one end. This was the first prehistoric lamp to be discovered and recognized for what it was. Since the rockfall had sealed the cave for eons, the engravings could not be forgeries. The lamp solved the puzzle of how the ancient artists had illuminated the caves.

After the discovery at La Mouthe, local amateurs and hobbyists returned to caves where they had noticed paintings or engravings but had paid no attention to them. François Daleau, who lived in a region just east of Bordeaux, had dug in a cave named Pair-non-Pair fourteen years earlier. (The name means "even, not even," the French version of heads-or-tails.) Now he returned to find engravings that had been exposed by his excavations. Since they had previously been covered with dirt that hadn't been disturbed for at least 15,000 years, they could not be forgeries or the pranks of children but had to be the work of the Cro-Magnons. This cave finally convinced de Mortillet, who had the grace to admit his conversion in 1898, shortly before his death.

In 1901 a schoolteacher in Les Eyzies discovered both Font-de-Gaume and a cave close by named Les Combarelles whose walls were covered with hundreds, perhaps thousands, of engravings. Cartailhac visited these two caves as well as La Mouthe and Pair-non-Pair. At last even he was convinced that all these paintings and engravings were not "a vulgar joke by a hack artist" but the work of prehistoric people. At La Mouthe he himself had scraped away a layer of dirt at the base of a wall and exposed the hoof of a painted animal. I've often wondered what this proud, stubborn, but intelligent man was thinking as he uncovered with his own hand the proof that his twenty years of malicious contempt toward Sautuola was all a terrible mistake.

It could be that even then he had conceived of what would become his masterstroke. He repented publicly in a paper he published in 1902 in *L'Anthropologie,* then as now the leading journal for prehistory in France. Cartailhac gave his paper the awkward title "Les cavernes ornées de dessins. La grotte d'Altamira, Espagne. 'Mea culpa' d'un sceptique."

This apology is sincere in its way, and his searching for reasons to explain his errors would even be somewhat touching if it didn't have an air of calculation. He begins with his visit to Pair-non-Pair and to La Mouthe, which convinced him of the "prehistoric antiquity" of the engravings. But how, he wonders, could they have been done with such a sure hand in the "vacillating light of smoking lamps?" He sees only one solution to this mystery: "One must believe that the eyes of the prehistoric people were more accustomed to seeing in semi-darkness than our own." Then, prevaricating, he says it was not having thought of *that* that made him complicit twenty years earlier in "an injustice that it's necessary to admit clearly and to put right." No, he continues, resigned at last to the inevitable, "One must bow before the reality of a fact, and I, as far as I am concerned, must make amends with M. de Sautuola."

Two generations of French anthropologists and archaeologists would reverently cite Cartailhac's "mea culpa" as an example of the bravery of a true scientist who loves truth enough to admit his mistakes publicly. That adulation meant that Cartailhac kept his position as the leading prehistorian of his generation for decades after his death. But lately there has been a movement to resurrect Édouard Piette, the man who first helped Sautuola at the World Exposition in 1878 and who believed from the very first that Altamira was genuine. Yes, the thinking goes, Cartailhac admitted his error, but he was wrong all those years while Piette was right. Piette didn't need to admit an error because he hadn't made one.

Perhaps it's the cynicism of our age, but in recent years the

"mea culpa" *has* begun to look like stage management rather than incorruptible honesty. When one is wrong, a splashy public apology can not only eradicate the error but also create more attention and respect than one might get just for being right. It's similar to a gambit in chess where an early loss turns out to be a trap for the opponent that leads to a stunning victory. One modern prehistorian who had been on the winning side of a public dispute confided to me that in the aftermath of the battle he had feared that his opponent would "do a Cartailhac" on him.

To Cartailhac's credit, however, his conversion was real. In August 1902, shortly after publishing his "mea culpa," he again visited La Mouthe, Les Combarelles, and Font-de-Gaume as part of the yearly meeting of the French Association for the Advancement of Science. These visits gave the cave paintings an official approval so that the doubters who remained were suddenly outside the scientific establishment rather than within it. Cartailhac then tried to make up for twenty years of lost time. He convinced a young assistant to come with him for an extended archaeological investigation of . . . Altamira!

That young assistant had not needed much convincing to go. He was a twenty-five-year-old priest named Henri Breuil who had decided that studying prehistoric art was his calling in life. He would unrelentingly devote all of his considerable energy and intellect to that calling for the next fifty-five years. Within three years of leaving for Altamira with Cartailhac he had become the preeminent force in the world in prehistory. Others called him the Pope of Prehistory, and in time he too began calling himself that. Beginning in 1902 he initiated several brave attacks on the existing orthodoxy about the painted caves, and he won every battle and every war. Throughout his long life his stature and influence never

*The meeting of the French Association for the Advancement of Science,
photographed at the entrance to La Mouthe in August 1906. Émile
Cartailhac stands fourth from the left holding what appears to be a
candle. Is his haunted expression the result of his reflecting on his
twenty years of malicious error? Abbé Breuil, later known as the "Pope
of Prehistory," is fourth from the right, wearing the priest's collar.*

disappeared entirely, and waned only when he was well into his
seventies.

Breuil had fixed on his vocation during the summer of 1897
while he was still a seminary student. A friend at the seminary
named Jean Bouyssonie invited Breuil to come home with him to
Brive-la-Gaillarde, a railroad town and commercial center on the
Vézère River a short way northeast of Les Eyzies. The two friends

investigated the known prehistoric sites in the area. Then Breuil continued on alone, going from site to site and in September finally arrived in Rumigny, a small village north of Paris that was the home of Édouard Piette, now sixty. Piette liked Breuil—not everyone did—and recognized his latent talent. During his career, Breuil worked with all the great names in prehistory, but he always referred to Piette as his master and inspiration.

Piette showed Breuil his collection of prehistoric objects of art, which was then unrivaled by any other collection, public or private. Breuil was overwhelmed, and in that moment he decided to devote his life to studying what he then called the Reindeer Age. Breuil was an excellent artist, and his artistic skill would soon make his reputation. He set to work making careful drawings of each object in Piette's collection—drawings for which the kind gentleman was generous enough to pay Breuil four hundred francs.

In September 1901 Breuil, working with two other enthusiasts, was again in the Vézère Valley around Les Eyzies. His small team had inspired the townspeople to explore the caves in the area. That was how a local schoolteacher had come to discover Les Combarelles. The teacher persuaded Breuil and his associates to explore it themselves. They entered on September 8 and immediately realized the teacher had made a discovery that would remove any lingering doubts about art in the caves. There are no paintings in Les Combarelles, but the walls are covered with hundreds of engravings. Breuil counted almost three hundred during his first few days studying the cave. Many of them show superb delicacy and artistic skill. Breuil threw himself into a frenzy of work in the cave and his excitement spilled over into a letter to Jean Bouyssonie on September 10: "Hurrah! Talking of discoveries, here is one and what a one; an immense engraved grotto more than 300 meters long and on over half of it, engraved figures of animals, especially horses, but also antelopes, reindeer, mammoths, ibexes.

I still feel as though I had dreamed it all—just to happen on it, quite casually, as you might find a stone on the road. And how we slaved yesterday; I traced eighteen of the beasts—some of them are magnificent . . . all in all I spent ten hours in the grotto; I am half-dead, I am aching all over, but I am very well pleased. Extraordinary, eh? As for myself, I am giving thanks to Providence."

Just four days later, on September 12, the same young schoolteacher from Les Eyzies went alone to explore a different cave nearby. He was hoping to find another Les Combarelles, but instead he found the long galleries of unrivaled beauty at Font-de-Gaume. For Breuil, here was a second gift from Providence, and he began furiously copying the paintings in the newly discovered cave.

Breuil and his colleagues published papers complete with Breuil's drawings early in 1902. This was the work that convinced Cartailhac to invite Breuil to accompany him to Altamira. They had nine hundred francs between them for the expedition. Cartailhac had obtained five hundred francs from a patron and Breuil contributed the four hundred francs Piette had paid him for the drawings of his collection. Breuil had saved the money for some special purpose for five years, and now that purpose had arrived.

Cartailhac arrived in Santander unsure of his welcome. After all, he had antagonized and ridiculed Sautuola, who was remembered affectionately and whose family still held a lofty status in the province. But he and Breuil were welcomed warmly by local dignitaries, who continued to perform various courtesies during their stay. Whatever had happened in the past could stay in the past; this was a chance for Santander, beautiful but remote, to become famous. Cartailhac, who was seeing Altamira for the first time, was also eager to forget the way he had treated Sautuola. The paintings

now excited him more than any artifacts he had ever seen. He proclaimed that Altamira was the "most mysterious and astonishing" of all the ornamented caves.

He and Breuil had intended to stay only three or four days, but the cave was so rich that, stretching their money, they stayed a month. They began work at dawn, going into the cave through its unimposing entrance, which was hardly more than a hole in a hillside among some bushes. By the time they left, night had fallen.

The work was arduous and was made worse by hazards in the cave. Rocks that had fallen from the ceiling covered the floor in the largest gallery. The amateurish digs Sautuola and Vilanova had made in 1880 were now very much in the way and a constant annoyance. The two men tried to clean things up and level the floor but it still remained littered with pointy, angular slabs. The painted ceiling that had so overwhelmed Sautuola, and now had the same effect on Cartailhac and Breuil, was about twenty yards long and twelve yards wide. It was quite low and uneven, so that the two men had to move around the room bent double. It was difficult for Breuil, who was only twenty-five and quite short; but Cartailhac, who was thin and rangy and fifty-seven years old, suffered even more. In some places the ceiling was so low they had to lie on their backs to see the figures completely. They used sacks of straw as cushions against the rocks, but the sacks provided more aggravation than comfort because the rocks constantly poked through the shifting straw.

In the end, Breuil was the one who had to lie on the ground, often in the most tortured positions, because his work was to make copies of the paintings. In those days before photography was common and inexpensive, drawings of discoveries were the only way for both scholars and the general public to see what the paintings were like. More important, an accurate copy allows for detailed study without risk of damaging the art itself. Since prehis-

toric paintings and engravings are frequently placed one on top of another, copies are a means of separating out the individual works. Today, elaborate manipulation of copies using computers is one of the most productive methods of studying the art in the caves.

At Altamira, as Breuil worked on his copies, Cartailhac circled uneasily around him measuring the dimensions of the paintings and taking notes. He had to be ever vigilant not to straighten up even slightly, since then he would brush against the paintings. At the same time, he directed the handful of local workers they had hired to hold lighted candles so that the faint light illuminated the precise area of a painting Breuil was copying.

In the midst of this tense, painful, and enervating work, the two men were interrupted constantly. As news about them spread through the neighboring villages and beyond, curious onlookers began to arrive. Some had traveled considerable distances to get there. To exclude them from the cave or to ignore them while they were there would have offended local customs. With their backs contorted in pain and with so much work still to do, Breuil and Cartailhac had to pause repeatedly and chatter politely with anyone who came to see the cave. Besides that, it rained hard day after day.

Occasionally, though, when the sun pierced the clouds, they were able to have lunch outside the cave on a hillside looking across the long, majestic valley. A photograph from the time shows Breuil sitting on a blanket during one of those pleasant afternoons. Although he has not yet lost his hair, he looks older than his years, with a high forehead and thick black eyebrows. His black cassock is covered with white daubs of wax that had fallen from burning candles as he worked inside the cave.

The persistent rain raised the humidity in the cave to the point that the paint on the walls and ceiling became sticky. Breuil couldn't trace the paintings directly without ruining them. Also,

the watercolors he usually worked with were useless in the cave's damp atmosphere. Fortunately, Breuil had also brought some pastels with him, and he taught himself how to use them. First he would make rough sketches of each painting. Then, using Cartailhac's measurements, he would execute his copies.

All the while, they saw the remains of hearths, broken bones from ancient meals, and stone tools, but they knew they lacked the time and resources to make proper excavations. Instead their month of work produced Breuil's copies and Cartailhac's inventory and description of all the paintings that they saw in the cave. Having finished and no longer having to endure long days bent double under the painted ceiling, Cartailhac became almost giddy with euphoria. "We left Santander on October 28," he wrote, "on one of those extraordinary nights when the entire sky was lit up with strange fires. We left thankful and enchanted, enriched by a dossier without equal of the oldest paintings in the world."

Breuil, too, left in high spirits. He was more certain than ever that he had found his true calling. "After Altamira," he said, "I copied many thousands of paintings and engravings. The animal art of the Cave Age was my main concern during my life as an artist." Later he estimated that over the years he had spent more than seven hundred days in seventy-three different caves "with my lamp in the darkness, deciphering, copying, tracing."

But what should be done with Cartailhac's dossier and Breuil's copies? Their work was too important to confine to a few run-of-the-mill papers in academic journals, yet publishing it as a book would be far too expensive for any scholarly society to afford. They had to wait four years until Prince Albert I of Monaco eagerly agreed to underwrite the publication.

Prince Albert was the great-grandfather of Prince Rainier of Monaco, who married Grace Kelly, and the great-great-grandfather of the present monarch, Prince Albert II. Albert I,

who lived from 1848 to 1922, was a robust, active, appealing man with real intellectual interests. He was passionate about deep-sea research and also about aviation, which was then just beginning. In 1906 he traveled by dogsled to the North Pole.

During the last half of the nineteenth century, archaeological digs in caves along the coast of Monaco had found human skeletons and a number of statuettes of women with huge buttocks. Albert had worked in these digs himself and met Cartailhac there. In 1906 he met Breuil at a scientific conference in Monaco. The encounter began a long association between the two men that culminated in 1910, when the prince founded the Institut de Paléontologie Humaine in Paris with the Abbé Breuil as director. The Institut remains a vital institution under the continuing patronage of Monaco's ruling family, who still maintain an apartment in a building across the street. There are many photographs of Prince Rainier, his family, and his ancestors along the dark halls of the Institut. In one, Princess Grace, wearing a pair of black glasses, daintily examines a prehistoric human skull.

In 1906, with Albert's patronage, Cartailhac and Breuil published *La Caverne d'Altamira à Santillane,* an immense (thirteen-by-eleven-inch) and expensive tome that Cartailhac, who cannot be faulted for a lack of ambition, made the monumental repository of everything then known about painted caves. It is here that all the subsequent studies of the painted caves—thousands of books and papers—have had their beginning.

In the book there is of course an account of the discovery of Altamira and the controversy that followed, as well as the inventory and description of the paintings in the cave. But that is only about a third of *La Caverne d'Altamira.* There are histories and descriptions of La Mouthe, Pair-non-Pair, Les Combarelles, Font-de-Gaume, and the six other decorated caves that were known at the time. One whole chapter is devoted to red ochre, its prepara-

tion and how it was used as pigment in the paintings. Another chapter compares the engravings on bones, ivory, and antlers to the paintings on cave walls.

But most important are three chapters comparing the art of native peoples in North America, Africa, and Australia with that in the prehistoric caves in Europe. These chapters anticipate the modern sensibility that regards all rock art, wherever it occurs and whenever it was done, as part of the same phenomenon. There from the very beginning was the risky but tempting habit of trying to explain the people who made art in the caves in France and Spain by comparing them to Stone Age societies that still exist. Since they assumed those societies used their art as hunting magic, Cartailhac and Breuil assumed the art in the caves must have been hunting magic as well. Australian tribes used abstract signs in their art as symbols of real objects; therefore, the geometric signs in Altamira "are also some images of some device, of a weapon." The faint silhouettes of human shapes with animal heads must be the hunting masks often worn by shamans in rituals. "A priori," Cartailhac argues, "the mask must have been known by our Paleolithic artists and also the masked dance." By using analogy it's possible to "join our group of Paleolithic engravings and paintings to the work presented by all primitive races across the continents." Through such analogies, he concludes, "We have had the satisfaction of seeing the civilization and the mentality of our prehistoric people revived in a manner we could not have hoped for." Although the language is outdated—Cartailhac, for instance, habitually refers to native people as "primitive," a word taken to be a serious affront today—the argument from analogy and the evocation of masked dances and shamanism as an explanation of the painted caves has never disappeared. On the contrary, it has recently been revived.

Cartailhac's text, although eerily prescient, is interesting

mainly as history. That is not true of the plates of Breuil's pastel renderings of Altamira's paintings. Bold, fluid, subtly shaded, vivid, Breuil's work shows the most loving and tender sensitivity both toward the paintings and toward the animals they depict. These species of horses, deer, and bison had been extinct for millennia. Breuil knew about them only through the paintings, yet it seems as if he knew them firsthand, as if he had somehow managed to inhabit the mind and body of one of the original artists in the cave who painted the animals from direct observation. Breuil himself apparently believed he really could transport his sensibility back through the ages. He once wrote, "I can readily imagine the artists of the Reindeer Age were like me . . . They cast upon the rock face, as I did upon paper, the inner vision they had of an animal." Again and again, in pastel renderings with titles like "Reclining Bison Turning Back Its Head" and "Female Bison Curled" and "Halted Bison Bellowing," Breuil creates images of such delicacy and such sympathy that looking through *La Caverne d'Altamira* is an intense emotional experience. You forget, almost, that these are not the paintings themselves.

But that is precisely what should never be forgotten. Breuil's great artistry is his strength and his treasured legacy to us. But it is also a bit dangerous. His paintings, his truly great works of art, copies though they may be, are works of art by Henri Breuil. They are infused with his vision and his understanding of the cave painting, and that vision and understanding deserve much careful consideration. But to understand cave art it's necessary to look at it in the caves. Breuil was painting Breuil's vision and not what a prehistoric artist had painted.

That difference is crucial. One example will show why. The paintings on the ceiling of Altamira are part of a composition or several compositions. There is a reason for these animals' all appearing together, random as some of the images may appear to

us. But Breuil paints individual images. They are well worth studying, but they are separated from their neighbors on the ceiling of the cave and thus can never carry the meaning they originally had.

When Breuil left Altamira that evening late in October 1902, he had accomplished the first great work of his life both as an artist and as a scientist. He was an artist of a particular kind and calling who nevertheless inspired other artists. When Pablo Picasso, then only twenty-five years old, saw Breuil's copies in *La Caverne d'Altamira,* he quickly went to see the cave for himself. As a scientist, with his work at Altamira completed, and with his early insistence that Les Combarelles and Font-de-Gaume were the work of prehistoric people, Breuil had vaulted from being an obscure seminarian into the first rank of French archaeologists.

But he had only begun. Three years later, in 1905, he was the star attraction at a scientific congress in Périgueux, a provincial capital not far from Font-de-Gaume and the other historic sites in the Vézère Valley. There he presented the second great work of his life: a complete revision of the accepted dating of prehistoric tools and art. He was ridiculed and his work was dismissed at first, much as his work at Les Combarelles had been. And, yet again, he persevered and triumphed. This massive revision of the accepted dating was not Breuil working as an artist. It was the work of an archaeologist, an anthropologist, a scholar, and a great one at that. But, like his paintings, his scholarly work was great in a particular, focused way.

As an artist Breuil was a brilliant copyist, and as a scholar he was essentially a brilliant describer and classifier. The huge philosophical questions that archaeology and anthropology lead toward—What does it mean to be human? for one—did not inter-

est him or at least did not find a place in his work. Perhaps his religious beliefs provided the only answers he needed. But it is astonishing in science what power can derive from simply placing all the available evidence in its proper order. That begins, of course, with determining what the proper order really is, and that was Breuil's brilliant accomplishment. The paper he delivered at the 1905 conference was the first salvo in a fight that lasted four years and came to be known as the Battle of the Aurignacian.

Despite the importance of this battle, its details are extremely technical. They concern the shapes and sizes of stone tools that different cultures made at different times during the Stone Age. An "industry" is the archaeological term for the tools and other artifacts left behind by different prehistoric cultures. During the Stone Age, which itself is divided into lower, middle, and upper levels, there is a bewildering array of industries, which are themselves sometimes subdivided into ever smaller classifications. Long papers, lethally boring, fill the journals with debates over whether a certain minor industry is discrete or whether it is only a local variant of another industry. Despite their tedium, the debates continue because they could turn out to be important. Putting all the stone tools and the industries they represent into a proper chronology is immensely illuminating.

In the mid-nineteenth century the first archaeologists tried to make sense of the artifacts they were finding. How did these ancient remains relate to one another? Which were older, which were younger? Was there any way to organize them? Those early archaeological pioneers had deduced some rough dates from the geological levels where the tools were discovered. In simplest terms that meant the deeper, the older. Noticing also that different fossil bones appeared in different geological levels, they concluded that certain animals had become extinct one after the other. So in 1861 Édouard Lartet, a respected founder of French archaeology

and the father of Louis Lartet, who would do the excavations at the Cro-Magnon site at Les Eyzies, devised a system of classification depending on which animal bones were found most often among the stone tools at different sites. This way he could assign certain kinds of tools to the Great Bear Age, which was the oldest. The Mammoth Age came next and had its distinctive tools. Then came the Reindeer Age and finally the Age of Aurochs. Today, this method of classification sounds quaint, like the creation of some hack poet of the mid-nineteenth century rather than the sober work of a leading scientist. But considering the evidence Lartet had to work with, it was actually inspired.

Inspired or poetic, it soon gave way to a system based on careful comparisons of the artifacts themselves, and this was the system that Breuil attacked. His assault was strictly scientific, but he may have felt some submerged personal satisfaction because the inventor of the system, Gabriel de Mortillet, despised all religion, but especially Catholicism. He was the political radical and evolutionist who had convinced Cartailhac that the paintings in Altamira were a trap created by Spanish priests.

De Mortillet believed in evolution with a zeal that sometimes seemed religious itself. To him evolution meant progress. As humans had evolved they had also improved, and their culture had improved by evolution as well. In particular their tools had become more and more sophisticated across the eons. De Mortillet named each industry according to the place where it was first discovered. Thus an early industry named the Mousterian, first found at a site named Le Moustier in France, evolved into the Solutrean, first found in La Soultré, and it in turn evolved into the Magdalenian, an industry first found at a site near Les Eyzies named La Madeleine. De Mortillet believed that the progress from one industry to another was direct and was clearly marked by steady improvement. "The Solutrean period," he wrote, "would have

first perfected stone work, then the Magdalenian period substituted for that largely bone work, and invented Fine Arts." And that was that.

De Mortillet's scheme had both the great virtue and the great weakness of simplicity. His nomenclature is still used today. And his chronological order of Mousterian to Solutrean to Magdalenian is accurate—accurate, that is, except for the inconvenient presence of the Aurignacian.

Aurignacian industries contain some tools made of bone. Solutrean tools are made from stone, usually flint. Since bone tools are advanced compared to stone tools, de Mortillet had no choice but to place the Aurignacian after the Solutrean. But that dating left him caught in an impossible contradiction because the Aurignacian contains some tools made of stone in addition to the ones made of bone, and the stone tools are clumsy and crude compared to the fine flint blades in the Solutrean industry. De Mortillet's theories could not account for the Aurignacian progression in bone and its regression in stone. He resolved this dilemma the only way he could. When he published his final classification scheme in 1872, he omitted the Aurignacian entirely. He pretended it didn't exist.

But, of course, it did exist. Breuil knew that de Mortillet's system did not fit the evidence. As he addressed the audience at the conference in 1905, reading from his "Essay on the Stratigraphy of Deposits in the Age of the Reindeer," Breuil described the characteristics of Aurignacian artifacts with a sensual intensity: "Bone tips in ovoid or diamond-shaped contours, sometimes cracked at the bottom, sometimes . . . without this crack, many pointy bones, diverse smoothing instruments, sometimes awls made of reindeer cannon bone, crude pins, ivory pearls, sticks and ribs decorated in hunting motifs, or in diverse elementary traits." He could cite Aurignacian finds all across Belgium and France. And the Aurignacian industries were always located above the Mousterian and

below the Solutrean, so chronologically the Aurignacian had to be between them. In fact, Breuil insisted, the existence of the Aurignacian between the Mousterian and the Solutrean was "one of the most certain facts" known about the Stone Age.

This was a direct affront to de Mortillet, but it was only a gentle jab compared to what Breuil had in store. He intended to thrust a stake into the very heart of de Mortillet's work—his belief that evolution was identical with progress. Breuil wrote, "If the clarity of a simplistic system has didactic advantages"—he is insinuating that Mortillet's system was little more than a teaching tool—"it is incapable of distinguishing, among the diversity of facts, those which will give rise to more objective and more adequate views of what's real." In other words, the system is useless because it is too simple to get to the truth. Prehistoric people in Europe didn't evolve in a "perfectly uniform and smooth" way from one epoch to the next, according to Breuil. Nor did they live in isolation: "The evolution of Western peoples is not as simple as has been thought; outside influences must undoubtedly have modified its course many times." Breuil was suggesting a radical change in thinking about early people, one with a more complicated chronology, with influences shifting back and forth, with forces from the outside interrupting again and again. It rejected the orthodox view of continual improvement over time, but it had the advantage of fitting with the facts.

In the years following this initial massive attack, de Mortillet's system collapsed and Breuil was able to refine his thinking as he continued to study, describe, and classify prehistoric artifacts. He came to believe that Western Europe of the Stone Age saw a number of migrations from the east and south by people who brought the Aurignacian industry with them. Similarly, the Solutrean industry did not evolve independently but arrived with another migration from the east, while the Magdalenian appeared after still

other migrations from the northeast. In broad outline, this theory is the one accepted by most prehistorians today, and Breuil was the one who created it.

Breuil had loyal friends and devoted acolytes, but toward most people he was quick-tempered, impatient, and not very likable. He lived for many years in a third-floor apartment in Paris on avenue de la Motte-Picquet, right above a Metro stop. It was littered with limp, half-smoked butts of the cigarettes he chain-smoked. People in the neighborhood referred to him as *le vieux prêtre rogue,* the arrogant old priest. When a friend told him that, Breuil cackled with pleasure. He took his meals with an English expatriate who had become his best friend. He never learned to drive a car, although when he was younger he had ridden horses well. Since his work sometimes took him to dangerous places, and since he often worked in isolation, he carried a pistol and learned to be a passable shot. While in Africa, where he spent many years, he carried a long spear instead of a pistol. He claimed that with it he could keep even a lion at bay.

All his life, solitude pleased him more than company. Frail and small as a child, he was bullied in school and in fact wasn't much of a student. One of his teachers said that instead of paying attention in class, he sat musing "like a little old man." But he appears to have known instinctively what qualities he would need during his life. Quite deliberately he taught himself to endure both fear and time alone, as he describes in this account of his trips home from boarding school when he was perhaps ten or eleven: "The long Station Road running between interminable high walls and feebly lit by a few miserable street lamps echoed to my footsteps in a most alarming way. I was afraid; and I was ashamed of being afraid. So, to overcome my fears, I made it a habit to take a quite dark and

very lonely shortcut that led up the Chatelier, a wooded walk, planted with great elms whose tall branches stood out against the sparkling night sky. In this way I taught myself to master my terrors and prepared myself for other and much greater solitudes which I was, later on, to endure for long periods at a time."

Breuil's father was the French equivalent of a district attorney in Clermont-de-l'Oise, a town forty miles north of Paris. When Henri declared his intention to enter the seminary, his family may have been disappointed, but they considered it as good a choice as any for this strange, solitary little son. All his life Breuil was as secular as one can be while still remaining a priest. He never had a parish, never presided at a wedding or a funeral, never tried to convert anyone, and never had any position with the church or received any money from it. If asked about the relation between science and religion, he replied disingenuously: "The two things are separate and distinct. They run parallel. They do not touch." For many years he was a close friend of Pierre Teilhard de Chardin. They worked together in China studying early hominids and human evolution and were part of a surprisingly large group of Catholic clerics who were known as "priestly evolutionists." Still, Breuil was always careful not to use his scientific studies to confront the church. He preferred not to attract the church's attention at all. That way he avoided the difficulties and the painful entanglements that came to plague Teilhard.

Breuil was a peculiar-looking man with a huge, long head and a prominent nose. He could be genial, approachable, and sometimes earthy. But he was also vindictive and he had the air of being certain of his own preeminence.

As Breuil traveled to remote places around the world, his frequent companion was a woman always referred to as Miss Mary E. Boyle. She was a plain, sturdy woman who wore plain, sturdy clothes often set off by a Chinese coolie hat. From middle age she

used a cane, just as Breuil did, and her broad, square face, straight mouth, and thick eyebrows gave her a subtle resemblance to the priest. In all she devoted thirty-seven years of her life to his service. She translated many of his books and papers into English. She camped with him in the remote African wilds. And she sat in the caves holding lights. Breuil called her his "human candelabra." It's unlikely there was anything physical about their relationship because, despite spending almost four decades together, there was apparently very little even personal between them. In an interview after Breuil's death, Miss Boyle said, "In the dark caves, in the camp, where we spent hours and hours, we hardly spoke. He moved my arm without a word, to light him . . . and he said that others yawned, sneezed, shuffled their feet, or talked, and that I was the only lighter he could really work with." Breuil worked in complete absorption and Miss Boyle learned to become absorbed herself. "For one thing," she said, "I liked the stillness, I liked the dark and I listened to drops of water falling from different heights and striking different notes and I wondered how much of the artist's pride, how much of his memories were still hidden in the unexplored galleries beneath our feet." She seems to have been the last Victorian virgin, sitting absolutely still and listening to the sound of dripping water while the man she loved, perhaps without even knowing she loved him, ignored her completely except for moving her arm now and again without uttering a word. For her sake I hope—in fact, I believe—that her presence was a comfort to Breuil, as cold and cranky as he was. And I suppose I believe that for his sake as well.

With male associates he was just as demanding but more flamboyant. Entering a cave in France with an archaeologist from England, Breuil insisted that they undress and stripped quickly to his beret and boots. When his companion had done the same, Breuil plunged ahead, lighting the way with an acetylene torch. Soon

they encountered an underground stream and were in icy water up to their waists. They had to struggle to stay upright as their feet slid on rocks. Suddenly Breuil announced, "We have to dive. This is the siphon."

He dived headfirst and his light went out with a hiss. Eventually he resurfaced, snorting loudly, and shouted back for his friend to follow. The Englishman dived and discovered he had to go under a stalactite curtain below the surface of the water. He made it, but barely, and surfaced next to Breuil, who relit the lamp. Beaming, Breuil said, "The siphon. Something, isn't it?" But a short way beyond, they reached the reward for risking their lives by diving past the siphon. There was a small cave bear that a Stone Age artist had modeled from clay.

Articles and books came cascading out of Breuil practically all his life. They are usually heavy treading, since his tendency is always to revert to description, as if he were trying to re-create in words the kind of copies he made with his paints and pastels. Unfortunately, he was brilliant while making copies with a brush but an ordinary plodder with a pen. The culmination of his life's work was *Four Hundred Centuries of Cave Art*, which was published in 1952 and dutifully translated into English by Miss Mary E. Boyle. It contains Breuil's detailed descriptions of the major caves and rock shelters where he worked, including Altamira and Font-de-Gaume. These precise, unemotional descriptions purposely refrain from any speculation about meaning. Their intent and value is to be a scientific inventory of the important caves Breuil had studied. There are also numerous photographs and reproductions of Breuil's copies, although all in black and white. This is Breuil's distillation of his life's work, and it seems, with one exception, peculiarly sterile when compared with the radiant beauty of

the copies he made at Altamira at the beginning of his career. The one exception, however, is glorious. It is a short chapter near the beginning of the book called simply "Origin of Art."

Breuil believed that art began with a desire for disguise, in particular disguise with masks. Cartailhac had expressed the same idea in their book on Altamira. These disguises weren't frivolous but grew from necessity. They helped with the hunt, since a man disguised as an animal could approach his prey more easily. That, according to Breuil, "convinced man that the mask or disguise itself possessed a ghostly magical power; its ceremonial use was also employed, not only in hunting, but in preparations or ceremonies supposed to exert a magical power over game." Although Breuil doesn't say so explicitly, it's clear from this passage that for him religion in the form of ceremonies to exert power over game appeared only after art was established in the form of masks and disguises. Perhaps he did not say this explicitly because he did not want to offend his superiors in the church by emphasizing that he believed religion owes its existence to art.

Although masks came first, a mask is not a painting, and masks didn't lead directly to painting. Masks, Breuil thought, "must have very soon led to the making of dolls." Instead painting came from noticing the resemblance between animals or humans and the lines made by fingers when they were scraped through clay or down the wet sides of cave walls. Such resemblances were at first accidental, but then were made on purpose. That, he contends, is the origin of art on the walls of caves. But why, Breuil wonders, "did wall Art, during this epoch, so rapidly take such an important place in human activity in Western Europe and perhaps Africa; and not everywhere, even in these regions?" The answer is hunting. It was hunters and only hunters who invented and refined painting in caves: "At the base of such artistic creation there must be a profound knowledge of the appearance of animals, which only daily

experience in the life of a big game hunter can give; if there is no big game hunting, there is no naturalistic wall art."

In fact, Breuil has little but contempt for nonhunting peoples, even in the Stone Age: "The Cro-Magnon shell-fish eaters of the sea coasts usually lacked that basic psychology and experience: hunting periwinkles and snails did not create nor feed their artistic imagination, nor were they even clever workers." Having put these poor souls in their place, he hurries to embrace his real heroes: "On the other hand, hunters of Rhinoceros, Mammoth, great Stags, Bulls, wild Horses, not to mention Bears and Lions, accumulated, during their dangerous lives, powerful and dynamic visual impressions, and it is they who created and developed the wall Art of our caverns . . . Everywhere it was big game hunters who produced beautiful naturalistic Art."

It's possible to see in these lines the passion for the paintings that a lifetime of study had not begun to satisfy. Even a casual observer of the art in the caves notices that there is a uniformity to the paintings that is as striking as their power. This enthralls Breuil. "This is no longer the work of an individual," he says, "but a collective, social affair, showing a true spiritual unity, I am inclined to say, an orthodoxy, suggesting some sort of institution registering the development of this Art by the selection and instruction of those mostly highly gifted." Schools of art in the Stone Age! Breuil comes to this conclusion inevitably from his theories, but as I mentioned earlier, there is evidence that such schools did exist.

As Breuil continues, we can see the yearning for an ordered society of the man who, though he may not have had a parish, lived his whole life as a priest: "It was not individual fancy which produced the painted caves, but some such institution which directed, and, in each period, created uniformity of expression. If at the start, some gifted individuals were needed to lay the foundations

of artistic expression, its development shows a control and exceptional common interest."

But what was the purpose of the art? Was it simply for beauty's sake or was it not really aesthetic at all, nothing more than part of a ritual of hunting magic? Breuil thinks it was probably both: "Without the artistic temperament with its adoration of Beauty, no great Art could exist nor develop. But without a society considering the artist's work as of capital interest, the artist could not live nor found a school where his technical discoveries and his passion for Beauty could continue and be transmitted through Space and Time." In this way, with the combination of artists of genius and a society that valued their creations, "all the west of Europe was conquered by this first illumination of Beauty."

In this burst of vision, Breuil at last allowed himself to reveal the world he imagined as he lay on sharp rocks for hours patiently making careful copies of paintings in the caves. It was a world of a few people with real genius who were supported, even revered, by a society whose members came reverently into the caves to perform rituals for the hunt.

Breuil never earned an advanced degree, but he received many honors. Although his publications identified him only as "Member of the Institute, Honorary Professor College of France," being a Member of the Institute is the highest honor for an academic in France. For the first half of the twentieth century he reigned as the Pope of Prehistory. He pronounced upon the authenticity of each new discovery and dictated how it was to be explored and studied. He published well over a thousand scholarly papers and many books and pamphlets.

Breuil's work had weaknesses and he made mistakes, which he would probably be reluctant to admit even if he were still alive. But

he was involved very early in a handful of great discoveries, Les Combarelles and Font-de-Gaume being only two. More important, after absorbing every detail of contemporary knowledge about prehistory, and after poring over each new discovery as it was made, he was able to make order out of the chaos of facts. He constructed a chronology for the paintings in the caves and for the surrounding events in prehistory, and he created a logical and inclusive interpretation of prehistoric art that, if it has lost favor among scholars today, still cannot be absolutely disproved. Breuil began when the study of prehistory was in its infancy. He shaped it into something mature, something with form and substance that could become clearer with new discoveries rather than more clouded. He was the beginning, and without him we might still be looking for the place to start.

That is why it seemed to be the natural order of things, and not mere chance, that Breuil was living close by when a boy and a dog happened upon the most spectacular painted cave ever found.

Noble Robot, an Inquiring Dog; The Abbé's Sermons on the Mount

On a Sunday afternoon in early September four teenage boys went into the woods on the side of a hill. They were going to search for treasure.

It was 1940. The hill the four boys climbed was just outside Montignac, a town in the Périgord region of central France, where the boys all lived. Although the Nazis had occupied Paris, the war had not reached the Périgord, but Montignac and the towns nearby were affected just the same. People went through the motions of life without really living. Time seemed suspended while they waited, powerless, to see what would happen next. For teenagers that meant there was nothing but long days of boredom and idleness. The four boys had decided to climb into the woods on the hill because they were desperate for something to do other than slouching back and forth along the streets of the village.

Then too, this hill had always had an air of danger, legend, and possibility. The road curved around the foot of the hill and passed by a deserted chateau on a small estate that belonged to the Comtesse de la Rochefoucauld-Montbel and her husband.

Through her mother she was a Labrousse de Lascaux, member of a family of local gentry that had acquired the property in the fifteenth century and built the château. A shout directed at the old building would produce a sound that was not really an echo but a long, eerie resonance that emanated, according to the inhabitants of Montignac, from a forgotten cavern beneath the house. The entrance to the cavern was now lost, covered over by an avalanche or a landslide, or perhaps concealed on purpose. The deserted house of an old and landed family, the mysterious cavern, and the lost entrance had given rise to the local legend that the secret cavern contained hidden treasure.

In addition to the resonating sound, there were other tantalizing reasons to believe in the existence of the cavern. As a young girl, the grandmother of M. Dezon, an elderly resident of Montignac whose family had lived in the area for generations, had known people who had lived through the Revolution and the great terror that followed after it. One of those survivors had told her that a priest named Labrousse had escaped from the terror by hiding in a cave in the hill named Lascaux. He had known about it because his family had had a château and an estate there also named Lascaux.

In the nineteenth century the hillside had been planted with grapevines, but they were killed by blight before they could produce. After that, the proprietor spread seeds for pine, juniper, oak, fir, and poplar and let the land go wild. In time the only people who went there were hikers, hunters, and the farmers who let their cattle graze among the brambles.

The hill's aura of mystery was intensified in the late 1870s. An early archaeologist named Reverdit poked around the hill and found a good number of stones with prehistoric carvings. In 1878 he even published a paper about his finds, "Stations et traces des temps préhistoriques dans le canton de Montignac-sur-Vézère."

The existence of the cavern remained nothing more than a local

legend until a powerful storm, in around 1920, blew down a fir tree. The tree's thick root system turned up the subsoil and partially exposed a deep hole. Farmers in the area, who were necessarily practical men and not so enamored of legend as teenage boys, warned one another about the cavity because it was a potential danger to their livestock. They filled it in with dirt, dumped garbage down the hole, and encouraged a thicket of brambles to grow there. Even with these precautions, a donkey fell into the hole and was never seen again.

As the boys set out on their hike, their dogs followed along. One, named Robot, was about to become famous. He belonged to Marcel Ravidat, who at seventeen was the oldest of the group by two years. Ravidat was their rakish, admired natural leader. He smoked cigarettes incessantly and no longer attended school. Instead he worked as an apprentice mechanic at the garage in Montignac. He was good at this work, clever with his hands and with machinery. All his companions called him "le Bagnard," which can be translated as "the convict" but really refers to a prisoner in a penal colony. Ravidat earned this nickname because his robust, blocky build made him resemble the French actor Harry Baur, who played Jean Valjean in a 1934 movie of *Les Misérables*. Le Bagnard was also very proud of his expertise in speaking the local patois. Even later in life, when he would occasionally be interviewed on French national television or radio, he preferred to answer questions in patois unless he was specifically requested to speak French.

The boys poked around the hillside until late in the afternoon without finding any treasure or cavern or even the slightest mystery to engage their teeming imaginations. As they at last turned toward home, Robot bounded off into a thicket and ignored Ravidat's calls to come back. What had the dog found in that thicket? It appeared to be nothing but brambles and undergrowth around some juniper trees, little pines and oaks, and a few rotting stumps.

The boys pushed their way in and found a large hole about three feet across and five feet deep. Robot was at the bottom, digging furiously. Ravidat crawled into the hole to see what Robot had discovered. It turned out to be a second hole only about six inches across. Holding Robot back, he dropped several rocks down this hole and was surprised to hear them roll on and on into the darkness. Each of the other three boys took his turn dropping rocks into the small hole and listening as they fell into the seemingly endless depths. This was suddenly no imaginary adventure. They had done it; thanks to Robot, they had found the entrance to the mysterious cavern.

But now it was late in the day, and besides, the boys didn't have the ropes, lights, and other equipment they would need to enter a cave. They descended the hill and went back home having made a solemn promise to explore this hole further as soon as they could.

That turned out to be four days later, on September 12, 1940, when there wasn't any work for Ravidat at the garage. He went to find his comrades, only to discover that two were working and the third was resting and felt too lazy that day to go. So Ravidat set out on his own, carrying a large knife that he had made himself and a crude lamp that he had rigged up by sticking a cotton wick on an oil pump from an automobile. But poor Robot! Ravidat had left him at home.

Along the way, le Bagnard encountered another group of friends, three of whom decided to tag along with him. They were Jacques Marsal, fifteen, who lived in Montignac; Georges Agnel, sixteen, a Parisian who was visiting his grandmother; and Simon Coencas, fifteen, another Parisian. Coencas was Jewish and his family had fled Paris to escape the Nazi occupation. These were the four who set off up the hill.

At the site it was obvious that they had to make the hole much wider before they could get through it. They set to work, taking

turns digging with the only tool at hand—Ravidat's homemade knife. After more than an hour's hard labor, Ravidat was able to squeeze through headfirst and slither down on his chest about twenty feet. There he lit the jury-rigged lamp to see where he was. Cautiously, he took a step, only to slip on a pile of flint. The lamp went out as he tumbled into the darkness.

The next few seconds must have been terrifying, since Ravidat didn't know how far the shaft went before it reached bottom. But fortunately he soon landed on the floor of the cave, where, bruised and aching, he pulled himself to his feet. He relit the lamp, which he had had the presence of mind to hold on to, and looked around. He was in a moderately sized room in a cave. There wasn't really any great danger. He called up to his three companions and told them to be careful where they stepped but to come ahead and join him. Each of the three made it down without incident, though on the way they noticed the skeleton of a donkey.

In the feeble light from the lamp, which barely illuminated the darkness before them, the four boys began to inch forward. They kept the lamp near their knees, since they had to straddle low formations that ran along the floor. They covered about forty yards without seeing anything but the floor of the cave and their feet.

At that point the passage shrank to a narrow corridor. They stopped for a moment and Ravidat raised the lamp. Jacques Marsal thought to look up. Startled, he let out an involuntary cry and pointed. The other three boys lifted their eyes. Paintings of horses and bulls spilled across the walls of the narrow corridor. In the vague, wavering light of the lamp they seemed almost to be moving, bursting alive right out of the rock.

Then as now children in the Périgord learned about the prehistory of their area in school, so Ravidat and Marsal knew that, although this wasn't the treasure they had expected to find, it was something far greater. Casting the light here and there, Ravidat

and the others saw painting after painting. The walls of the room they had just crossed with their eyes on their feet were covered with paintings. They became giddy, bouncing here and there in the cave and seeing paintings all around them. "A band of savages doing a war dance," Ravidat said later, "couldn't have done better." Marsal recalled simply, "We were completely crazy."

Too soon, however, the lamp began to burn low and the four boys realized they had to return to the surface. They all swore not to tell a single person about their "treasure," a code word they immediately began to use to refer to their discovery. They would return the next day and explore farther into the cave.

The next day was Friday, September 13, 1940. The boys managed to scrounge up better lights and some rope. They left Montignac individually at intervals of ten minutes or so and took different paths out of town. They thought this elaborate ruse would prevent people in the town from becoming suspicious. Simon Coencas, apparently breaking the vow of silence, brought his brother Maurice along. So there were five boys who met at the entrance.

They widened the hole a little more and then slid down into the cave. They found a second hallway that ran off at an angle to the one they had discovered the day before. It too contained paintings, but the walls were mostly covered with engravings. The giddiness from the day before returned, until they found themselves at the edge of a hole that went straight down. They couldn't see the bottom.

The younger four boys didn't want to go down the hole because they were afraid they couldn't climb back out. The only rope they had was smooth and difficult to grip. That didn't worry Ravidat, who was confident of his strength. He worried instead that the boys couldn't support his 150 pounds as he descended. There was nothing to tie the rope around, nor anything for the

boys to brace themselves against. But the lure of the unknown was too powerful. With the other boys all holding one end of the rope, Ravidat dropped over into the abyss. He had appeared calm and brave to the boys, but once over the edge he could feel his heart pounding in his chest. When he finally found the floor, he had dropped about sixteen feet.

He called up to his companions that he was all right and began to explore. The passage gave out after a few yards. Disappointed, Ravidat turned back and found himself directly in front of a painting that startled him. A human figure, the only one in the cave, seemed to be falling over backwards. It was a man with the head of a bird and hands with only four fingers. He had apparently been knocked over by a bison that was standing beside him. These two figures were spread out over six feet of the cave's wall. Ravidat had just discovered what is now known as the Shaft Scene, one of the most powerful and mysterious paintings in all of prehistoric art.

He climbed back up the rope and told the others what he had seen. He had to lower them one by one into the hole and then pull each one back out. He noticed that his friends were pale, visibly affected by this strange painting.

The next day, Saturday, they all returned to the cave, but now their treasure was too big a secret to keep. They brought along four more boys and took them into the cave. On Sunday, just one week after Robot had initiated these momentous events by bounding off into a thicket, they took twenty more boys down. By now the news had spread throughout the town and countryside.

Jacques Marsal, the boy who had first looked up and seen paintings on the ceiling of the cave, had a roguish, Huckleberry Finn charm. Ravidat had his constant cigarette, but Marsal, at fifteen, already smoked a pipe. He lived in Montignac, where his mother had a restaurant. In the midst of their rounds, the local gendarmes liked to stop in there, and the boy had gotten to know them. One of

these officers liked digging around and once had found some Roman artifacts that he had taken to Léon Laval, the local schoolmaster. When the officer heard young Marsal telling his family about the treasure he had found, he told the boy, "You shouldn't keep this to yourself. You're too young. You don't understand what's important about the cave. You should tell M. Laval."

Marsal talked this idea over with Ravidat and the Coencas boys from Paris, and they all agreed it was the right thing to do. They went to see Laval on Monday, September 16. Marsal and Ravidat had been Laval's students. By now he was well into his sixties. Although in good health, he was short, stout, and no longer agile. Besides, he was a cautious man with no taste for adventure, and he remembered these two wiseacre former students all too well. When they told him about the cave, he thought they were playing a trick on him. Perhaps they wanted to get revenge for their school days by fooling him into hiking up the hill and sliding into some hole.

Laval tried to ward the boys off by telling them that they had probably seen only natural rock formations that looked like animals. When the boys persisted, Laval asked Georges Estreguil, another former student, who was nineteen and more trustworthy, to visit the cave and bring him sketches of what he saw. The drawings overcame Laval's skepticism and caution. The next day, Wednesday, September 18, he trudged up the hill, steeling himself for the descent into the hole.

When he arrived, he didn't like what he saw. The hole was so tiny and covered with brambles besides! Even though many people had gotten into the cave and back out through that very hole, the boys set to work with shovel and axe to widen it still more and to carve out a few rude steps for their former instructor. Laval tentatively began the descent, but some brambles scratched his face. When he touched the scratches with his hand and it came away bloody, he lost his nerve and backed away.

A rustic farmwoman more than seventy years old was standing nearby. "Well," she said, "if you don't want to go down there, let me by. I'll go have a look." She disappeared into the hole. Her non-chalance fortified Laval, who later said he didn't want "to seem more cowardly than a woman." He followed her down the hole, accompanied by Ravidat, Marsal, and several other boys from the town.

Laval had to crawl among wet stalactites and, prim as always, he found their touch very disagreeable. At last he was able to stand up in the first chamber. The boys, who had come down after him, gathered around. When Laval looked up and saw the paintings, he was so overcome that just two words escaped from his lips: "Oh, shit!"

He was astonished that the paintings appeared so fresh and that in the flickering light from their lanterns the animals seemed to dance in a wild circle all around them. He went from gallery to gallery, and everywhere the unexpected brilliance of what he saw intensified his enthusiasm. Later he said the experience made him "literally mad."

Once out of the cave, Laval insisted that the boys tell him how they had found such a glorious marvel. Ravidat compressed the two first visits into one and embellished the story a little. He said he had simply followed after Robot, who had fallen down into the cave. These minor alterations made a better story, so much so that over time Robot's fall became accepted as the truth behind the discovery.

By now Ravidat and Marsal had pitched tents near the entrance, where they lived round the clock. They acted as self-appointed gatekeepers and guides to the cave. And to all these early visitors the two boys repeated the same story about the dog. Since Robot was living in the tent with Ravidat, the boys could introduce the now famous dog to the admiring crowds. In fact,

Ravidat remained a guide until the cave was closed to the public in April 1963, and he repeated the story year after year.

By living in their tents and protecting the entrance, the two boys were actually performing a needed service. Within a week of the discovery as many as two hundred people a day were climbing the hill to see the cave. The city fathers of Montignac had erected a sign pointing toward the way out of town that read: "Lascaux Cave Two Kilometers." Another sign was tacked to a skinny tree by the side of the road. The crowds did damage enough merely by trampling over the floor of the cave and destroying any footprints or other traces left by the artists who had painted the cave so long ago. But the presence and watchful eyes of Ravidat and Marsal prevented any outright pillaging or vandalism.

Meanwhile, the schoolmaster Laval made a few ineffective attempts at an archaeological dig at the site. He did find three stones that had been hollowed out to make lamps. The boys also had picked up some worked flint and wood charcoal from the cave floor as souvenirs during their first visits. This leaching away of what might have been valuable evidence, as well as the continuing press of the crowds, made it clear that someone needed to take charge, someone who knew both how to protect the cave and how to begin a scientific study. Fortunately, the perfect person, the abbé Breuil, had recently taken refuge in Brive, only fifteen miles from Montignac.

Breuil had fled the Nazi occupation of Paris and come to Brive to live in the home of his old friend from seminary, Jean Bouyssonie, who was by now a respected prehistorian himself. Breuil learned about the discovery at Lascaux when his young cousin arrived in Brive with sketches he had made at the new cave. Breuil left for Montignac almost immediately, arriving on September 21,

just nine days after Ravidat and his friends had first wriggled through the narrow opening and dropped down into the cave.

The schoolmaster Laval met the great celebrity and, together with Ravidat and Marsal, led him down the passage to the cave. Breuil was now sixty-three. He was short and bald and had an immense round chest on top of spindly legs. He could not stand erect—the result, he said, of falling down a staircase as a child—and he walked with a decided forward bend and needed a cane. Nevertheless, he was still active and surprisingly agile, although at this moment his vision was obscured. A few weeks earlier a thorn had scratched his eye and the wound still had not healed completely. Nevertheless he was determined to see the cave. The photograph on the facing page shows him at the entrance, leaning on his cane. As was his custom while working underground, he is wearing a beret stuffed with newspapers to protect his head.

Fortunately, the boys had widened the entrance yet again for him, though it was still not much bigger than a soldier's foxhole. Breuil found the steep slope "slippery and slimy," but on the floor of the cave he immediately perceived artifacts from prehistoric times that the schoolmaster Laval, the boys, and all the townspeople had missed. Breuil saw "flakes of worked flint of poor quality, but Palaeolithic, some fragments of reindeer horns and many pieces of conifer charcoal [that were] the remains of the grotto's lighting system."

During the next three months, Breuil spent hours of intense study in the cave. He had dominated French prehistory for so long that news of his presence at Lascaux spread throughout the region around Montignac. People gathered on the hillside below the entrance and waited for him to emerge from the cave. With the help of brave Robot, the two boys Ravidat and Marsal kept them in order. Journalists from newspapers and from the national radio came as well and interviewed Breuil, the boys, and people from the

This is the entrance of Lascaux, nine days after the discovery. The schoolmaster Léon Laval (far left) is about to take Henri Breuil (far right) into the cave for the first time. The two older men flank two of the four boys who discovered the cave. Marcel Ravidat is second from left and Jacques Marsal third from left.

village who were eager to talk. This discovery was a piece of good news for the French in the midst of the German occupation. "That was a charming and picturesque period," Laval recalled. "L'abbé Breuil gave real lectures in the open air to the pilgrims, who listened to him attentively and understood the importance of his work." Laval called Breuil's impromptu lectures his "Sermons on the Mount." The people climbed the hill to the cave and stood listening to Breuil despite the chill of darkening autumn afternoons.

CHAPTER 4

The Great Black Cow;
How to Paint a Horse

M arcel Ravidat assisted Breuil as he worked in the cave. "What little I've learned," Ravidat said later, "he taught me. He was inexhaustible. It's hard to describe because he was a simple man but so learned. And he put you in your place. I remember holding a tracing for him for an hour. Not a word. Then, suddenly, 'Hey, Ravidat, have a cigarette.' He was a smoker. He was a marvelous man. At any rate, in these paintings and engravings he saw a cult."

And that is what everyone who enters the cave sees as well. Lascaux was carefully chosen as the proper place for these elaborate paintings. Some pieces of charcoal left behind from burnt torches suggest that ancient people must have entered the cave and explored it sometime before the paintings were made. Those early explorers would have had to climb over mounds of rubble and push through whatever bushes and brambles grew there. Inside the cave, they had to keep their footing as best they could on the soft, slippery muck of clay and sand. Their visits were short enough that they didn't bring along any food. The traces of charcoal were all they left behind. But they explored the cave all the way to the

distant point where the passages suddenly narrow and become impassable.

At the very least, those charcoal remains from the first visit scattered through Lascaux prove that the people of the region knew of the cave and understood its layout and then, with that knowledge, chose to paint there. The cave was perfectly suited to their needs and intentions. The hill is the highest point in the area, and the cave is close to the summit. From there, like a cathedral built on a cliff above a village, the cave looks out over all the surrounding countryside. Below the hill a long plain extends into the distance and is neatly intersected by a slow bend in the Vézère River. Here, in prehistoric times, herds of horses, bison, reindeer, cattle, and all the rest of that era's teeming wildlife crossed back and forth during their seasonal migrations, pursued not only by humans but by wolves, leopards, lions, wolverines, and the rest of the vast menagerie of predators. The cave stood above all this great animal drama. As the humans crossed the plains or camped near the riverbank or stalked a young reindeer that had ventured rather too far from the herd, the hilltop with its cave was always in sight, a reminder of whatever power or protection derived from its paintings and rituals. It was a force, a constant presence in the life of the people who lived in the hills and across the valleys.

The entrance to Lascaux has special qualities as well. The hole that Robot sniffed out was not the original entrance but the result of the collapse of a portion of the ceiling centuries after the cave and its paintings had been forgotten. The original entrance was nearby, only a short way below Robot's hole, and a rockslide or similar event had covered it as well. It faced to the northwest. That meant that both the setting sun and the sun during the summer solstice shone directly in. The entrance passage ran straight for about fifteen feet with only a gentle incline downward before it began a steep descent of about sixty-five feet to the bottom level. But the

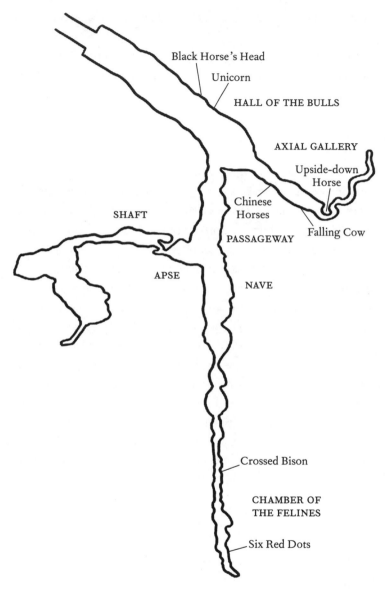

Black Horse's Head

Unicorn

HALL OF THE BULLS

AXIAL GALLERY

Upside-down
Horse

Chinese
Horses

Falling Cow

SHAFT

PASSAGEWAY

APSE

NAVE

Crossed Bison

**CHAMBER OF
THE FELINES**

Six Red Dots

*A map of Lascaux, showing both the different sections of the cave and
the location of some important figures.*

passage was so straight that a small patch of sky would still have been visible even there, far inside the cave. That, together with the orientation of the opening, meant that both in the evening and during the summer solstice sunlight penetrated surprisingly far into the interior, perhaps almost to the beginning of the first grand chamber. It would have faintly illuminated the center of the passage while casting mysterious and provocative shadows along the walls, until finally the overhanging rock blocked the sun and darkness began.

The first room past the entrance is what we now call the Hall of Bulls. It is sixty-two feet long and twenty-two feet wide. The walls curve gently inward and meet in a naturally domed ceiling almost twenty feet high. The walls are remarkably smooth and consistent. They are colored an earthy brown from the ground level to a height of about five feet. From there on they are covered by grainy calcite that is so vividly white it is almost translucent.

The walls and ceiling are generally dry and there are no stalactites hanging anywhere to interrupt the view. That's because there is a layer of nonporous rock above the cave. Water could enter through a crevice near the entrance and trickle down into the Hall of Bulls, where it collected in large basins across the floor. A hole shaped like a funnel in the floor at the end of the chamber allowed the overflow from the basins to drain into the lower, inaccessible levels of the cave. Shortly after the discovery, Breuil had the basins in the Hall of Bulls pierced and many thousand gallons of water rushed through the room and down the funnel. Still, as caves go, Lascaux was rather dry.

So here was a cave on a hill that commanded the surrounding countryside. It opened in a direction that received the evening sun, and the first room just beyond the sunlight's reach was long and spacious. The white calcite covering the smooth, dry walls gleamed as brightly as any bare canvas stretched across an artist's frame.

Lascaux is not only the most famous painted cave but also the most important to archaeology and to art. Many caves have certain beautiful paintings, and others, like Font-de-Gaume, Altamira, Niaux, and Chauvet, have a wealth of exquisite masterpieces. But none has the huge bold figures thundering across the ceiling like Lascaux does or the great variety or the great numbers or the immense, encompassing artistic vision that makes these paintings unsurpassed by any other art. It's often repeated that Picasso, following a private tour of the cave after World War II, emerged to say, "We have learned nothing in twelve thousand years." Apparently, this visit never occurred, but the quote, whoever said it, retains its force, especially since modern dating techniques have shown that Lascaux is much older than was originally thought. It turns out we have learned nothing in 18,600 years.

But in addition to the grand paintings there are hundreds of engravings at Lascaux, generally deeper in the cave, where walls are narrower and the space is cramped. There is also the enigmatic scene hidden in the deep shaft that Ravidat and his friends lowered themselves into by a rope. Other caves have either grand paintings or a profusion of engravings in difficult passageways, but Lascaux is one of the rare caves with both.

Lascaux is not large, at least not the part of the cave where a human can penetrate. From the entrance to the most distant paintings is less than 90 yards, and the area available for painting or engraving is not quite 2,700 square feet. Within that space the ancient artists crammed 1,963 figures. Of these, 613 are so faint, deteriorated, or strange that it's impossible to tell what they are. Of the remainder that can be identified, only a single one depicts a human being, and it is located at the bottom of the shaft. Slightly fewer than half of the figures—915—are animals of some kind, but only 605 have been precisely identified. The rest are either effaced by time or only vaguely drawn or hidden within or behind other figures in a confusing mélange.

It's common for the walls of a cave to show one animal considerably more than others, and in Lascaux that animal is the horse. There are 364 images of horses, just over 60 percent of all positively identified animals in the cave. The next most common is the stag, with 90 renderings.

The four huge, black bulls in the Hall of Bulls are among the most famous images from Lascaux. But cattle are only 4.6 percent of the animals, and bison are just 4.3 percent. There are also seven felines, one bird, one bear, and one rhinoceros, but no mammoths. Nor is there even a single reindeer. That omission is extremely curious and puzzling, since reindeer were by far the principal source of meat for the people who lived in the vicinity of the cave. In fact, we know from discarded bones discovered in the cave that the artists ate reindeer as they worked.

One-fifth of the individual figures are neither animal nor human but are geometric signs. They appear everywhere in the cave. They are next to animals, they are inside animals, and they are on apparently random places on the wall. The signs have a variety of forms. There can be red and black dots two to three inches in diameter. Sometimes the dots are isolated, but more often they are arranged in a line. Other signs consist of straight lines arranged in a variety of related patterns. Often there are one or two or more short lines at oblique angles to a longer one without any of the lines actually touching. These and similar signs are repeated throughout the cave. Certain rooms contain rectangular grids. Sometimes these are blank but other times they are colored in and look like a section of a checkerboard or a color chart. There are rows of straight lines with barbs at the end like arrows, and, especially near paintings of cows, there are rectangular grids with only three sides. They look like the business end of a pitchfork. In various other caves the most common sign is the positive or negative imprint of human hands, but there are no hands at all in Lascaux.

It is impossible to determine how many different artists worked at Lascaux. Certain paintings of animals appear to be by the same hand, but it's best to be careful about drawing conclusions from these similarities. Throughout the cave the paintings obey stylistic conventions in the way hooves, horns, and bodies were drawn. Paintings that look similar might be the work of different artists who were carefully following the conventions. Perhaps, contrary to our aesthetics, these artists did not want their work to appear individualistic or unique.

Often the accepted forms require a technique the abbé Breuil was the first to describe. He called it "twisted perspective," and it appears in practically every painting of cattle or deer. The legs are in profile but the hooves are shown full face from the bottom. It looks as if the animal had left tracks on the cave wall. Horns and antlers are also often in twisted perspective. In true perspective one horn would partially conceal the horn behind it. That is never the case at Lascaux, where the two horns appear parallel and complete. Generally they have a sensuous twist that makes them look like a lyre. We know twisted perspective is a convention because the painters used true perspective to great effect when they chose to.

The ears of the cattle and deer also follow a convention. They are not treated in any perspective, true or twisted. Instead they are a single black slash like a knife blade sticking out behind the horns or antlers. This convention is so maladroit that at first the slashes are hardly recognizable as ears. The artists who painted Lascaux were certainly skilled enough to have found a better way to show ears had they cared to, which obviously they did not. Instead they followed tradition.

Horses, too, all tend to have the same appearance—small head, thick neck, round body, and short, spindly legs. Norbert Aujoulat, a French archaeologist who has spent twenty years patiently

studying Lascaux, has discovered that the artists followed the same sequence each time they painted a horse. They began with a thick black line that became the mane and face. Then they sketched a light outline of the back and belly either in red ochre or by engraving. Next they colored in the body, neck, and tail, using black, yellow, browns, or shades of red. Last, they sketched the hooves, legs, belly, and rump, as well as the back and tail, in black and shaded them in. The horses all look so much alike, regardless of their size, because the artists drew by faithfully following this sequence.

Modern researchers think that the span of activity in Lascaux was less than a thousand years, perhaps much less. Certainly the coherence in the style of the paintings means that all the art was created at roughly the same time. But events from that long ago appear roughly simultaneous to us even if they happened five hundred years apart. We can't tell whether the paintings were all done in a matter of months, which is quite possible, or over several years or several centuries. The paintings and the archaeological evidence give the strong impression that the time was short—weeks, months, or just a few years. But a strong impression is not a fact. When paintings overlap, as they often do, it's clear that the one beneath is older than the one on top. But whether it's older by a minute or by a century is impossible to know.

It is clear that these paintings were not the work of some solitary genius. They required the organized effort of a team that was charged with the job and was supported by the rest of the community as the work progressed. It's probable that one person would have directed or executed a group of paintings in one room of the cave and other people would have worked on different groups in other rooms. And while it's likely that a single master was the sole creator of certain figures, that grand master would have needed assistants working at the same time. Someone had to maintain and

adjust the small lamps as they burned so that sufficient light fell on the portion of the wall being painted. The artists balanced themselves precariously on ledges or perhaps on short ladders or even scaffolding. The tree limbs for the ladders or scaffolding had to be dragged into the cave and then constructed. And while balancing on a ledge or even leaning out from a ladder, the artists would have needed someone to steady them to prevent a fall. Someone needed to mix the paints and someone needed to pass food around and someone had to go fetch whatever they forgot to bring in the first place or replenish whatever supplies ran low—extra red ochre for pigment, for example. It's irresistible to think of a master working with one or two young apprentices, much as artists with commissions for monumental paintings have always worked. And, in addition to the assistant painters, the master would have needed several other helpers who had the patience and strong backs to haul in the tree limbs, the lamps, and the food.

The entrance of the cave leads into the Hall of Bulls, the first and, at twenty yards long and seven yards wide, the largest room in the cave. The first painting in the cave is a vague and shadowy grace note before the great symphony of the Hall of Bulls begins. It is the head of a horse. The artist has completed only the first two steps in the process of painting the animal. Two curving rows of black splotches form the thick neck and tiny muzzle. A thin, faint red line makes just a hint of a backbone and the shape of the rock suggests the rest of the animal's body. The horse is facing the entrance and stands apart, separated from the next painting by several feet of white calcite. All the other horses in the room are in groups and face the interior of the cave.

This figure, to me at least, suggests a stallion standing at a distance from the herd watching for danger in the only direction from

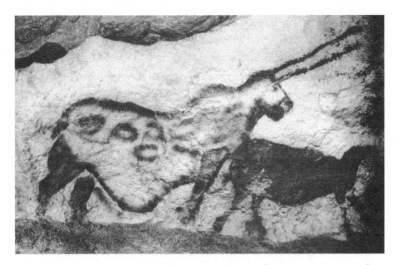

The Unicorn: This is the second painting from the entrance of Lascaux, but what is it? It looks oddly like a circus costume where two men pretend to be a horse or a bull. Also, with the top of the muzzle covered, the head appears to be a bearded man.

which it might appear. But its privileged position in the cave implies something more, particularly since there are far more horses painted in Lascaux than any other animal. Was it an insignia to show who claimed possession of the cave? Was it a sanctifying sign like a cross above the door of a cathedral? Or was it a warning to keep profane intruders at bay? And another question is just as perplexing and intriguing. What is the relation between this horse and a similar shadowy and incomplete horse, just a neck and small muzzle painted in black with a line to suggest the back, on the wall in the depths of the shaft?

The next figure, to the right of the horse, is significantly larger and more puzzling because it's a fantasy. Breuil inappropriately named it the Unicorn, even though it has two—not one—long, straight black rods sticking out of its skull like horns. The Unicorn

tilts way forward, its belly sags, and it is spotted haphazardly with black dots, black circles, and a reddish stain. It makes no apparent sense and there is nothing exactly like it in any other cave. Maybe it was a creature in a local legend. Another theory contends that it was meant to be an extinct species of leopard whose features, known only by oral tradition, had been distorted by time. It is, however, possible to see the profile of a bearded man in the head of the Unicorn, and the rest of the figure resembles one of those comic costumes in a circus that conceal two men pretending to be a horse or a bull.

The remaining figures in the Hall of Bulls are painted with such realism that they are immediately recognizable. In addition to the horse at the entry and the Unicorn, there are thirty-four animals, including seventeen horses, eleven bulls, six stags, and one lonely bear painted inside the body of a bull. Despite this menagerie, four black bulls dominate everything. They are huge. One on the right wall is seventeen feet long—larger than life and by far the largest animal in all known cave art. The bulls have beautiful horns drawn in twisted perspective. One horn bends in a delicate bow while the other twists like a sensuous, elongated S. The bulls have soft, expressive muzzles. Their deep but placid eyes are mere black dots beneath a black arc. The lines of their backs and bellies curve seductively across the rock, giving a powerful feeling of volume and weight that is nevertheless delicately balanced on their thin, almost matchstick legs.

The bulls are in motion. Three of the four face the interior of the cave and they and the herd of horses all seem to be caught in a maelstrom that is sweeping them into the narrow cleft at the end of the room where the two walls appear to meet. One of the bulls on the left wall is facing in the opposite direction, as if he wanted to slow the frantic rush of the others. But his somber presence only intensifies the intoxicating flurry. The stags, which are the smallest

of all the animals in the room, are turned this way and that in confusion, as animals swept along in a stampede would be.

There are ninety-four signs in addition to the animals. While less overtly dramatic, they augment the sense of swirling confusion. Some are simply single red or black dots or rows of dots. And there are lines—curved lines over dots, straight lines, broken lines. Some are thin, while others are bold and thick. They appear to have been placed at random. There is a long broken line inside one bull and there are several faint red lines inside another. Breuil, for one, thought these indicated spears or wounds, in keeping with his theory of hunting magic. But similar signs also appear isolated in a blank area of the wall, independent of any animal. Conceivably they could be spears that missed their mark, but the animals, especially the immense and powerful bulls, seem completely unfazed and unharmed.

The artist or artists who created these timeless paintings meant for their work to be seen from the center of the Hall of Bulls. Several of the figures are oddly elongated when seen directly from the front, but the proportions appear correct when the paintings are viewed from the center. And the sheer size of the bulls means that the artists must have mapped the locations on the wall and marked the dimensions of each animal at least in rough outline. These paintings were not some spontaneous outpouring but a deliberate composition that followed a detailed plan.

Just as rooms in a church are dedicated to different purposes—some for large meetings, some for intimate rituals, and still others for private worship and meditation—it appears that each room in Lascaux had a special purpose of its own. The Hall of Bulls was certainly the most public space in the cave. Situated just inside the entrance, accessible even to the old and infirm, it was also large enough to accommodate fifty or more people. In those days, when people were few, that could be an entire community. The people

stood in the middle of the chamber, perhaps hearing chants or songs or drums, watching as the wavering light of lamps and torches made the paintings appear to move. Scenes of some great national epic involving bulls, horses, stags, and a single, lonely bear would have surrounded them. The animals were the characters in that epic, and the signs somehow marked the events and made them fall into place.

The left and right walls of the Hall of Bulls meet above a passageway that is hardly more than a slit. At ground level it is barely a yard wide, but it expands into a semicircle near the top, so that it looks like a keyhole. The second bull on the left wall and the second bull on the right wall meet exactly above this passageway, another proof that the paintings in the Hall of Bulls were carefully planned. The passageway leads to a second room, called the Axial Gallery. It's slightly longer than the Hall of Bulls but only four to six feet wide and with a slightly lower ceiling. It proceeds for twenty-four yards before narrowing into a tiny, impassable hole. The cave painters marked this dead end with two signs. One is simply a large red dot; the other looks like a fishhook made of four unequal red lines.

If the Hall of Bulls, with its animals spilling across the sky, seems like a grand symphony performed under the direction of a fiery conductor, the Axial Gallery is more like a tiny basement jazz club with four or five hot quartets blazing away all at the same time. This narrow, inconvenient, uncomfortable space contains works at the pinnacle of Paleolithic art. Even their names are evocative—the Four Red Cows, the Cow with the Collar, and, of course, the Falling Cow. She was known as the Jumping Cow until a close study of the torsion in her hindquarters revealed that she couldn't be jumping at all. She is instead twisting as she falls. She is in the air over three black horses. Her long front legs are splayed apart while her back legs curl up under her belly and her body con-

torts in panic as she tries to find her balance in midair. It's a great painting—dramatic, dynamic, the splayed legs in perfect perspective, and the great, heavy beast convincingly portrayed as aloft in midair.

Of course there is more—the Great Black Bull, the Mountain Goats Face to Face, the Chinese Horses, the Frieze of Tiny Horses, and the magnificent Upside-Down Horse. This last is painted curving around a conical projection so that his hind legs are exactly opposite his front legs. He has pulled back his ears in terror and his nostrils are dilated as he appears to be either sucked down off the cone into some abyss or spewed up out of it. This horse painting has exactly the same dimensions as those of other horses near it, but because it is wrapped around the conical projection, there is no point where it's possible to see the whole figure at once, yet there is not a single mistake in the rendering of the horse's anatomy.

In this room a brown ledge runs from the floor to five or six feet up the wall. The white calcite begins only after that, although it then covers the remainder of the wall and the ceiling, which is twelve to thirteen feet above the ground. How did the artists get close enough to the walls to paint them? Jacques Marsal, Ravidat's friend who entered the cave with him, claimed to have been the first to notice holes in the walls that were filled with compressed clay. These presumably once held tree limbs that were the base of what must have been elaborate scaffolding. The reindeer bones were found on the floor nearby. Presumably they were tossed aside by the artists sitting on the scaffolding. The floor was also covered with fossil pollen from grasses, which indicates that the painters must have made cushions of grass to sit on. That further implies that the scaffolding was indeed intricate, since the top layer had enough branches placed closely enough together to support what were probably sacks of hides filled with grass. Traces of carbon

reveal that wood from juniper trees, probably shaved and twisted, served as the wicks in the prehistoric lamps.

The paintings in the Axial Gallery are the most intricate and delicate in the cave. The whiteness of the calcite here, particularly on the roof, allowed a much wider palette than usual, including reds, shades of brown, and highlights of yellow. There are 190 paintings in all, counting both animals and signs, and each of them, whether it's the Chinese Horses or the Falling Cow, appears as part of a larger composition that dominates its section of wall. All this seems to be the work of several artists who, as they were sitting on the scaffolding, would have needed assistants to pass them paints, or anything else they needed. The gallery is so narrow, particularly at ground level, that it would have been impossible for more than two or three people to work at a time. Later, when the paintings were completed, any group larger than two or three would have had to come in and go out walking in single file. Perhaps entry to the Axial Gallery was reserved for certain people on certain occasions. Or perhaps everyone entered and exited in order, as dictated by some elaborate choreography. In one painting there is even a small clue that such a procession might have taken place. The Upside-Down Horse is near the end of the chamber. If you walk past it toward the final few feet of the passage, the horse becomes animated and seems to revolve around the partial pillar as the different parts of its body come into view and then disappear. Why go through the difficulty of making a painting like that unless participants would see the horse's movement as they filed by?

Lascaux was closed to the public in 1963 because contamination brought in on visitors' shoes had given rise to algae that threatened the paintings. In 1984 a replica of the Hall of Bulls and Axial Gallery opened. It's situated about two hundred yards down the hill from the entrance to the real cave, which is now surrounded by

a heavy chain-link fence topped with barbed wire. The reproduction of the paintings and of the cave walls in Lascaux II is precise, and each day well-schooled guides who speak a variety of languages conduct groups of tourists through the replica. The tours attract about a half-million people a year and often sell out, especially at the height of the summer season. Both an artistic and a popular success, Lascaux II is a perfect compromise between public demand to see the paintings and the absolute necessity of preserving them.

But there are two great flaws, neither of which can be corrected. One is that Lascaux II is not a cave. It's not apparent how important this distinction is until you have visited a real cave with real paintings. Caves are usually vibrant systems busy forming themselves. Water seeps through walls or drips from the ceiling, very slowly creating new formations. The atmosphere is damp and chilly and the floor is slick when the base is rock, or muddy when the base is clay. Either way, the footing can be treacherous, especially when the floor sinks at a dramatic angle or twists suddenly as a passage narrows. And it's easy to trip over nubs in the floor that are stalagmites in the making. Caves contain nooks, crevices, and passageways that lead . . . where? There is a sense of danger and of adventure. Absolute darkness surrounds the light you carry, and in a cave of any size getting lost would be inevitable without a guide. And caves are not mute. You hear sounds echoing up from the far depths. It's probably just drops of water amplified by the echoes, but how can you be sure? Here and there a solitary bat hangs in a cranny. Seeing the paintings in a real cave, even in one with regular tours for tourists, is more vivid and emotional—more daring, really, and certainly closer to the experience of the cave painters themselves—than seeing them in the unavoidably sterile atmosphere of a replica.

The second problem with Lascaux II is that it represents only a

third of the real cave. It's the correct third; that is, if one were going to duplicate just part of the cave, then the Hall of Bulls and the Axial Gallery would be the choice both of scholars and of the public. Still, because it's only part of the whole, Lascaux II gives a skewed impression of the real cave.

In the replica it appears that the Hall of Bulls leads only to the Axial Gallery, but in fact there is a second, less apparent opening. Its mouth is on the right wall of the Hall of Bulls just before the hindquarters of the great black bull. This opening leads to a fifty-five-foot-long tunnel called the Lateral Passage. It in turn leads to a fork. On the left, another long passage penetrates deep into the cave. The right fork is much shorter, but it leads to the Shaft and its enigmatic painting.

"The Lateral Passage" is an unfortunate name because it implies that the space was merely a connector between more important spaces. And in fact it has a rather functional appearance now, since a continual draft and a stream that runs occasionally have effaced almost all the paintings that once were there. But at the time the cave was in use, the walls here were covered just as thickly with paintings as the walls of the Hall of Bulls and the Axial Gallery. Plus, there are 300 to 350 engravings. (They are often faint and overlap besides, so an exact count is impossible.) Over half the engravings are of horses, 18 are of cattle, 17 of bison. There is also a smattering of crosses, grids, and other signs, along with an elk, a bear, and possibly a wolf. That is many more engravings than all the paintings in the Hall of Bulls and the Axial Gallery combined, even though those rooms have considerably more wall space available than does the Lateral Passage. And that isn't counting the paintings that the air and water have worn away. In all its glory, the Lateral Passage was probably the most densely decorated area of the cave.

Originally this passage was only three to five feet high. During

their first visit, Marsal and Ravidat crawled along it on their hands and knees, just as the prehistoric people did. The floor also used to slope dramatically to the right. The painters must have sat on the floor, perhaps cushioned by sacks of grass, as they worked.

Many other caves have low, narrow tunnels whose walls are covered with engravings. The artists made drawings, signs, lines, and scratches one on top of the other. The result is a confusion of lines that can take hours and hours of careful tracing to decipher, if it can be deciphered at all. Many of the engravings in Lascaux and in other caves are as beautiful and technically accomplished as the best paintings, but many are not, and instead appear to be the work of unpracticed, untalented people who weren't artists at all. Presumably the paintings in the Hall of Bulls and the Axial Gallery were planned and executed by great artists to be part of some public occasion, although the audience in the Hall of Bulls could have been much larger than the one in the Axial Gallery. But the engravings in the Lateral Passage and in other narrow tunnels in other caves don't appear to be part of any grand design. They were private scratchings that were apparently part of a personal rite that individuals came here to perform.

After World War II someone made the boneheaded decision to lower the floor of the Lateral Passage to make it easier for tourists to see. Soil—tons of it—was dug up, put into wheelbarrows, and rolled outside, where it was dumped on the ground without any effort to sift it for archaeological remains. Who knows what was lost?

At the time of the discovery, the Lateral Passage led to a large mound of clay. To the left was a treacherous slope that slanted down to a tall, sloping gallery now called the Nave that is twenty yards long and over eighteen feet high in some places. The Nave contains paintings and engravings of fifty or so animals, as well as twenty-four signs. The art here is the equal of the finest art in the

rest of the cave and includes compositions famous and impressive enough to be given names—the Great Black Cow, the Swimming Stags, and the Crossed Bison, which is the last painting, at the end of the gallery. It shows two bison back-to-back. Their rumps overlap and the intricate perspective of the two pairs of back legs is one of the great technical achievements of Paleolithic art. This mastery of perspective wasn't seen again in European art until Paolo Uccello in the fifteenth century. And the bison were drawn freehand. Most Paleolithic paintings began with an outline, often engraved. The Great Black Cow in this same gallery, for example, has an engraved outline. There are many places along the neck and back where the first line wasn't satisfactory and the artist engraved a second or even a third until it was right. But the Crossed Bison was painted directly with a brush without an outline or any false starts. Its perfection shows the assurance of a master.

The Nave contains a number of rectangular signs that are themselves divided into smaller rectangles. First the lines were deeply engraved; then each inner rectangle was painted a different color, making the whole composition look rather like a quilt. The colors are among the subtlest in cave art—hues of red, brown, yellow, and even purple. One such multicolored rectangle is beneath each of the hind legs of the Great Black Cow. Some scholars have proposed that these and similar rectangular signs represent traps—but if so, why the intricate coloring? And the Great Black Cow looks placid and unconcerned, which is not the attitude of an animal whose hind legs are ensnared.

At the end of the Nave is a narrow tunnel that is frequently filled with carbon dioxide that rises from inaccessible chambers below the cave. It's impossible to stand erect anywhere in it, and often it narrows so much that the only way to move is on hands and knees. After ten or fifteen minutes this difficult journey ends in

the Chamber of the Felines, which is only somewhat larger and taller than the tunnel. This is the most remote room in the cave. It has spectacular engravings of lions, but even here more than half of the fifty animals are horses. One engraving is famous because it shows a horse face on. Other than this one, almost every animal in all the known caves is pictured in profile. The last animal in the Chamber of Felines is a bison, or rather the head of a bison. After that, two rows of three red dots, one directly below the other, mark the end of the chamber, where it's impossible to penetrate farther into the cave. Graphically the dots are completely different from the painting of a horse's head at the entrance to the cave, but there is some implied connection between the dots and the horse. The horse's head marks the beginning of the cave and the six dots indicate its termination.

Or, more precisely, they indicate one terminal point. There is a second one. As we have just seen, a left turn at the mound of clay at the end of the Lateral Passage leads to the Chamber of Felines, but a right turn leads to a room called the Apse, which is above the most mysterious and moving place in Lascaux: the Shaft.

Lascaux contains so many paintings and engravings that it alone has one-tenth of all the Paleolithic art known in France. The Apse, though it is smaller than all the other rooms in the cave except for the Chamber of Felines, contains more than half the art in Lascaux. There may have been paintings here that have disappeared, but what we have today are well over one thousand engravings done one right over the other and covered everywhere with random lines and scratches. From the moment of discovery, scholars and laypeople alike have wondered at the contrast between the grand paintings in the rest of the cave and the hundreds of small engravings in the Apse, all packed together in an intoxicating mélange that is impossible to decipher entirely.

Even in the most detailed books about Lascaux there is usually

a line that says a full discussion of the Apse would require a book in itself. So far that book has not been written because the task is so daunting and the uncertainties are so many. Clearly, though, the engravings in the Apse weren't made as part of an elaborate composition, they weren't created as a setting for any ceremony, and they weren't there to be seen. Piled one on top of the other, they *couldn't* be seen. The Apse seems to be one place in Lascaux where the act of drawing was itself part of some ritual or ceremony, where the making was more important than the result.

Engravings cover the ceiling of the Apse, which varies from six to nine feet in height. The higher places are among the most intensely decorated, and the artists would have needed scaffolding to reach them. But the Apse is rather wide, unlike the Axial Gallery, where the base of scaffolding could be wedged between the walls. In the Apse the scaffolding must have been freestanding and at least eight feet tall. The artists, or their helpers, must have cut and trimmed pine branches with stone axes, dragged the branches through the Hall of Bulls, and then crawled with them for fifty feet through the Lateral Passage to the Apse. There they constructed the scaffolding, using cords made of leather or plant fiber to secure the branches to one another.

The Apse is directly above the Shaft, a hole in the floor sixteen feet deep, where Ravidat bravely descended by a rope held only by his three young friends. Ever since the discovery, the assumption has been that the Paleolithic people lowered themselves into the Shaft the same way. Support for this theory turned up accidentally one day when researchers inadvertently broke a piece of clay off the wall in the Chamber of Felines. The clay held an impression of a rope of twisted fibers.

If descent by rope was the only access to the Shaft, then visits there in prehistoric times were probably rare. However, Norbert Aujoulat, the French archaeologist who identified the stages of

painting the horses in Lascaux, has proved that there was once a separate entrance to the Shaft that allowed direct entry at ground level. He studied the way currents of air had effaced paintings in the area above the Shaft and concluded that a current must have come up from the Shaft. That would have happened only if there had been an opening to the outside. And there was still more evidence—quaint, but decisive. The Shaft contained bones of various tiny animals like mice, hedgehogs, and frogs. These little beasts never penetrate farther than twenty or thirty yards inside a cave. Since the top of the Shaft is considerably farther inside the cave than that, the mice, hedgehogs, and frogs couldn't have fallen in from above and must have come in by way of a separate, lower entrance. This direct and presumably easier entrance means that prehistoric visits to the Shaft may have been more frequent than previously thought.

Nevertheless, the Shaft and the Chamber of Felines were certainly visited less frequently than the other rooms in the cave. They are at the distant ends of the cave, and they both regularly fill up with carbon dioxide gas. Carbon dioxide can be lethal in high concentrations and is disorienting in lower levels. In recent years researchers have entered the Shaft only to have to leave suddenly when they began to feel the disorienting effects of the gas. One man saw thousands of dots before his eyes; another, while resting in the Apse after having fled the Shaft, thought he was visited by a human shade that spoke to him for several minutes. The gas is odorless and arrives without a sound. Its presence in regular cycles and the hallucinations it caused—as well as the fact that a flame burns less brightly in an atmosphere rich in carbon dioxide— could have played a role in the mythology that surrounded those parts of the cave and in the ceremonies or private rituals that took place there.

Although the Shaft is not large, the walls offer plenty of space

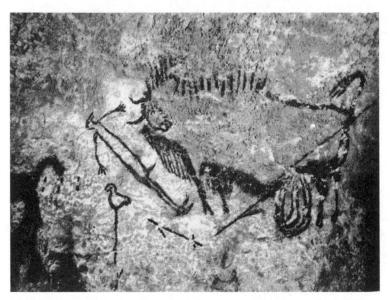

The Shaft Scene at Lascaux. This is one of the few narrative scenes in the painted caves. Apparently, the man has wounded the bison, whose intestines are spilling out, and the bison has knocked over the man. The man's bird's head and hands have led to speculation that he was a shaman.

for paintings. Yet—in contrast to the rest of the cave, where paintings and engravings fill up practically all of the available space—there are only four figures and three signs in the Shaft. One wall is devoted to one of the few clearly narrative scenes in all of Paleolithic art. A bison stands with his muzzle tucked against his chest. He has lowered his horns as if he is about to charge or has just made a charge. The animal is enraged. He has raised his tail and the strands of hair in his mane are standing straight up. A long spear lies across his hindquarters and his intestines are pouring out of his belly onto the ground, presumably from the wound made by the spear. The outline of the bison, including his head, mane, and

tail, is painted in black, but the animal is cleverly positioned over a large yellow stain in the wall so that the painting appears to be colored in.

A peculiar stick figure of a man is in the act of falling over backward in front of the bison. He has two pointed feet, spindly legs, and an erect penis in the shape of a triangle. Two long lines form an oblong torso that ends in a bird's head and a sharp, open beak that points in the same direction and at the same angle as his penis and feet. His thin arms each end in a set of four lines for fingers—something that looks more like a bird's foot than like a hand. A bird on a stick—the man's totem, perhaps—is either lying next to him or standing stuck in the ground. A stick with a barb at each end lies next to his feet. Some have surmised that this is a spear thrower. That could be, but there are similar figures throughout the cave, so it is more probably an important sign whose meaning is impossible at present to guess.

The bird-man is the only human figure in the cave and the bird on the stick is the only bird. Immediately to the left of them, separated slightly by a crevice in the rock, stands the only rhinoceros. He is outlined in black and his long back has thick shading, but his forelegs and chest are missing entirely. Like the bison, he has raised his tail. Immediately behind it are two rows of three dots, one row immediately below the other. These dots are identical to the six dots at the end of the Chamber of Felines, except for being black instead of red. Since the dots begin immediately to the right of the rhino's raised tail, they have occasionally been interpreted as turds. But that ignores the connection with the red dots in the Chamber of Felines, where nothing suggests that they are excrement, and it also ignores the fact—what is the best way to say this?—that animal turds simply drop straight down and do not fly in formation.

On the opposite wall the head, neck, mane, and back of a horse

are outlined in black. This horse is the forgotten figure in the Shaft and is often completely ignored in discussions of the more famous composition of the bird-man and wounded bison on the facing wall. But this figure recalls the similarly incomplete horse in the Hall of Bulls at the entrance to the cave. Also, it is important always to remember that the paintings and engravings in Lascaux show more horses than all the other animal species combined. The presence of a solitary horse in the Shaft must be significant. If there was a separate entrance to the Shaft in prehistoric times, as Aujoulat believes, then this horse might mark that entrance just as a similar incomplete image of a horse marks the entrance to the much larger cave above. But the Shaft is a closed room, which makes it not only the beginning but also the end of a passage, as marked by the six dots. It's a minute opening into the mind of the ancient hunters that the sign of the horse and the sign of the six dots are both present in this small room.

Some of the paintings in the Shaft were made by brush. They include the bird, the six dots, the upper torso of the man, the head of the bison, and the bison's horns. The painter or painters made everything else by blowing the pigments on the rock walls. And there probably were at least two painters. Norbert Aujoulat has made a careful analysis of the pigments and of the techniques used in each painting in the Shaft and has concluded that the rhinoceros was painted at a separate time from all the rest of the paintings there. It's impossible to tell how much time passed between the two paintings, although it likely wasn't too long. Apparently the man, bison, bird, and horse are part of one narrative. The rhino, partially separated from the rest of the scene by the fissure in the rock, may have been some artist-poet's later addition to the tale.

The abbé Breuil, whose discernment and powers of observation were impressive, came to the same conclusion during his stud-

ies of the cave during and after World War II. He decreed that the style of painting in the rhino showed that it had been created separately. Nevertheless, he thought it was an integral part of the story. In his masterwork, *Four Hundred Centuries of Cave Art,* he wrote that since "no lance-thrust could thus disembowel a Bison, the presence of the Rhinoceros, calmly strolling off to the left, gives the explanation. It seems to be moving away peacefully after having destroyed all that annoyed it." For Breuil, the rhino had gored the bison and the enraged bison had then gored the man.

Unfortunately, this reading, prompted by Breuil's insistence that hunting was the theme that informed all the art in the cave, forced him into a rather mundane final interpretation of the scene: "One thing remains to be explained, the post with a barbed end topped by a conventional bird, legless and with almost no tail. It reminds me of the funerary posts of the Eskimos in Alaska or those of the Vancouver Indians. It would be interesting to ascertain if there is not a burial at the foot of this picture, perhaps commemorative of a fatal accident during a hunting expedition."

In 1947 Breuil initiated a dig at the foot of the Shaft in hopes of finding the grave of the man whose death he presumed was commemorated in the painting. Sadly, both for Breuil's reading of the scene and for archaeology, he didn't find a grave. But he did find some 350 stone tools and other relics. Further excavations twelve years later also turned up much of interest.

There were two reasons why the Shaft held so many relics. First, the floor of the Shaft, luckily, was never dug up for tourists, as most of the rest of the cave was, so the Shaft has remained the most fruitful part of the cave for artifacts. Second, the Paleolithic people dropped things into the Shaft, some perhaps by accident but most apparently on purpose as votive offerings. The digs turned up thirteen spear points, often decorated with barbed lines, like the one at the feet of the man. A similar number of seashells that were used as jewelry turned up. They had once been painted and they

still showed traces of red ochre, and they were pierced so that they could hang from a necklace or from fringe on clothes. A number of tools and blades also appeared, as well as dozens of plain lamps that are little more than stones with a small hollow, and one exquisite lamp carved from pinkish sandstone. It is shaped like a broad spoon and decorated with the same barbed lines found on the spear points and in the painting. The presence of so many lamps in the Shaft adds weight to the theory that things took place at times when the carbon dioxide level was high. Each individual lamp would have burned less brightly in an atmosphere rich in carbon dioxide, so more lamps than usual would have been necessary.

The story of a man and a bison must have been widespread, even a universal myth, during Paleolithic times, since the Shaft scene in Lascaux is not the only confrontation between man and bison in the art in the caves. In Villars, a cave in the same region only about fifty miles from Lascaux, there is a painting of a bison about to charge a thin man. The man is standing and waving his hands above his head as if he wants to provoke the animal. There is a horse painted below this scene. The paintings in Villars are about the same age as those in Lascaux. Rouffignac, a cave about fifteen miles from Lascaux, has a large room with a flat ceiling covered with paintings. In the corner there is a shaft not unlike the one in Lascaux, and here there is a painting of a man's face and two bison, although this time the man and bison are not confronting one another. At Roc-de-Sers, a site slightly farther northwest, a bas-relief shows an almost comical figure of a human threatened by a bison. For this theme to appear so frequently, even with its slight variations, the story of a man and a bison must have been universal, a part of the culture shared by everyone.

To the end of his life Breuil clung to his theory that the paintings in Lascaux and all the other caves were part of rituals of hunting

magic. He was aware that the Paleolithic people ate mainly reindeer, while there are no reindeer on the walls of Lascaux. "Now why?" he asks in *Four Hundred Centuries of Cave Art*. And he has a clever explanation: "No doubt because this game, which passed in the autumn in great herds coming from the north, spent the winter in Aquitaine and left in the spring, following for thousands and thousands of years (as in Canada) the same trails, in spite of the ambushing hunters who killed them in hundreds; this game, in the eyes of the Paleolithic men, needed no hunting magic to slay. The Reindeer were very stupid, not very agile, easily secured as they passed; so no magic was necessary for their capture, no more than for the capture of Salmon or other fish in the rivers, very seldom shown in the wall drawings."

But then why did different animals predominate in different caves? Horses dominate Lascaux, but in Rouffignac, the cave that also has a shaft with paintings, it is the mammoth that dominates. Yet the diet of the people near these caves was more or less the same.

The hunting-magic theory was fading when Lascaux was discovered, despite Breuil's insistence on it, but the appearance of such a cave undermined it for good. Lascaux changed almost everything that had been assumed until then about the caves and the people who painted them. It wasn't just the beauty of the paintings. Altamira and Font-de-Gaume had beautiful paintings, too. But the scope of Lascaux was so grand and the paintings were so intense that it was clear that the people who created the art there had far greater intellects, a much richer culture both materially and spiritually, and a more powerfully energetic society than anyone had ever thought. Breuil, to his credit, recognized exactly that. "The variety and number of successive techniques, following each other in a relatively brief time," he wrote in *Four Hundred Centuries*, "is indicative of a sort of artistic fever, rich in inspiration and experiment. There was nothing to foretell that, in this remote

epoch of which, before Lascaux was· discovered, we had known only a few artistic fragments of this Art, there would be such an outburst of really great Art, perfect of its kind."

But, if it wasn't hunting magic, what did this perfect art mean? When World War II ended, it was sixty years after Marcelino Sanz de Sautuola looked up and saw the bison on the roof of Altamira. For all the papers and conferences, for all the archaeological digging and discoveries, the people who admired the paintings in the caves, whether they were scholars or laypeople, were still asking the same question Félix Garrigou had written in his notebook in 1864 after visiting the painted cave Niaux: "There are paintings on the wall. What can they be?"

CHAPTER 5

A Stormy Drama Among Bison; The Golden Section

In 1935 a man named Max Raphael left Paris on an excursion to visit the caves around Les Eyzies. He was an anomaly among students of the caves, being a German, a Jew, and a Marxist to boot. Furthermore, he was already forty-six and had had no training or experience in either archaeology or prehistory.

Until that trip Raphael had devoted his life to writing extremely intellectual studies of contemporary art and philosophy. His publications included books such as *Proudhon, Marx, Picasso: Three Studies in the Sociology of Art* and *The Marxist Theory of Knowledge*. These books and the rest of his work, brilliant as it was, remained in obscurity while he was alive. That was partly due to his peripatetic life. He deserted from the German army in World War I, lived in Switzerland, then in Berlin, then in France, and had to flee from Europe to avoid the Nazi concentration camps in World War II. He went through Portugal to New York, where he spent the rest of his life. His difficult personality also helped undermine his career. He was obsessive, dark, and given to bouts of depression. He had dark, deep-set eyes and an immense bald brow. With a straight mouth, his lips pressed together, he had an air of almost demonic concentration.

121

But Max Raphael did have the rare and valuable ability to see what was directly before his eyes. Looking at the paintings in the caves around Les Eyzies, he saw what no one else had ever seen until then: The paintings were whole compositions in which the positions of animals in relation to one another conveyed their meaning. As he wrote in a letter to the abbé Breuil shortly after his journey, "In front of the originals, I conceived the hypothesis that where there is a spatial proximity among several animals, there was an intended meaning that we must discover."

This was a blinding, radical perception that seems not to have occurred to anyone else. It completely changed the thinking about the painted caves—but only eventually. It took about twenty years for Raphael's ideas to seep into the mainstream. With all the interruptions in his life, he didn't publish anything about the caves until 1945, when his *Prehistoric Cave Paintings* appeared, beautifully and expensively published by the Bollingen Foundation through Pantheon. It is only fifty-one pages long, but it is dense and difficult because the text was a stilted translation into English from Raphael's German manuscript. That muted its effect, but even if the translation had been velvet prose, the fact that the book appeared in English made it seem tangential. At that time, researchers in prehistory were almost always French or Spanish and the most important work was published in either French or Spanish, especially French. Work from the United States was nothing but an apparition on a distant periphery. In fact, *Prehistoric Cave Paintings* wasn't translated into French until 1986, forty-one years after it first appeared.

Although his work seemed to have little effect, Raphael labored on from New York, maintaining an extended correspondence with the leading prehistorians of the day, in particular with Breuil. At that time photography in the absolute darkness of the caves was still difficult and rare, so Raphael was dependent on the

Max Raphael. Working in obscurity and isolation, he was the first to recognize that the paintings in the caves were not random but had a coherent structure. He thought that analyzing that structure would lead to the meaning of the paintings.

paintings, sketches, and tracings of cave art executed by Breuil and other researchers. With them at hand he prepared extensive notes for a second book on the caves and in 1952 began planning a trip to France and Spain so he could see the original paintings again.

All his life he'd had a staggering capacity for learning and for hard work, but now he found himself confronted by the miserable fact that he could not afford the journey he was planning. He descended into a deep depression. He was desperately poor, and summer in New York was especially hot that year. Max Raphael killed himself on July 14, the French national holiday celebrating the fall of the Bastille and the triumph of the Revolution. Much of his writing existed only in manuscript when he died and slowly appeared in the following years thanks to the efforts of his widow in cooperation with Boston University.

In addition to the disruptions in his life and the negative effect of being published in English, one other circumstance slowed the recognition and acceptance of the brilliant originality of *Prehistoric Cave Paintings*. Raphael was not a "dirt archaeologist," as those who get down on their knees and sift through the soil at a site proudly call themselves. Dirt archaeologists like Cartailhac, like

Breuil, and like some others we will encounter have always domi-
nated the field of prehistory. Raphael, on the other hand, was an art
historian and an intellectual, which meant his ideas were automati-
cally suspect to archaeologists. (I once mentioned an academic
scholar of prehistory in a conversation with a confirmed, lifelong
dirt archaeologist. "Oh, her," he said. "The thing about her is
she's really just an intellectual.") The archaeologists believe, with
some reason, that art historians are ignorant about prehistory.
Worse still, art historians don't know they are ignorant because
they study the paintings as art rather than as part of the evidence
that remains to us about the Paleolithic world. Art historians
also think they can understand the cave paintings just by look-
ing at them instead of studying them in the context of all that is
known of the Paleolithic world. And this pride leads them to make
ridiculous errors.

It's true that Raphael's work is marred by a few small errors of
fact. In some cases, such as when Raphael remarks that Paleo-
lithic artists painted mammoths even after they were extinct in
France, his work has been overtaken by new research. Now it
appears that mammoths survived in France much longer than had
been thought. But in other, more culpable cases, Raphael simply
misidentifies the figures in a painting. Once he calls a grown bull
with well-developed horns a calf. But the essential, illuminating
perception about the cave paintings—that they are compositions
and not simply pictures of individual animals—escaped the dirt
archaeologists for a generation and first occurred to an art histo-
rian, Max Raphael.

Raphael for his part bristled at the prejudice against art history.
In *Prehistoric Cave Paintings* he went on the counterattack: "Paleo-
lithic archaeology, disdaining, so to speak, its own magnificent dis-
coveries, has regarded its own material as a collection of unrelated
fragments and thus completely missed the forms and even the sub-

ject matter expressed by the forms." Paleolithic archaeology had made this disastrous mistake because it regarded prehistoric art as primitive. That smug assumption infuriated Raphael, since for him prehistoric art was not primitive art at all: "It has been said that Paleolithic artists were incapable of dominating surfaces or reproducing space: that they could produce only individual animals, not groups, and certainly not compositions. The exact opposite of all this is true: we find not only groups, but compositions that occupy the length of an entire cave wall or the surface of a ceiling; we find representation of space, historical paintings, and even the golden section! But we find no primitive art."

Today, most scholars, whether they are art historians or archaeologists, would deny that there even is such a thing as primitive art. Instead the current wisdom holds that each culture creates the art it needs according to its own beliefs, history, and conventions. Whether or not that current wisdom is true, it's not at all what Raphael meant.

His thinking about the caves contained two main pillars. The first is his belief that the cave paintings could not be understood by comparison to the art and societies of "the so-called primitive people of today." According to Raphael, the Paleolithic people who painted in the caves were "in the throes of a continuous process of transformation" because they were a heroic people who "squarely confronted the obstacles and dangers of their environment and tried to master them." This put them in "fundamental opposition" to the undeveloped people of today, toward whom Raphael was impatient and unsympathetic. He thought they had adopted certain habits and beliefs that they never changed, and did not allow to be challenged. As a result, their existence was "stagnant" because they stubbornly clung to their superstitions, which were rigid and dogmatic, and avoided difficulties that might cause change. The contrast Raphael perceived between the dynamic, continuously

transforming society of the Paleolithic culture and the stagnant society of modern undeveloped cultures still trapped in the Stone Age led him to the conclusion that "prehistory cannot be reconstructed with the aid of ethnography."

This is a direct attack on Breuil, although Raphael doesn't frame it that way. Breuil used ethnography—comparing the Paleolithic world to present-day undeveloped societies—in order to explain the meaning of the cave paintings, to the exclusion of any other method. Most other scholars of his generation followed Breuil's example. But are these comparisons really valid? Is it legitimate to study people of today such as the Australian aborigines or the San of Africa—both of whom make elaborate paintings on rocks—and use their example to draw conclusions about the life and society of the Paleolithic artists? For Breuil and for many prehistorians even today, the temptation is just too great to resist, especially when an ethnographic comparison can support a pet theory.

Raphael rejects this approach entirely and in a very dogmatic way. He believed in the "continuous process of transformation" in Paleolithic times. He offers no support for this belief, much less any proof, and it's even difficult to know what transformations he could possibly be talking about. His notions about the "stagnant" life of undeveloped societies in the present are also unsupported and, I suspect, would drive a modern ethnographer into apoplexy. But, for all that, his instincts led him to a profound conclusion about a central problem. Using ethnography to explain even the slightest things about the world of the cave painters is not just dangerous but deeply counterproductive.

To imagine the lives of people living in the Paleolithic era we must look back across 40,000 years of discovery, of invention, and of advances in science, technology, medicine, agriculture, and much else. In this long history we can see the differences that

major advances such as writing or electric power have made in individual lives and in civilizations. That makes it almost inevitable for us to think of those people who live outside that long history—that is, people who still live in undeveloped cultures—as essentially the same as the people of the Paleolithic era in Europe and Asia who lived before any of those advances were made. But that is an error.

At that time the civilization that covered the vast territory from Western Europe to Siberia was advanced far beyond the rather limited cultures that had come before it. As Max Raphael understood, that civilization has little or nothing in common with the undeveloped societies of today. Rather, just as it is most appropriate to compare great civilizations with one another—classical Greece with Renaissance Italy or the Egypt of the pharaohs with the Indus Valley civilization—the Paleolithic civilization in Europe and Asia should be compared with the most advanced civilizations of the past and of today. The greatest flowering of that civilization was the paintings in the caves. We should study them, not as ethnography, but the same way that we study Greek tragedy or the temples of Angkor Wat, expecting to find on the cave walls the history and beliefs of a great people along with the deepest philosophy and the most profound understanding of which humanity is capable.

The second pillar of Raphael's thinking is that the paintings are not individual works done one by one over time as Breuil and his contemporaries had assumed. Instead the paintings were part of a single, deliberate composition. We first have to recognize "the existing material for what it is—and very often we have to deal not with single animals, but with groups." After that it is necessary "to interpret the parts in relation to the whole, and not to isolate them." Then by considering the form of such compositions we may derive their meaning, because "in art, content and form tend to become identical."

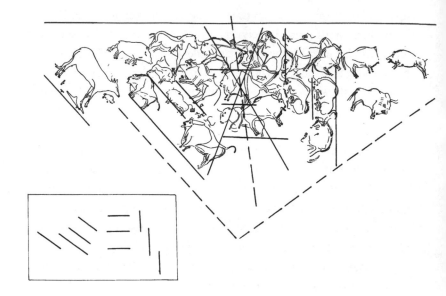

The ceiling of Altamira as analyzed by Max Raphael. These apparently random paintings are actually a single composition grouped around a center line. The animals in the middle are arranged horizontally; those on the right, vertically; and those on the left, diagonally.

The idea that the individual paintings are part of a planned composition is the equivalent of an axiom in mathematics. From it Raphael derives several provocative theories. They might even be true. He makes the same observation everyone else makes—that the same animals are painted again and again in cave after cave—but he then takes it one step further: "The character of each animal seems to be as limited as the subject matter; everywhere the reindeer live a bright cheerful idyll, just as the bison live a stormy drama; the horses display playful sensitivity and the mammoths unshakable dignity and gravity." What did the artists mean by this

consistency? Raphael believed the animals represented clans. The scenes on the walls with all their superimpositions represent conflicts, alliances, weddings, or other historical events among the clans: "Animals pictured one inside the other may represent . . . alliance in the struggle, while the superimposition of animals may stand for domination, mediation or a promise of support. The latter is probably the case in the many pictures showing a mammoth superimposed on other groups of animals." He insists that the ceiling of Altamira is the history of the conflict between the deer clan and the bison clan and sees this conflict repeated on the walls of other caves. The wounded horses in the Nave in Lascaux represent the horse clan that was vanquished by the clan of bulls and cows. It's a very seductive notion, especially since Raphael presents it with such calm self-assurance. But there is no proof at all that Paleolithic people had clans or, if they did have clans, that those clans identified with totem animals.

Raphael also believed that the Paleolithic artists represented space in ways that are now alien to us. For instance, animals are commonly painted one inside the other, which seems confusing and arbitrary to us. According to Raphael, that might signify the unity of two clans or the dominance of one clan over another, but it also could be a convention for showing that one animal is *behind* the other. The size of the inside animal indicates how far away it is—the smaller, the farther away.

Similarly, the difference in size between two animals that are near each other is, according to Raphael, "equal to their distance from each other; in other words, if they were of equal size, they would touch each other." Another way of explaining what he means is to say that the smaller the animal is, the farther behind the foreground represented by the cave wall it is supposed to be. On a wall where a large bison is standing next to a small mammoth, modern people, used to our artistic conventions, see two animals

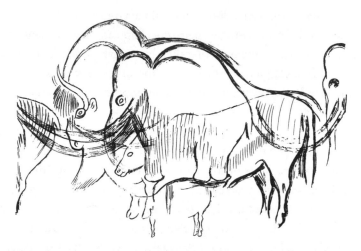

A tracing of a mammoth inside a bison at Font-de-Gaume. Mammoths were much bigger than bison, and for years archaeologists have puzzled over the cave painters' apparent indifference to proper scale. But Max Raphael thought the differences in scale were a way of representing space. The smaller an animal is, the farther away it is.

of wildly mismatched proportions standing in the same plane. The Paleolithic artist saw a mammoth standing far behind a bison.

Raphael also believed that the prehistoric artists knew and routinely—even ritually—used the proportion that eons later Leonardo would name the golden section. These are proportions, based on the human body, that in theory produce the shapes that are most pleasing to the eye. For a shape like the body of an animal (not counting the legs) those proportions are 2:3 and 3:5, so that the body of a horse that was, say, two feet high should have a length of three feet. And Raphael insists that the animals in the caves conform to these proportions with "great frequency," so often in fact that it is a phenomenon that requires explanation, which he is eager to provide. He believes that painters found these proportions by looking at their own hands.

On average, two lengths of a male's hand is equal to three widths. Also, when the fingers are separated in the most natural manner—that is, making a gap between the middle and fourth finger—both the proportions 2:3 and 3:5 are created. In one case, three digits (the thumb and two fingers) are opposed to two digits (the fourth finger and the pinkie). At the same time, three digits (again the thumb and two fingers) are opposed to five (the whole hand). That "there can be no doubt that the golden section . . . was developed out of the hand" has tremendous importance for Raphael, not just in his interpretation of the art but for his vision of Paleolithic society's ideas and beliefs. That's because the "hand was the organ by which erectly walking man could translate the superiority of his consciousness over the animal's thinking capacity into practice." In other words, human intelligence could dominate the animal world only because the hand could make tools, blades, spears, and other weapons. Then the hand could throw and thrust them to wound and thus dominate animals—or other humans.

Raphael believed that since the hand was the body part that became the instrument of domination, it always had great importance in the magic of early humans. "It would seem," he wrote, "that Paleolithic man took for granted the formal analogy between the animal and the hand, which for us remains a paradox." Yet in Raphael's words, the analogy between the two is quite clear: "The hand is not a structure centered on an axis, it is unsymmetrical in shape, it has one-sided direction just like the animal in motion, and its motions are free and independent of one another, because, unlike the human body as a whole, hands do not constitute a single system of balance."

Also, the hand had a role in the formation of language, since language must have developed to articulate communication that previously was possible only through signs or other gestures made

with the hands. Raphael says, "the fact that the hunters used the hand as a means of communication in order to avoid frightening their prey by shouts, suffices to support my assertion that the hand is the basis of formal composition of all Paleolithic (Franco-Cantabrian) painting." Deriving the golden section from the hand was "the first concrete example of the derivation of the aesthetic significance of the hand from its magic significance."

The magical, or at least the spiritual, significance of the hand is universal. We see it in the hand of God on the Sistine Chapel reaching to touch the hand of man, in the pointing finger in the paintings of Leonardo and other Renaissance artists, in the laying on of hands in religious ceremonies, in the hand and finger postures in the Buddhist art of India and China. But "during the Paleolithic age the animal was the measure of all things—but only through the intermediary of the human hand." Thus the paintings showed animals, but animals created by the hand and based on the proportions of the hand. (Raphael doesn't make the obvious connection between this fact and the numerous imprints of hands in either red or black on the walls of many painted caves. Perhaps that was because there are no painted hands in Lascaux and few in the caves he visited near Les Eyzies.)

Finally, Raphael puzzles over one of the great conundrums of cave art, one that archaeologists tend to ignore because it is emotional rather than scientific. The paintings look modern, familiar. But how could that be, since, as Raphael says, "in reality there is no art more distant and alien to us?" It is distant because it is so old, and it is alien, first of all, because it begins with a different premise. Art in the West is centered on humans or on the relations between humans and gods. Paleolithic art is centered on animals. This central focus means "there is no place in [Paleolithic art] for the middle axis, for symmetry and balance inspired by the structure of the human body. Rather, everything is asymmetric and shifted." And

the point of view is different in Paleolithic art: "The objects are not represented as they appear when seen from a distance, as we are accustomed to seeing them in paintings from the times of classical antiquity, but as near at hand—for the Paleolithic hunter struggled with the animal at close quarters, body against body; only the invention of the bow . . . made the distant view possible." And finally, the paintings should seem alien because "the object of Paleolithic art is not to picture the individual existence of animals and men, but to depict their group existence, the herd and the horde." How, then, can this art, while remaining mysterious, still appear so close to us and speak to us so directly?

Raphael's solution to this mystery is a testament to his genius. He believes the reason is that the painters "were produced in a unique historical situation and are a great spiritual symbol: for they date from a period when man had just emerged from a purely zoological existence, when instead of being dominated by animals, he began to dominate them. This emancipation from the animal state found an artistic expression as great and universally human as was later found by the Greeks."

This assertion—this inspired guess—can never be proved, but it cuts close to the bone. It is another version of the biblical Fall of Man. For millennium upon millennium, members of the genus *Homo* did not see themselves as separate from the other animals. Then, somehow, *Homo sapiens* acquired forbidden knowledge and came to believe they were somehow distinct from other animals. The paintings express the guilt, the regret, and the triumph that came with the belief in that separation.

Raphael, as an atheist and a Marxist, avoided characterizing this new awareness as a fall and instead described it as the result of a social struggle: "The Paleolithic paintings remind us that our present subjection to forces other than nature is purely transitory; these works are a symbol of our future freedom. Today,

mankind . . . is striving for a future in the eyes of which all our history will sink to the level of 'prehistory.' Paleolithic man was carrying on a comparable struggle. Thus the art most distant from us becomes the nearest; the art most alien to us becomes the closest." Today, when it is clear that the Marxist future Raphael envisioned in 1945 has failed, these lines seem jagged and off-key. But if you drop out the Marxism, what remains is Raphael's shrewd perception that the dynamic—the struggle against domination by nature—in Paleolithic civilization that led to the art is similar to a dynamic—the struggle against domination by forces other than nature, that is, by forces of ideology—in our own time. That's one reason why this ancient art is deeply meaningful to us and not merely a pretty curiosity from the distant past.

A Lively but Unreliable Creation;
Quaint, Symbolic Arrows

In 1951, just a few months before his death, Max Raphael mailed a typed manuscript of thirty-one pages to a woman in Paris named Annette Laming-Emperaire. He'd titled it "On the Method of Interpreting Paleolithic Art." It consisted of introductory notes to the first part of a long work Raphael had intended to call "Iconography of Quaternary Art: Methods and Systems." It was meant to extend and in some ways replace the work he had begun with *Prehistoric Cave Paintings*. Raphael's second book would have included not only his methods of interpretation but also his revised chronology of the painted caves, a chapter on isolated paintings of two or three animals, and a treatise on the concept of historical progress, which Raphael thought was somehow the key to understanding prehistoric art. At the time of his death, "Iconography of Quaternary Art" consisted only of the notes he sent Laming-Emperaire, earlier and later drafts of those same notes, and some other random notes and observations. The 1986 French translation of these papers, which is the only published version in any language, is less than sixty pages.

Annette Laming-Emperaire was thirty-four years old in 1951

when she found Raphael's package of typescript in her mailbox. As with everyone else who lived through those times, the normal course of her life had been interrupted and delayed by the war, but now she was racing toward the future. She was technically just a graduate student at the Sorbonne who had begun studying the painted caves only five years earlier. But her brilliance was already apparent, and word about her had begun to spread in the small but intense community of French prehistorians.

In 1948 she wrote the text for *Lascaux: Chapelle Sixtine de la préhistoire,* a book of photographs taken by Fernand Windels, who had begun photographing the cave soon after its discovery. The English translation of this book appeared in the United States in 1950. Raphael must have spent hours studying it, since these were the most complete photographs available of Lascaux at that time. In fact, they were the most complete photographs of any cave. That Laming-Emperaire got to write the accompanying text was an impressive debut and probably what prompted Raphael to send her his notes.

Laming-Emperaire, for her part, was intrigued but not seduced by the notes for "Iconography of Quaternary Art," or so she wrote when she discussed Raphael in the book that earned her place in history, *La signification de l'art rupestre paléolithique* (The Meaning of Paleolithic Rock Art). The important word in her title is *signification,* "meaning." It's a testament to her desire to confront the most important questions and also to her nerve. Modern scholars have mostly abandoned the search for what the paintings mean because they believe it is impossible for us ever to know. That's correct, in a way, but for Laming-Emperaire studying cave art without searching for its meaning rendered that study, well, meaningless.

She was the precise image of a postwar, French, intellectual woman. She was handsome and physically appealing without

being glamorous. She wore plain, sensible clothes that were also flattering. Her thick, almost luxuriant hair was sometimes unruly even though she wore it in a short bob. She was serious, hardworking, concentrated. Photographs often show her staring without expression into the distance, although in one taken in South America sometime in the 1970s she reveals a radiant and completely natural smile. Her students adored her. In Annette Laming-Emperaire's character there was also something that was soulful, romantic, and passionate, perhaps because she seemed to live in the shadow of tragedy.

She was born to French parents in St. Petersburg in 1917 on the eve of the Russian Revolution. Soon after her birth, the family had to flee with her toddler brother and Annette, a babe in arms, through Finland and Great Britain back to France. Ten years later her father died, leaving his widow with four young children and a difficult and unclear future. Annette lived for a while in Turkey with her grandfather, whom she loved. For years she kept a Turkish carpet, even though it grew more and more threadbare, because it came to her from him.

She was twenty-five, living in Toulouse, and a student of philosophy, chemistry, and biology, when she began working in the Resistance against the occupying Germans. Her daughter remembers her occasionally telling stories of carrying documents by bicycle among Resistance cells, of secretly tearing down German notices, and of trying to stay warm when fuel and rations were scarce by drinking tea with butter. After the war Annette worked in Germany helping to repatriate French children who had been sent to concentration camps. It was 1946 before she was able to return to Paris and resume her studies.

By now she had focused on prehistory, and in 1948 at the Sorbonne began the lengthy labors that would eventually lead to *La signification*. She supported herself by working for the Musée de

l'Homme (Museum of Mankind) in Paris and by serving as a member of the archaeological teams sent by the Centre National de la Recherche Scientifique to digs in France, England, and Switzerland. At one of those digs she met a young ethnographer and anthropologist named José Emperaire, whom she married in 1953, their relationship having begun several years before.

José had recently returned to France after spending twenty-two months among the Alakaluf, a tribe that still lived according to its traditional ways on remote Wellington Island in the Straits of Magellan. He was planning a long archaeological expedition to Patagonian Chile as well as writing a book about his time with the Alakaluf. He left for South America in August 1951. Annette left to join him a few months later. This would have been only a short time after she received the typescript of "Iconography of Quaternary Art" from Max Raphael. José and Annette did not return to Paris until October 1953. From then on Annette spent about half of each year in South America, sometimes in Patagonia but often in Brazil, and the rest of the year teaching in Paris at what is now the École des Hautes Études en Sciences Sociales (School of Advanced Studies in Social Sciences) during this exceptionally fertile period in French anthropology and archaeology. Her daughter Laure Emperaire, being a botanist, works at a different institution, but she has inherited Annette's pattern of life and splits her time between Paris and Brazil.

In June 1957 Laming-Emperaire successfully defended her thesis at the Sorbonne and began preparing it for publication as *La signification*. But tragedy intruded. In December 1958 Annette and José Emperaire were in Patagonia preparing to mount a major dig when José was killed. He suffocated when an excavation trench where he was working collapsed and buried him beneath rocks and dirt.

Annette had just turned forty-one, and after her husband's

death she threw herself ever more passionately into her work. She never remarried. Most of her later work took place in Brazil as she tried to discover and understand the series of migrations from the north that peopled South America. Her interest in Paleolithic art seems to have waned by comparison. In later life she published only a few minor papers and short book reviews in this area. Perhaps the work in South America consumed her because it let her, in a sense, still share a life with her husband. But the work she had done on the caves in the 1950s, culminating with the publication of *La signification de l'art rupestre paléolithique* in 1962, made her the great central figure in the history of the study of cave art. Everything that came before leads directly to her; everything that came afterward proceeds directly from her. Sadly, in 1977 she, too, died in an accident. Gas from a leak filled her room while she slept in the house of friends in Brazil.

Although during her life her brilliance was always apparent, her great originality seems to have burst into being like a fire. *La signification* turned out to be that most rare beast, a graduate thesis that changed an entire discipline, which was exactly what she meant for it to do. In the first sixty pages she gives the history of the discovery of Paleolithic art and the methods for dating it. The next ninety pages are a history of the theories about the meaning of the art. In successive chapters she demolishes the long-honored explanations of hunting magic, fertility magic, and totemism. Then she gives a detailed and critical description of Henri Breuil's work. All of this, the whole body of work dedicated to explaining cave art, sixty years of consistent effort by many brilliant minds, she sweeps aside.

For Laming-Emperaire, all the research that had come before her all of it was fatally flawed because it depended on ethnography. Max Raphael thought that using ethnography to explain the cave paintings was wrong because the Paleolithic societies were

undergoing a "continuous process of transformation" while the contemporary Stone Age societies were "stagnant." Laming-Emperaire's reasoning is less romantic, but more convincing. She even admits that there are two circumstances when ethnographic comparisons are legitimate. The first is at the beginning of research in order to orient ideas or create hypotheses. The second is when a characteristic is universal, found among all the known "primitive" societies. Then "everyone acknowledges that it is legitimate to attribute it equally to prehistoric times." But there are only a few universal characteristics. Practicing sympathetic magic is one. So is the belief in man-beasts or fantastic animals. An elaborate mythology is another. It's therefore safe to assume all of these were present during the Paleolithic as well. There are other universally shared characteristics, but the list dwindles quickly.

She thought that, except in these restricted instances, using comparisons with present-day "Stone Age" people is dangerously misleading. Laming-Emperaire said researchers "indiscriminately invoke facts from some societies that, by their social, religious, or economic structure, can be very different from prehistoric societies—about which we know practically nothing in any case— and that are often very different among themselves." One of the biggest offenders was Breuil: "In order to explain the presence of masked individuals in Paleolithic art, the abbé Breuil invokes each in turn, the Paleo-Siberians, the Eskimos, the Indians of North and South America, the bushmen of South Africa, and the Australian tribes." But the masked figures that exist in these societies do not all represent the same thing. The masks are for hunting among the bushmen; they were used in sacred dances among American Indians, and as representations of gods and mythic ancestors among the Australian tribes. The Paleolithic people might have used masks for any of these reasons or for different reasons entirely. The comparison proves nothing at all.

And these comparisons tend to be completely arbitrary. A researcher finds an artifact, a sign, or a symbol exposed during a dig. He forms a hypothesis to explain it and then he leafs through monographs of ethnology. "And," Laming-Emperaire writes, "such is the richness of human invention that one can generally find some way to support his thinking." Or sometimes the process works in reverse. The researcher finds a hypothesis in ethnography and then returns to the digs looking for evidence to support it. Either way, a prehistoric symbol or figure can mean anything one wants it to mean.

Despite the iron certainty of her logic, Laming-Emperaire must have arrived at that conclusion with some reluctance. She knew that without comparisons drawn from ethnology, the state of research in prehistory would begin to look bleak. She saw it dividing into two schools. One consisted in gathering artifacts and then dividing and subdividing them in a rigorously exact and objective enumeration of places, dates, sizes, and shapes. This work would establish a template where future artifacts could be arranged in order. "For some," she said, "in practice if not in theory, the field of prehistory stops there."

Researchers who use the second method begin with this chronological and geographical order but try to wring a vivid, living past from it. They want to create a "complex image of prehistoric man including his physical appearance, the world in which he lived, his habitat, his skills, and his beliefs." This method, pushed to its extreme, leaves science behind and creates fiction set in prehistory instead.

Laming-Emperaire saw prehistoric research oscillating between these two poles: "sclerotic rigor on one side, a lively but unreliable creation on the other." Her purpose in the remainder of *La signification* was to show a way forward that avoided both extremes.

She believed that from the very beginning students of the paintings had always been far too eager to look for explanations outside of archaeology—that is, in ethnography—before they had exhausted all the possibilities that archaeology offered. The archaeological study of an object such as a blade made of flint focuses on three characteristics: the way it was made, the signs of use it exhibits, and the location in which it was found. Why, she wonders, shouldn't the paintings and engravings be studied the same way? After all, they are archaeological artifacts themselves.

But, she cautions, only one of the three archaeological characteristics is really helpful in illuminating the meaning of cave art. The way the paintings were made—that is, what tools were used, what minerals made the pigments, and so on—may be interesting, but it says very little about meaning, which is independent of the tools and materials the artists used. Looking for signs of use isn't especially helpful either, since paintings almost never show any sign of use whatsoever—although, she adds, that in itself is significant. If the art really had been used for hunting magic, it probably would show signs of being stabbed at with spears, or something similar. Then, too, the general scarcity of remains in the caves shows that they weren't used very often and that whatever ceremonies or events took place there were rare.

But the third focus of archaeology—the place where the art is found—is supremely important for trying to understand what cave art meant. A prehistoric man might accidentally have dropped a flint blade away from the place where it was made or used. Or water or even rodents might have carried it to a random location that had no connection to it. Such dislocations happen often and make dating and identification tricky or impossible. But we can be sure that the art in the caves remains exactly where the Paleolithic artists placed it. And, she says, it's the position of the paintings in remote parts of the cave, rather than what the pictures

usually show, that suggests their magical or religious importance. Furthermore—and here is where Laming-Emperaire begins to sound like Max Raphael—it's not just the placement in the cave that is important for trying to understand the meaning of the art. It's also the placement of figures in relation to one another. The way a group is composed, the superimpositions, the way that one kind of animal is placed near or on another, the frequency with which that happens, and the way signs are placed near animals— all this can lead toward real understanding.

She then shows how this method of archaeological analysis, without resort to ethnology, could be applied to Lascaux. In practice what she did was draw diagrams of the cave walls using symbols she invented that look like arrows with a variety of different points. The symbols showed both the species represented and the direction it is facing. By studying the diagrams she began to see which animals were repeatedly grouped together and where the groups were located in the cave. Her most spectacular insight was in noticing the many parallels between two paintings in Lascaux: the scene of the Falling Cow in the Axial Gallery and the Great Black Cow in the Nave. "The central subject," she writes, "is the same: a large black bovid advancing towards the back of the cave. On one panel the animal appears to be leaping towards a latticed sign; on the other, its two hind legs and its tail are entangled in three similar signs. One bovid is surrounded by some seventeen painted horses, the other by about twenty, both painted and engraved, some of which it masks completely." The comparison goes on. Her careful inventories of each scene have opened the possibility that not only are these two paintings purposeful compositions involving many animals, they could also be purposeful compositions of the *very same scene*. If similar scenes appear in other caves, she says, with stereotypical characters always in the same relation to one another, "we would be it seems in the pres-

ence of the most ancient stories told by mankind that have come down to us." And this exciting conclusion would be valid because it derived entirely from archaeology, not from ethnography. The scene in Lascaux and other caves of a man threatened by a bison could represent yet another ancient story.

She also perceived that certain animals were frequently paired and that the pairings were crucially important to the meaning of the art in a cave. In particular she noticed that bison always appeared near horses. She also saw that in deeper parts of the cave horses appeared near lions and that women were frequently associated with bison. She called for further meticulous study in Lascaux and in the other known caves that would inventory the common associations of animals such as that between bison and horses. But research mustn't stop there: "The study of the innumerable signs, some of which appear to be arrows while others have been interpreted as traps, is one theme of primary importance. The imaginary beings—monstrous or composite animals, hybrid humans with animal heads—constitute a smaller group but one even richer with suggestion."

Such inventories would require long, tedious hours of taxing work, but they were the only way to come to a deep understanding of the art in the caves that was based on valid science. Even her admittedly brief and inadequate survey of Lascaux had allowed us "to proceed from the notion of a magical Paleolithic art to that of an art more complex and richer, charged with a new meaning." Although she doesn't mention him in this instance, this is a direct attack on Breuil and the world where simple hunters hoped their paintings would work magic on their prey, as he and his contemporaries imagined. This audacious graduate student is saying it's time to leave the thinking and the methods of the past behind and march in the manner she prescribes into the future.

And, broadly speaking, that is exactly what happened. The goals and expectations are rather different, and the techniques,

particularly those using computer graphics, are more sophisticated, but detailed inventories and comparisons like those she first suggested remain at the heart of the study of Paleolithic art. Even her charts filled with quaint, symbolic arrows for each animal survive as easily manipulated computerized drawings.

Most important, she convinced the scholarly world that came after her that Paleolithic art was not "primitive." Nor did "primitive" people create it. Like Max Raphael, Laming-Emperaire thought the cave painters lived in a developed civilization with a long history and a vast mythology that grew from their probing and pondering the meaning of the world around them: "It is still too soon to determine the meaning of these themes [in the paintings and engravings]. They could be mythic and recount for example the origin and history of a certain human group in its rapport with the animal species; they could solidify a very ancient metaphysics and express a system of existence where each species, animal or human, has its role, and where the sexual division among beings plays a primordial role; they could be religious and bring supernatural beings onto the scene. They could be all of that at the same time—mythical, metaphysical, and religious—without the distinctions that we introduce among these different modes of thinking having great significance, and all applied at the dawn of human thought." This, then, became her legacy and her great challenge to archaeology. "It's worth whatever effort it takes," she wrote in the last line of *La signification,* "to unlock the secrets of this first Treatise on Nature."

We can't leave Laming-Emperaire without commenting on certain pages in *La signification* that can only be called peculiar. They contain her response to the thirty-one typed pages she received from Max Raphael. In them Raphael elaborated on his theory that the animals in the paintings represent the totems of various clans. Laming-Emperaire spends a whole chapter debunking totemism as an explanation, lumping it with hunting magic as a shallow theory

with little basis. Nevertheless, she can't help but be impressed by Raphael's observation that many caves have a predominance of one species. Some such caves contain pictures of animals of both sexes while others show one sex only. And, aggravatingly, totemism offers a handy explanation for this phenomenon.

According to the notes Raphael sent her, the dominant species in a cave is the totem of a clan. The caves with only one sex of a dominant species were places the clan used for initiation. In caves with both sexes of one species, or with several species, the paintings are the symbolic history of the clans. The superimpositions of one animal over another, which were previously assumed to be accidental, instead show the victory of one clan over another. The conquering clan, having assured their possession of the cave, purposely drew their animal totem over the existing paintings of the totem of the defeated clan. At Lascaux, for example, the superimposition of large bulls and cows on a series of smaller horses in the Hall of Bulls just inside the entrance to the cave signifies the victory of the wild cattle clan over the horse clan. The Falling Cow and the Great Black Cow, both of which obscure some of the surrounding horses, could memorialize the same victory. It was always a problem for the hunting-magic thesis that only 5 or 10 percent of the figures had wounds, spears, or arrows. But the theory of totems allows the wounds and weapons to be explained as representations of battles between the clans.

Laming-Emperaire immediately responds with "It is difficult to follow Raphael to these conclusions . . . The totemism thesis is adopted without real proof . . . The hypothesis of the historical meaning of the representations is similarly adopted without discussion." But, she continues, there is something else to consider. In Raphael's manuscript one can find "some pertinent criticisms against the classical interpretations of cave art." What about the fact, which "no one until now seems to have noticed," that many caves have a dominant species or sex? "There is here a fact in con-

tradiction to the theories of magic and demands to be explained. Why are there some caves with mammoths, some caves with horses, or some caves with bison? The question remains open." Raphael's explanation, of course, is that they were clan totems. But, she insists, "This interpretation is probably doubtful."

Why is she being so careful and so awkward? Well, in part it must be because it was 1962. Raphael had published his book in 1945, she had been in possession of his notes since 1951—more than ten years—and now the fundamental idea in her book of seeing the art in the caves as whole compositions is uncomfortably close to the fundamental idea in his. But her discomfort could also be because the totemism theory cannot be dismissed as easily or as certainly as hunting magic. Near the end of *La signification,* as Laming-Emperaire ponders possible directions for future research, she returns to Raphael's perceptions again, but this time without attribution: "Was there a cave of bulls and a cave of mammoths, a cave of does also, or a cave of mares? That is not impossible. In that case it will be necessary to study the rapport that connects the dominant animal with the other figures. It will also be necessary to note, and perhaps to interpret, the total absence of certain animals in certain caves. Why are there for example neither mammoths nor reindeer in Lascaux?"

Of course, totemism would explain these facts quite easily— easily, yes, but not scientifically, since Raphael offered no proof for the belief in totemism or the existence of clans. And the great purpose and achievement of *La signification* was to advance a method for discovering the meaning of cave art that was scientifically valid in the strictest terms. Laming-Emperaire was bothered, intrigued, and perplexed by Max Raphael's observations, but his explanations had no place in her system. In fact, his ideas were its antithesis. Raphael was, after all, an art historian. Neither her daughter nor her sister can recall ever hearing Annette mention his name.

CHAPTER 7

The Trident-Shaped Cave;
Pairing, Not Coupling

Annette Laming-Emperaire's thesis adviser, the person who loomed behind *La signification* from start to finish, was a man named André Leroi-Gourhan, who was only six years older than she was. He was indisputably a genius and his work made him as great a figure in prehistory as Breuil, who hated him. Leroi-Gourhan dominated archaeology and anthropology in postwar France in the same way that Jean-Paul Sartre dominated philosophy.

But because Laming-Emperaire was his student, and because the theories that Leroi-Gourhan developed in his voluminous publications are similar—some would say identical—to hers, there has always been an undercurrent of dark academic gossip that Leroi-Gourhan had swooped down upon his student's ideas and claimed them as his own.

This is the kind of seething, divisive feud that French academics find irresistible. The accusations have been repeated so often that Leroi-Gourhan's supposed theft has lately come to be considered an incontrovertible truth in certain circles. But to learn what really happened, it is necessary only to look at what the two people

involved, Leroi-Gourhan and Laming-Emperaire, said at the time. The decisive moment for Leroi-Gourhan occurred in 1957 when he entered a cave named Le Portel in the foothills of the Pyrenees just northwest of Foix. For ten years he had been thinking about writing a book on prehistoric art. He had visited various caves from time to time, but now, "having assimilated the available literature"—as he calmly described what would be years of work for most people—he had begun to work in earnest. His original intention was simply to write the text for a book of photographs that would illustrate the history of European prehistoric art, although he did intend for his text to break new ground. He thought that Breuil's work, for all its brilliance, had left a gap. The abbé in describing a cave would often construct a chronology of the works in that one cave, but he had failed to create a systematic synthesis that included all the known art. That's what Leroi-Gourhan originally intended to do.

At Lascaux and Altamira, as well as at other caves he visited, he had expected to see chaos, with works scattered here and there as successive generations of hunters had arrived, made their paintings, and left. He thought he was going to have to work out the dating of the successive waves. Instead he was impressed by the unity within the caves. His interest in dating problems faded quickly, replaced by a fascination with the cave as a whole.

That was his state of mind as he entered Le Portel. This cave is located near a mountain pass. It's shaped like a trident, with the present entry at the end of a long, narrow tunnel that forms the staff. Where the three prongs meet the staff, there is a large chamber where the prehistoric entrance was probably located, although it is now covered with fallen rock. The paintings in Le Portel are well preserved on the whole, but it was their arrangement that struck Leroi-Gourhan with special force. Again and again two different species were grouped together, in particular bison and

Annette Laming-Emperaire (standing) working with André Leroi-Gourhan (kneeling with camera) in 1975. The prevailing theory now is that they were feuding, but here they appear to work together congenially.

horses. At the original entrance there was one bison and one horse. There was one bison and one horse in the large room at the base of the three prongs. One of the prongs contained eight bison and one horse; a second prong contained practically the mirror image of this distribution—nine horses and one bison. Breuil had written a detailed study of Le Portel, and Leroi-Gourhan made his own exact diagram while he was in the cave. As he studied the two analyses, his impressions began to crystallize that there was some kind of order reflected in the arrangement of the figures.

At the very time when Leroi-Gourhan was visiting and puzzling over Le Portel, he was also, in his capacity as professor of

ethnology at the Sorbonne, directing Annette Laming-Emperaire as she wrote *La signification*. And, as we have seen, her whole point was that the arrangement of figures in a cave is the key to the meaning of prehistoric art. Laming-Emperaire defended her thesis in 1957, the same year that Leroi-Gourhan visited Le Portel. As the director of her thesis, he would have been aware of every detail of her ideas. Only months later, in 1958, Leroi-Gourhan published three papers in a single issue of the *Bulletin de la Société Préhistorique Française*. They were titled "The Function of Signs in the Paleolithic Sanctuaries," "The Symbolism of Large Signs in Paleolithic Rock Art," and "The Distribution and Grouping of Animals in Paleolithic Rock Art." They contained the essential elements of his theories, which were very close to the ideas Laming-Emperaire had just expressed while defending her thesis. Her *La signification* appeared in 1962. Leroi-Gourhan's *Préhistoire de l'art occidental*, which contained the full elaboration of his thinking, followed in 1965. In each case, his work followed hers, and the substance of the pernicious gossip is the claim that Leroi-Gourhan never acknowledged this indisputable fact.

But he did. Here's just one example. In *Treasures of Prehistoric Art* he begins a chapter titled "Groupings of Animal Species" by emphasizing his debt to her: "The groupings of animal figures of different species is certainly one of the most characteristic features of Paleolithic art—a feature which was entirely overlooked until Mme. Laming-Emperaire published her work." There could hardly be a more direct acknowledgment of her work than that. (There is a more detailed discussion of their relation in the notes.)

"All theory," André Leroi-Gourhan said, "is a piece of a self-portrait." That statement is more revealing than it might appear, since Leroi-Gourhan was opposed to theories all his life. Perhaps

his opposition came in part from his reluctance, famous among his adoring students, to reveal himself by exposing even a small piece of a self-portrait. One student remembers, "[He] was extremely reserved, voluntarily silent. And, when he spoke, it was almost always about things without great importance rather than those things he truly held in his heart." Frequently he would talk about oddities of zoology or botany, subjects he particularly liked. It was extremely entertaining, but it was a verbal smoke screen as well.

He spoke slowly and softly and was normally so shy that he avoided his colleagues. Nevertheless, he was a charismatic teacher who inspired devotion in his students. "Listening to him," one recalled, "you were captivated in an exciting intellectual adventure." A proud dirt archaeologist, he spent several months each year in the field. In the morning he proposed new ideas and hypotheses about the work and what they were finding. Anyone could comment or disagree. In the evening, students could sit with him at dinner, a kind of egalitarianism that was rare in French academic life at the time. Once students discovered him, they stayed with him. In 1964 a quarry operation uncovered an open-air Stone Age site, subsequently called Pincevent, not far from Paris. The site would quickly have been destroyed had not Leroi-Gourhan, overcoming his shyness for once, rallied his students. More than fifty dropped what they were doing to join him at Pincevent to excavate the site. This created such a sensation that after four months André Malraux, then the minister of culture, bought the land for the state.

Both Leroi-Gourhan's background and his personality made him a maverick from birth, and as his life progressed he apparently decided to remain a maverick. His decision hurt his career, although that was difficult to perceive in France, where he had all the prestigious positions and honors anyone could dream of. His important works were widely translated into a variety of European

languages as well as Japanese. But except for *Treasures of Prehistoric Art,* very little was translated into English, which was increasingly becoming the common tongue of archaeology and anthropology. Consequently he is almost unknown even now in the English-speaking world, and his influence on North American, English, and Australian archaeology has been negligible until very recently.

He was born in 1911 in Paris and lost both his parents during World War I. His maternal grandparents then raised him and his younger brother. Very early on he adopted their name, Gourhan, as part of his own. He adored excursions to the museum of natural history with his grandmother, but he was indifferent about school, which he left at fourteen when his grandfather decided it was time for him to make his own living. He sold women's hats and hose and then worked in a bookstore. He read on his own, attended lectures in anthropology at the Sorbonne, and somehow attracted the attention of a kindly librarian, who took him under her wing. She directed him toward the books he should be reading, especially *Les hommes fossiles (The Fossil Men)*, by Marcellin Boule, a hugely influential book in its day by the man who was then the leading archaeologist in France. In 1928, when Leroi-Gourhan was only seventeen, this librarian, whose name is unfortunately lost, also introduced him to the director of the School of Oriental Languages. The precocious teenager became the director's secretary and began to take courses in the school. By the time he was twenty he had earned a degree in Russian. Three years later he received a second degree in Chinese and began working on a doctoral thesis on Siberian mythology.

In 1936, when he was twenty-five, he married Arlette Royer, who would become a noted archaeologist herself. They left immediately for Japan, where they spent three years, studying in Kyoto some of the time and living among remote native tribes during the rest. He also traveled across Asia, especially in China.

When the war forced the couple to return to France, Leroi-Gourhan retreated to the lower Pyrenees far to the south, where, dispirited, he considered buying a farm and raising horses. The farm became a forgotten dream, but he never lost his affinity for horses. He was short and slight and, although he was generally retiring, he had an intensity that was noticeable even at a distance. His hair was black and extremely thick and he was already wearing it in the crowning, swept-back pompadour that he would retain for the rest of his life. As the war progressed he became involved in the Resistance. He played down his exploits in later life, treating his encounters with German troops as nothing but comic anecdotes. But his brains, instinctive reticence, and unobtrusive demeanor must have been great advantages to the Resistance. His work was dangerous enough and valuable enough that after the war he was awarded both the Croix de Guerre and the ribbon of the Legion of Honor.

His time in Asia provided fodder for his studied oddballness. He played a variety of exotic musical instruments while he sang in Russian, Chinese, or Japanese. He wore strange-looking hats from remote villages across the Orient. They contrasted with the checked shirts and jodhpurs he favored. At a dig, he would come roaring into camp in the morning on a horse galloping at full speed while he sat in the saddle playing bagpipes. For relaxation, he repaired spinets.

His publications are too numerous and varied and his career too long—he died at seventy-five in 1986—to recount in detail. Discoveries and technological innovations since his death have made some of his work obsolete. Some of the rest is, at best, out of fashion. For instance, he believed that evolution implied progressive improvement and over the ages led up a scale toward humans, a belief that is a relic of the confident assumptions of the nineteenth century. Nevertheless, in addition to his work on the painted caves,

he left a significant legacy. Two of his ideas in particular are worth mentioning briefly. One is the *chaîne opératoire*. This phrase, which sounds melodious in French, becomes the grim "operational sequence" when forced into English. In either language the idea behind the phrase is disarmingly simple but has become a powerful analytic tool. He conceived of the *chaîne opératoire* in the 1950s as he watched experiments by prehistorians who were trying to re-create the methods by which Stone Age people had made their various tools from raw pieces of flint. This operation, in which progressively smaller and finer pieces are broken away from a large rock, was first called a "reduction sequence." But the idea of manufacture by reduction, which usefully explained the production of stone tools, didn't apply at all to other types of manufacturing where, as in basketry, each step in manufacturing involved adding something.

Leroi-Gourhan realized that neither reduction nor addition was the important point. Each was a discrete step in a process that began with raw materials and human intelligence and proceeded by short but distinct steps to the end results. Re-creating the *chaîne opératoire*, which in practice means entering each step into an analytical grid, is a tedious process that, like the tedious process of creating the inventory of paintings in a cave, can produce great discoveries and insights.

The laws of nature impose the earliest steps in the sequence. An arrowhead can't weigh ten pounds, so a piece of rock nearer to the appropriate size needs to be chipped away from a larger one. This step, dictated by natural laws, is the beginning of every stone arrowhead. But as the operations continue, each one becomes less determined by universal natural laws and more determined by the choices of the fabricator. These choices are determined at first by culture and finally by personal preference. That is why arrowheads from different tribes can look completely different, even though

they were manufactured to perform the same function, and why arrowheads made by different individuals within the same tribe can look different in particular details.

Following the chain from the raw material outward shows exactly the moment when cultural differences begin to appear. Following it from the outer ends back inward, especially together with a vast number of charts from a variety of cultures, can show what tools and other manufactured objects that appear to be quite different really have in common. The *chaîne opératoire* has been a fundamental idea in French anthropology and archaeology since the 1960s, and it finally spread into Great Britain and the United States in the 1990s.

Leroi-Gourhan made another permanent contribution by rotating the axis of an archaeological dig by ninety degrees. He had realized for many years that this rotation was necessary, but he couldn't carry it out until his dig at Pincevent, the open-air site near Paris where more than fifty of his students dropped their own work and rushed to join him.

Breuil and his contemporaries dug straight down in relatively small but sometimes deep pits. They recorded what they found in every layer. Leroi-Gourhan thought such digs were almost worthless. Instead he thought the digging should proceed horizontally in a series of thin slices across the whole area. He explained his purpose by an analogy with a cake that had several layers of icing and "Happy Birthday!" written in cream and buried somewhere among the layers. "If you cut through vertically," he said, "as was still widely done at this time, you can read nothing at all. All you see are the little bits of cream on the slice of cake, nothing more. You've got to cut horizontally if you want to see the inscription. Prehistoric terrain is exactly the same. If you want to find what men have had to say, you must proceed layer by layer."

Just as with the *chaîne opératoire*, this simple idea produced

profound results. It exposed all the features of a Paleolithic site—fireplaces, postholes for dwellings, discarded bones, broken tools. Those features aren't there by chance but rather by the innumerable choices made by the inhabitants. Thus, as Leroi-Gourhan said, "the very fact of casting a used object off has meaning."

His work in Pincevent became the model in Europe for excavating an open-air site. The archaeological team labored on wooden planks supported by cement blocks that made a grid about a foot above the archaeological level. Sometimes a single square meter required a full week's work by three or four hardy students who lay on their bellies on the planks for hours on end as they slowly picked dirt away from the remains.

The excavation began in 1964, but it was twenty years before Leroi-Gourhan published a complete account of the discoveries at Pincevent. He was careful to distinguish between the archaeological facts and the conclusions he drew from them, but his account becomes as clear a picture as we have of daily life among the people who made the paintings in the caves.

Several dozen families, perhaps a hundred people or so, would come to Pincevent year after year as part of a nomadic cycle 11,000 to 12,000 years ago, in the final era before the practice of painting in caves disappeared. They arrived in late July or early August and remained until the beginning of winter, living in tents of various designs. Some tents were circular like tepees. Each tepee had a round fireplace in the doorway and faced northeast so that the back of the tepee was to the prevailing winds. A few tents had three openings and three fireplaces. The two openings on the ends faced east while the single opening in the middle faced west. This arrangement made it easier to create a large common area inside the tent. People ate around the fireplaces and tossed the bones outside the tent. The bones formed a fan-shaped scatter pattern beginning at the entrance and remained there on the ground for

eons until the young archaeologists working with Leroi-Gourhan found them.

Nearly all the bones came from reindeer, practically 100 percent. The remaining few belonged to hares, horses, mammoths, and wolves. There are no bones at all from bison, wild cattle, stag, roe deer, or antelope, even though their remains are found in every other Paleolithic dig. Why didn't the people at Pincevent eat those animals? That remains a puzzling mystery.

In addition to reindeer and the other animals, the hunters ate eggs (eggshells turned up inside one habitation), birds, fish, and a variety of leaves, roots, grains, fruit, bulbs, and mushrooms. They probably also ate insects. They dragged whole reindeer back to camp, where the reindeer were butchered. Horses, though, they butchered in the field and brought only the meat to camp. Although there was an abundance of game, the people at Pincevent broke *every* bone open to get at the marrow inside. Some of the marrow they probably ate almost raw, as one might do today with a roasted leg of lamb. They probably used other broken bones to enrich bullion they made from water heated by stones taken from the fireplace.

The fireplaces consisted of a circular or oval basin dug into the ground and bordered with flat rocks. The heat caused pieces of the rocks to break off. The larger pieces were then used to line the basin, while the smaller ones were thrown aside. The people at Pincevent used shoulder blades from reindeer to shovel ashes.

Some of the fireplaces contained only remnants of charcoal produced by burning wood. There were no bones or other debris from cooking or eating, so the fireplaces must have belonged either to a smokehouse or—why not?—a steam bath. Native tribes in cold climates from Finland to Canada pour water on hot rocks in enclosed places to make steam. That's an analogy from ethnology, but the universality of the practice in northern regions makes it convincing.

The hunters also made fireplaces in the open, away from any dwelling. The fireplaces consisted of a circle of rocks with no basin at all. One of these flat fireplaces was quite large. Presumably it was used for heating flint, bone, wood, or bark so the materials could be worked more easily. Another, smaller, flat fireplace was stained red with ochre. This suggests it was the scene of some ritual, or, as Leroi-Gourhan wrote more precisely, "One of these flat fireplaces saw acts unfold that resulted in the spreading of ochre on the ground." But for all the clues about Paleolithic life the fireplaces provide, we still don't know how the hunters made fire.

The hunters arrived at Pincevent carrying an array of finished tools made from flint foreign to the immediate region. That means the hunters must have stopped somewhere to replenish their tools immediately before arriving at Pincevent as part of their yearly migration. They also made tools at Pincevent, however, using local flint. They made knives, blades that they fitted into batons of wood or antler to make a mace, graters, scrapers, awls with a point fine enough to pierce a pearl, and a variety of delicate needles. The needles, which are identical in form to needles today, imply that they could fashion elaborate clothes, which they would have needed, living in a cold climate. But, regrettably, everything made of fur or leather disintegrated long ago. They worked sitting around the fireplace and tossed their scraps, their mistakes, and their broken tools out among the bones.

Here and there the researchers found various seashells that had been pierced for stringing on necklaces or on clothes. The shells were fossils that the hunters found in the course of their migrations or that they traded for with other communities. Across 20,000 years—from 30,000 to 10,000 years ago—these shells fascinated prehistoric people. Their value as decoration, Leroi-Gourhan thought, "must have been doubled by a symbolic value." At Pincevent the researchers often found them with fragments of fool's gold, other fossils, and strange spheres of flint carved into

the shapes of apples and cherries. They have no apparent meaning, but they must have been simple curiosities, stakes or markers in games or gambling, or instruments of magic.

Finally, there is a residue of ochre around the periphery of the domestic fireplaces. The hunters used this mineral—iron oxide— in a variety of ways, including, of course, to make red pigment for painting in caves. The color red can stand symbolically for blood, fire, or, in the largest sense, for life itself. Some have proposed that the hunters spread ochre on the floors of their dwellings in order to sanctify them. At Pincevent, though, the ochre is thickest in places where the remains from working flint are also the densest. The ochre deposit built up progressively over time as the tool working proceeded. That means that, although they may have used ochre to sanctify the ground, they also used it regularly for routine tasks such as tinting the shaft of a spear or coating their skin. It might also have been a preservative.

Although the remains at Pincevent were waiting to give this picture of prehistoric life, none of the results that are so evocative—the scatter of bones and flint, the arrangement of fireplaces, the spread of ochre—would have yielded their secrets if Leroi-Gourhan hadn't tipped the axis of excavation. Digging straight down would have found some artifacts but severed them from everything nearby, everything that could give them meaning.

When he went into the painted caves, Leroi-Gourhan made extensive drawings and notes that he then transferred to long index cards with tabs and holes punched at strategic places. He created a punch card index for each cave, section by section. This permitted him, in those days before computers, to run a metal needle through a stack of cards and extract, say, every example of a horse and bison painted together or a female figure found next to bison, and

so on. He could also find where the paintings were located—that is, examples of horses at the entrance of caves or in their depths. His cards still exist in various archives and private collections. They are ingenious, but even though they date only to the 1950s, they have an almost Paleolithic air. In fact, if a Stone Age artist somehow obtained long index cards and wanted to make his own study of the caves—an admittedly unlikely supposition—he might have devised a similar system. We are often less removed from those times than we imagine.

Today, no one would use a stack of punched cards for work that a computer can do more quickly and accurately. But the method Leroi-Gourhan originated, drawing on the work of Max Raphael and Annette Laming-Emperaire before him, is fundamental to the way archaeologists study caves today. The field is dominated by elaborate statistical studies, by stroke-by-stroke re-creations of the way the artists painted, and by considerations of the position of the paintings relative to one another and to their locations in the caves. That is his legacy, and it is more important, more vibrant, and more illuminating even than Breuil's. Nothing can replace Breuil's beautiful painted copies. Nothing can replace his thousands of tracings and sketches. And nothing can replace the example he set for dedication and sheer hard work. But no one now thinks about the caves in the way Breuil did. A modern scientist explores a cave thinking like Leroi-Gourhan.

Statistics were fundamental to Leroi-Gourhan's work. In preparing to write *Treasures of Prehistoric Art*, he visited 66 of the 110 sites that were known at the time, where he recorded 2,188 different animal figures. He counted these by species—610 horses, 510 bison, 205 mammoths, and so on. Then he counted them according to where the figures occurred in the caves and found that the results were, as he put it, "extremely clear cut." He found that 91 percent of the bison, 92 percent of the oxen, 86 percent of the

horses, and 58 percent of the mammoths occur in the central por-
tions of the caves. Ibex and stags were what he called "framing
animals." Ibex tended to be on the periphery of the central
compositions, while stags appeared near the entrance and at the
back of caves. But, oddly, 12 percent of the horses occur at the
entrance or end of a cave instead of stags. Leroi-Gourhan would
create little games of suspense as he approached the remotest part
of a cave. "Will there," he asked himself, "be a horse?"

Then, following the lead of Laming-Emperaire, he made a sta-
tistical tabulation of all the possible combinations of animals and
found that the paintings fell into two groups, each one consisting
of a complicated network of relations among animals, human fig-
ures, and signs. And the key to understanding cave art was to see
how an animal from one group was paired with an animal from the
other. The classic and most frequent pairing was the one Laming-
Emperaire first noticed: the bison associated with the horse. (He
referred to this as "pairing" rather than "coupling" because "there
are no scenes of copulation in Paleolithic art." He repeats this
assertion several times in *Treasures of Prehistoric Art*. His delicacy
here might be in reaction to Breuil, who not only didn't like him
but also disagreed with his conclusions and accused him of having
a "sexomaniac obsession." About ten years later the archaeologist
Jean Clottes showed Leroi-Gourhan the engraving on a flat stone
of a Paleolithic couple having sex. Leroi-Gourhan looked at the
engraving for a long moment and said, "Well, I have written that
there are no sexual scenes in Paleolithic art. Now there is at least
that one." "He was like that," Clottes told me once. "Evidence was
evidence and he would accept it.")

In addition to the bison-horse pairing, Leroi-Gourhan found
that female figures and vulvas were most often paired with bison,
while male figures were seen more often near horses. These associ-
ations made him suspect that the bison-horse pairing also repre-

sented a female-male pairing. Then he turned to the study of the signs found in the paintings. Again statistical analysis lay at the heart of his method. He found that, just as with the paintings of animals, the signs divided into two sets as well. One set consisted of "single dots, rows of dots, short strokes, and barbed signs; the other of ovals, triangles, rectangles, and brace-shaped signs. The first set occurs in entrances and the remote areas at the end of caves and the second among the paintings in the central parts of the cave." Thus, he thought, these two groups correspond to the same system of distribution as the animal figures. And here begins the "sexomaniac obsession." He observed that the ovals, triangles, rectangles, and similar signs were basically abstract variations of vulvas, while the dots, strokes, and barbs were abstract male signs. Just male signs are found at the entrance and depths of caves, but, just as with horses, male signs also occur in the central areas along with bison and female signs.

What he had discovered was a repeated pattern in each cave whereby male signs and horses played one role and female signs and bison played another. The discovery was both thrilling and frustrating to him: "I found myself in the end confronted with a system of unexpected complexity—the skeleton of a religious thought, as impervious to my understanding, moreover, as a comparative study of the iconography of sixty cathedrals would be to an archaeologist from Mars." He was limited to "the reliable but utterly banal statement that there existed a religious system based on the opposition and complementarity of male and female values, expressed symbolically by animal figures and by more or less abstract signs . . . Although crowded with images this framework is quite simple; it leaves us completely in the dark concerning what we should like to know about the rites, and, let us say, about an underlying metaphysics."

Leroi-Gourhan's *Treasures of Prehistoric Art* is a monument,

but like many monuments it is not forgotten exactly, but ignored. The reason, unfortunately, is his connecting different signs and animals with a male or female principle. Breuil wasn't the only one who found this identification unconvincing. Others, most notably the English archaeologists Peter J. Ucko and Andrée Rosenfeld, attacked him almost immediately. Leroi-Gourhan had his faithful acolytes, many of whom still carry the flame today, but the evidence for his assertions became less and less convincing as new caves were discovered or as other researchers reexamined the known caves and found that the animals weren't always just where Leroi-Gourhan had claimed they were. The vaunted system of punch cards had let him down. Finally, by 1972 even Laming-Emperaire had joined the assault against him. This was a formidable moment, since she herself had proposed a sexual association to the bison-horse pairing. But now she presented a paper at a major symposium in Spain wherein she insisted that his theory of sexual duality wasn't supported by the evidence in the caves because the association of supposedly male and female animals wasn't consistent. Instead, recalling Max Raphael, she said the paintings represented "the image of a system of alliances among social groups." She presented this as "not so much a theory as a direction of research." It is not a direction that has been much followed, but the attack on Leroi-Gourhan had its effect. Even he, toward the end of his life, gave up on the idea that there was a sexual duality to the paintings. His last major work on cave paintings was *The Dawn of European Art,* published in Italian in 1981 and in English in 1982. In it he still analyzes pairings and groupings but without mentioning any sexual association.

His determination to be unique had done him in again.

Three Brothers in a Boat;
The Sorcerer

R obert Bégouën handed me a pair of blue coveralls. "Wear your jacket under these," he told me. "The cave is cold." He put on a sweater and stepped into coveralls identical to the ones he had given me. I struggled into mine. Then we sat on the back of his peculiar little jury-rigged truck and pulled on tall rubber boots and fastened pads around our knees. Each of us also had a carbide lamp that strapped around the waist. It consisted of a reflector that held a tiny burner tip and a black box about the size and weight of an average book. The reflector, connected by a tube to the black box, could be removed and held in the hand. That finished our preparations. We were going into Les Trois-Frères.

In his masterwork *Four Hundred Centuries of Cave Art*, the abbé Breuil wrote long chapters about the caves he called "The Six Giants." They were Altamira, Lascaux, Font-de-Gaume, Les Combarelles, Niaux (the cave with the inscription reading "What can they mean?"), and Les Trois-Frères. Caves have been discovered since then, but only two—Chauvet and Cosquer, both discovered in the 1990s—would merit being included with Breuil's other six giants. The public can visit Font-de-Gaume, Les Com-

Robert Bégouën puts on rubber boots before entering Les Trois-Frères. His family tree contains four successive generations of important prehistorians.

barelles, Niaux, and replicas of Altamira and Lascaux. They are all owned by governmental bodies, but the descendants of Count Henri Bégouën own Les Trois-Frères. It is on their estate west of Foix in the Ariège not far from the border with Spain. The art in the cave is vulnerable, the passage is sometimes difficult, and parts of the cave system flood regularly. Consequently, the Bégouën family has never opened the cave to the public and will permit only limited visits. From 1912, when the cave was discovered, until 1979, only 1,055 persons had been in the cave, fewer than 16 a year.

The entrance to the cave is a short way inside a forest growing at the edge of a pasture. Nothing announces the cave is here or marks the way through the trees. Robert stopped by a mound in the side of a hill and unlocked a door of iron bars. Just inside that door was another door of solid metal that he unlocked as well. This was not the entrance during Paleolithic times. It is possible that there were several openings then that have since been covered when parts of the hillside collapsed. The cave twists and turns, but the total length of its galleries is about a half mile. Paintings and engravings on the walls, as well as flints, fireplaces, and other traces of human presence, show that the ancient hunters explored every foot of the cave.

I bent over and went through the door into the cave. The going was difficult immediately. The floor, which alternated between rock and clay, was wet. That made the rock slick and treacherous, while the clay tended to ooze around our rubber boots and suck at them. Sometimes the passage narrowed to a tunnel and we had to crawl for some distance, making me glad to have the knee pads. Here and there we descended narrow metal ladders that dated to the time between the two world wars when Breuil studied the cave. The ladders were wet and I wasn't confident of my rubber boots on the rungs. There were some long declines where we sat down and scooted to the bottom. Some of these were quite steep and there were holes dug out so you could use your heels to brace against a precipitous slide. And it was cold. Robert had been right to tell me to wear a jacket. Looming, shadowy shapes surrounded us, and the beams from our carbide lamps faded away in the darkness.

Robert is a prehistorian, and an important one, known especially for his work on Les Trois-Frères and other caves, designated collectively as the Volp caves, that are part of the same underground system. Robert's father, Louis Bégouën, was also a prehis-

A historic visit in 1912 through the Volp caves. From left to right: Count Bégouën, his sons Jacques and Max, the abbé Breuil (with cane), Louis Bégouën, and Émile Cartailhac.

torian. Louis's younger brother, Jacques, was a noted folklorist, and his older brother, Max, wrote a novel set in prehistoric times titled *Les bisons d'argile*, which appeared in English as *Bison of Clay.*

Max, Louis, and Jacques are the three brothers memorialized in the name Les Trois-Frères. They are the sons of Count Henri, who in a long and varied life also became a prehistorian and was a friend of Émile Cartailhac's. His paper from 1929, "The Magic Origin of Prehistoric Art," is still cited frequently. From Henri to Louis to Robert and now to Eric, who is Robert's son, makes four successive generations in the Bégouën family devoted to the caves.

Count Henri doted on his three sons. He was a charismatic, distinguished-looking man with a round head like a bowling ball perched on a round chest. He had an immense, flowing walrus mustache. The river Volp ran through his property, diving underground at one point and emerging a mile and a quarter later. Over the millennia it had hollowed out an intricate system of caves and underground lakes. Count Henri had once found a carved reindeer antler near the entrance.

In July 1912 the three boys, who were then in their late teens, got the idea of building a boat of boards and boxes, kept afloat by empty gas cans, in order to paddle deep into the cave. Along with a friend their age, the boys paddled about three-quarters of a mile before they found a gravel bed where they could beach their boat. They returned to this spot several times in the next few months. In one direction they found a lake with fish and an enormous eel and a way out of the cave. In the other direction there was a chimney that they could climb that led into a straight corridor. There were engravings here of two fantastic beasts, one above the other, with grotesque heads and ugly, twisted snouts. Breuil later declared that they were the guardians of an important room in the cave.

When the three brothers and their friend arrived at these engravings, the corridor seemed to be a dead end. But during a visit in October 1912, Max deduced that a curtain of stalagmites had sealed off a narrow passage. He broke through it and found himself in a large corridor. This time he was with his brother Louis and their friend. The three boys pushed on as the passage widened and then narrowed so much that they were forced to crawl. When it widened again, they found themselves in large halls with glorious stalagmites.

Worried that their lamps would falter, they exited the cave. That afternoon, all three brothers returned with their father. This time they carried plenty of fuel for their lamps. As they made their

way, they saw bones of cave bears. The hollows the bears had made for hibernation still had the imprints from their paws and coats. And there were signs that ancient hunters had been here, too. The Bégouëns saw footprints, impressions from a knee, and, on a wall, finger tracings. There were even a few objects—a blade or two, a pierced tooth, and a bear skull left where someone had knelt down to pull out the long canine teeth.

But none of that prepared them for what they discovered in a low room at the end of the gallery. Here, three-quarters of a mile deep into the cave, they saw two bison about two feet long beautifully modeled in clay. They were cracked here and there but otherwise in perfect condition. One was male. His eye was extended. The other was female and her eye was indented. Her tail had fallen off, but the parts still lay there on the floor. Nothing like them had ever been seen before.

Max, Louis, Jacques, and their father, Count Henri, searched the room to see if there were more, but they were disappointed. In one corner they did find a sagging heap of clay, probably all that was left of some other statues after seeping water had dissolved them. They also found rolls of clay that looked like phalli, but they could have been nothing more than simple rolls of clay. Nearby, in a damp bed of clay, they saw a random pattern of fifty heel prints so small they must have been made by an adolescent.

Immediately afterward, Count Henri telegraphed a single sentence to his friend Cartailhac: "The Magdalenians also modeled clay." Cartailhac answered that he was on his way. He and Breuil arrived four days later. Although part of the Volp system of caves, the cave with the bison and the heel prints is separate from the one known as Les Trois-Frères. It is called Tuc d'Audoubert. According to the best current dating, the art and artifacts in the Volp caves are between 14,500 and 13,500 years old.

· · ·

Louis Bégouën and his two older sons examine the clay bison in 1950. Robert Bégouën, who showed the author through Les Trois-Frères, is the young lad on the left.

As Robert and I continued through Les Trois-Frères, squeezing through passages, ducking low here and there, creeping along a ridge with a wall on one side and a sharp drop into darkness on the other, trying not to slip on the slick rocks or stumble over an outcropping jutting from the irregular floor, I marveled over how intrepid the cave artists must have been.

First of all, they didn't get lost. If they had, skeletons of the unfortunate would still litter the cave floors. Evidently they could keep their bearings even though they didn't enter the caves often.

There are painted signs that might mark paths or crossroads or the entrance to a chamber, but they usually appear suddenly deep in a cave, while no signs mark the confusing path from the entrance to the first paintings in the cave. Yet they knew their way. If they left markers, bears' teeth or pieces of antler or piles of rock, they must have picked them up again as they left.

Their only light came from torches or small lamps burning animal fat. The hunters had to carry enough fuel to last their trip in, the time they spent painting and performing ceremonies, and their trip out. A sudden draft could easily blow out such a lamp. Dropping it would also put it out. When there were several people in the party, such accidents wouldn't have been catastrophic, since the lamp could be relit from a neighbor's flame, but the incident would have been unsettling nonetheless. Did any prehistoric person ever enter the caves alone or, having entered with a group, leave the others to go on to some special chamber alone? It's possible; there are engravings in passages so narrow only one person at a time could have squeezed in. If the lamp went out then, it would have been terrifying.

Rationally, we know that caves do not hold subterranean monsters that lurk in passageways or rise from the center of the earth so they can swallow us up. Still, there are noises, echoes, plops and splashes, and the sound of air going by that all threaten our rationality.

The first painting Robert showed me was a left hand painted in outline in red. The painter put his palm against the wall of the cave and blew red pigment around it. Next to it is a black bison, and next to that, another hand. In all there are a total of five hands outlined in red, some red dots and lines, and several groups of red and black dots and signs. The five hands here are the only ones in the cave.

This gallery narrows to a corridor that ends at a large room. A

stalactite has grown in the center of the passage. Without Robert's guidance, I would have slipped around it and gone on without noticing the small room that the formation both creates and partially conceals. Breuil named the room the Chapel of the Lioness because of the principal engraving on its walls. He thought this lioness was the guardian of the important paintings located deeper in the cave. But a visitor coming into the cave for the first time would pass by the narrow entrance without noticing the Chapel or the lioness on its walls. So, contrary to Breuil, the hidden animal couldn't have been much of a guard.

Robert led me through a narrow opening in a shielding curtain of stalactites and into the chapel. Several years ago, right at this entrance, he found a flat rock only two and a half inches across with an engraved bison. The natural shape of the stone forms the bison's back and there is even an edge that juts out to suggest a tail. The head and horns are skillfully carved. The eyes and muzzle are especially vivid. There are three or four upside-down Vs inside the body, signs that are assumed to indicate wounds.

It's possible, of course, that the carved stone was dropped accidentally, but Robert is the coauthor of a paper that argues that it must have been placed there on purpose. Similar pebbles litter the floor nearby, so the artist presumably found one in the shape he wanted and did the engraving on the spot. Enlène, a cave like Tuc d'Audoubert that neighbors Les Trois-Frères and may have been attached to it in Paleolithic times, contained more than a thousand engraved rocks and other small pieces of art. But the carved bison is one of only two small engravings found in Les Trois-Frères. That fact, along with ten peculiar objects found inside the Chapel, imply that the bison carving was left intentionally where Robert found it so many millennia later.

The Chapel turned out to be surprisingly open. It has a roughly oval shape and, at fifteen feet by ten feet, is about the size

of a modest office. The ceiling is inconsistent but often shoots up to twenty or twenty-five feet high. The walls of the enclosure glowed warmly in the light from our carbide lamps and diffused it. Elsewhere in the cave, light just disappears into the blackness or illuminates a small spot when directed at a wall. But here in this small enclosure the light seemed to fight the surrounding darkness to a draw. The wavering light from a few Paleolithic lamps would have been enough to produce a similar effect, except that their light would have looked even warmer. There are the blackened remains of a fireplace against one wall. It proves that the light in the Chapel was important to the cave artists, too. They built rather large fires there and let them burn. (Elsewhere in the cave the three Bégouën brothers found another hearth on their first visit. This discovery was very exciting because they thought it dated to the Stone Age. But when Breuil arrived and they showed it to him, he noticed that one of the burnt pieces of wood looked worked. He picked it up and found an iron nail sticking out of it. He thought Roman soldiers must have come in through an entrance that's now blocked.)

We walked over to the lion and Robert shone his light directly at it. Usually, it's best to illuminate cave art with oblique light. That emphasizes ridges and valleys, however faint. But here the surface of the wall is irregular, so the engraving had to go deep. Direct light best reveals the difference between the white in the depths of the grooves and the yellowish surface of the wall. That contrast, and not a difference in relief, brings up the image. The lion, drawn full figure from the side with its head to the right, is engraved on a solid area in a wall of stalactites. Breuil called it a lioness because the beast has no mane, but paintings and engravings in other caves show lions that are clearly male—either their penis or testicles are showing—but have no mane. Since that proves that cave lions didn't have manes, the "lioness" in the

Chapel could be of either sex. There are marks here and there on its body and several barbed lines on its side that could be spears or even arrows.

Its body has a normal appearance, but both its tail and its head are peculiar. The lion's back curves down to the top of the tail, which then extends almost straight out. But a human arm, bent at the elbow, appears near the lion's haunches. The hand is just under the tail and seems to be grabbing for it. This arm is so improbable that Breuil evidently couldn't believe it. His sketch of the lion shows two tails, as if the artist had drawn one and then reconsidered. But it's definitely an arm.

And the lion has two heads. One, attached in a normal position, is turned to face the viewer straight on. It has peculiar, deep eyes and loopy ears that shoot out at odd angles. A second head in three-quarter profile floats unattached just in front of the first. Was this an attempt to show movement? A mistake? Or simply the beginning of a second lion? Inside the body of the lion there are finer lines that may be the head of a horse and a bison that perhaps makes some connection with the bison on the rock at the entrance. A lightly engraved lion cub is to the left of the larger lion—one reason for thinking it may be a lioness after all—and below the rear paws there is a peculiar, elongated bird with an immense beak. And there is another lion's head underneath the lion's chest. It has two round eyes inside a round head. It seemed to stare at me happily out of the wall.

I was still absorbed by the lion when Robert said, "Look here," as he directed his light into a small fissure in the opposite wall. I peered in and there, almost as if stage-lit in a nook in a dollhouse, was a seashell. It was crescent-shaped, fluted, and about the size of the fingers on a hand. Long ago someone had carefully placed it in the crevice and propped it against the side of the fissure.

Les Trois-Frères is about a hundred miles from the Mediter-

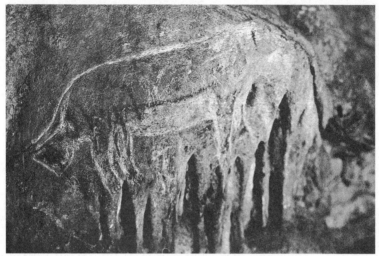

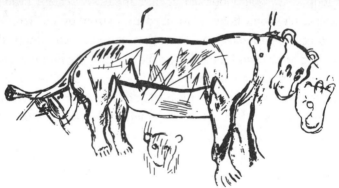

A photograph of the lion in Les Trois-Frères, and Breuil's faulty tracing of the image. Breuil evidently just couldn't believe that there was a human arm, bent at the elbow, below the lion's tail, so he drew it as a second tail.

ranean and two hundred miles from the Atlantic. "You mean that shell got here somehow all the way from the sea?" I said.

"No, it was a fossil already," he said. "They found it and brought it down here." Robert is a thin man with close-cropped

black hair and an easy, natural elegance. It's interesting just to watch him move. He smiled, raised his eyebrows, and shrugged. "Who knows why," he said.

I looked in again at the shell. Unexpectedly, I began shaking slightly and my pulse raced. The strangeness of the cave, the slick rocks and the sucking clay floor, the narrow ladders, the darkness, the disorientation of not knowing where I was, the glowing light in the Chapel, the strange two-headed lion with the human arm under its tail—all that had touched my nerves. But none of it had reached as far into me as that shell did. I didn't know what it meant. And the more I stared at the shell, the more it was simply itself. One day or night fourteen thousand years ago, a man or woman or boy or girl had brought a rare and precious object into this cave and propped it on its edge in a fissure expecting it would remain there for all eternity—and it has.

I turned away from the shell. The hunters had left nine other artifacts in the cracks of the Chapel walls. There were five flint tools, two bone splinters, a bear's molar balanced on its roots, and a burin—that is, a stone chisel. It was set in one of the spaces between the hanging secretions just below the lion's paws, as if the artist, having finished his work, had purposely placed his tool on display.

I followed Robert out of the Chapel and we made our way across 130 yards into a large open room Breuil named Le Tréfonds. It's a clever name. A literal translation gives the prosaic "the Subsoil," but the word also has a literary meaning—the depths of the soul.

Le Tréfonds is a vast room with a long slanted rock floor that looks like a glacier descending from the cave wall. At its deepest part there is a thick rock that projects from the wall where there is a single painted bison, almost five feet long. Its horns form a sinuous S-curve and the eye is alive, expectant. The lines for the

back and chest gradually fade away, but the shape of the rock perfectly suggests a bison's body. It's a great masterpiece, relatively unheralded because there is so much else in Les Trois-Frères.

About ten yards away and halfway up the slanting rock floor, there was a battered, misshapen metal chair standing in splendid isolation. "My grandfather brought it in for Breuil," Robert told me. "So it will always stay here."

On a rock ledge not far away, two engraved owls stood on either side of a younger owl, presumably their chick. The back of one owl is part of a line that also forms the back of a mammoth. An owl and a mammoth are two dissimilar animals, but the artist recognized that if you adjust the scale, an owl's back is identical to one portion of a mammoth's back.

By now, I was feeling more used to the cave. It was wet but not unpleasant, and I was plenty warm enough in my jacket underneath the blue coveralls. We passed many long columns and stalactite curtains that made beautiful formations. The cave is rich with deposits of ochre that often stain the walls red, and this sometimes made it hard to tell what was a painted sign or dot and what was a natural stain.

Here and there in every room, the ancient hunters had stuck pieces of flint into crevices in the walls or shoved flint or bones into the clay floor. Enlène is a cave next to Les Trois-Frères. In fact, in Paleolithic times the only way into Les Trois-Frères was probably through Enlène. That cave has no art, but in one chamber there are about sixty pieces of bone, spearheads, and teeth shoved into the floor. Some of these have engraved diagonal lines. They are distributed over the floor in no discernible pattern, but still, there they are. Nearby, pieces of bone have been stuck into the wall, high and low, in cracks and under ledges, pointing in every direction. Obviously the floors and walls of the cave were important in themselves

and weren't just a neutral canvas for art. One theory, which will be discussed later, holds that the cave painters thought there was a world that existed behind the surface of the rock. The paintings were a way of going through the rock to that other world. The bones and stone tools pushed into the wall, and for that matter the shell in the niche in the Chapel that had so affected me, made this theory seem all the more plausible.

At last Robert took me to the Sanctuary, the most famous room in the cave, although without telling me that was where we were headed. That was a subtle gesture that I appreciated as I thought back on my visit because it allowed the cave to speak for itself. The Sanctuary is shaped like a bell. The floor slopes sharply toward the back, where there is a low outcropping that partially hides a low tunnel. I followed Robert there and, like him, lay on my back and shoved myself under the ledge. He shone his light at an angle to the wall, and I saw an intricate tangle of fine, faint engraved lines. At first they appeared to be just a mélange of heads, horns, and hooves. The engravings continued along the wall for yards and yards and disappeared around a corner. There were hundreds of them. Robert said there were many more lining the narrow tunnel, and probably more still to be discovered. Everywhere they are packed tight. I later read in Breuil that it often took him more than a month to copy and decipher just a meter's length of these engravings.

"Look just here," Robert said, pointing to a place on the wall only a few inches from my head. He shifted the lens of his carbide lamp slightly one way and another and then I saw it, one of the most distinctive figures ever found in the caves, one that has provoked and puzzled archaeologists, anthropologists, and art historians ever since the Bégouën brothers discovered it in 1912. The whole figure is thirteen inches tall. The lower half is clearly a man, because his penis is visible. He is standing on his right leg while his

Breuil's tracing of the engravings containing the sorcerer with the bow. The surrounding animals appear oblivious to him except for the one directly in front, who stares back in apparent alarm. It is a mythical combination of a bison and a deer.

left thigh is brought forward. His left knee is bent because he has just lifted his foot off the ground. He seems to be either dancing or taking a studied, marching step. But the upper half of this strange figure is a bison. He has a round, hairy belly with a tuft of fur at his navel, a hairy mane on his back, and a bison head with two curving horns. His two arms are really bison legs that end in hooves. Is this

a picture of a mythical bison-man or is it a man who has put on a bison head and hide? And, supposing it is a real man parading in a bison disguise, is he doing so as a hunter to fool his prey or is he imitating the mythical bison-man in a ritual dance?

Lying there, I thought at first that he was certainly hunting because there is dramatic tension in the setting for this strange beast-man. He is facing straight ahead toward a hooved, four-legged animal that appears to be his prey. This animal has turned back to look at him. But the supposed prey is also a mythical beast. Its head is more or less like a bison's, but not entirely. Its body is like a deer's.

The answer to what is really going on seems to lie in two faint lines lying across the bison-man's right "arm." One line is curved slightly and the other straight, and they touch at each end. It looks like a bow, and a bow would prove that he was hunting. When the bow and arrow first appeared in history is still unresolved, but it was probably after the age of the painted caves. At any rate, there isn't any evidence, except perhaps this small engraving, that the Paleolithic hunters used bows and arrows. And this bow, if that is what it is, is resting across the figure's right "arm" about where the elbow would be. That is not at all the way anyone has ever held a bow and arrow.

However, it is in exactly the position the bison-man would hold a musical bow if he were playing the violin. But—how strange!—one end of the bow is stuck in the bison-man's nostril. Could this be a picture of the world's first nose flute? The name sounds com-ical, but the nose flute has a long history and appears in cultures around the world. Played like a kazoo, a nose flute produces a sur-prising amount of racket. And if the "bow" is really a musical instrument, that would be consistent with the purposeful dancing, prancing position of the bison-man's left leg. Why then, I won-dered, would the bison-deer animal be looking back at the bison-

man? Perhaps it is attracted—or alarmed—by the sound of the flute.

I lay looking at the engravings for a long time, shifting my shoulders from time to time to get a better angle of vision or scooting over to a slightly new position. Tiny rocks on the floor poked me now and then, but I rather enjoyed the sound my coveralls made scraping over them. Although the engravings contained a large bestiary including rhinos, bears, and ibex, three species predominated, each in its turn. First bison, then horses, then reindeer. Some of the engravings were large, but most were small. A few of the most beautiful were *very* small. There was a perfect horse's head with fine detail and full of expression that was no bigger than my fingernail. There was a bear with fifty or sixty small circles on his body and long lines coming out of his mouth as if he were vomiting blood. This, for once, appeared to be a hunting scene. A bison floated above the bear. It had marks like spears hanging from its body. And a horse with twenty or thirty spears reared up just to the left of the bear. Still farther to the left, in a panel crowded with at least twenty-five bison and a handful of horses, another small bison-man appeared with his head turned to look behind him. This figure has human thighs and a prominent penis. Again, he could be either a mythical figure or a man disguised as a bison to creep in among the herd. Breuil remained noncommittal and called him simply a "small, complex being," which, I had to admit, he is.

Certain figures stood out because they were larger or more deeply engraved, but mostly the animals were one on top of another in a jumble. It was clear, however, that there was no intent to damage the lower engravings. They were simply drawn over, and then over again. They were not marked out, destroyed, or replaced. Instead they seemed more like a running ledger that might be read through, the way a modern archaeologist reads

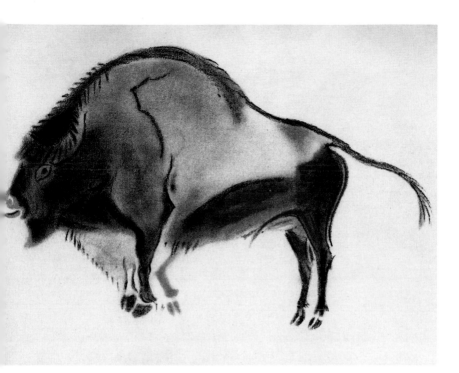

Henri Breuil painted Halted Bison Bellowing *(top) and* Reclining Bison Turning Back Its Head *(bottom) in Altamira in 1902. Beautiful as they are, they are part of a larger composition and cannot alone convey the meaning that the cave artists intended.*

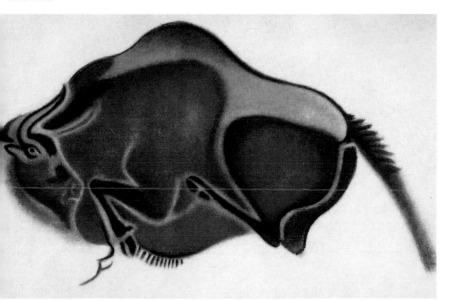

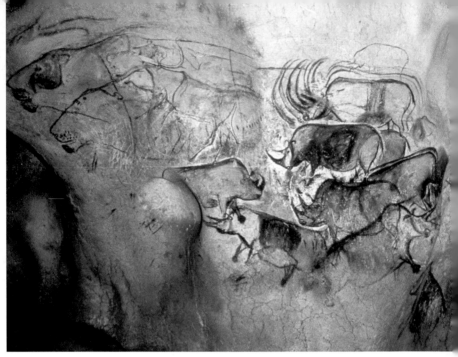

Above: This complex composition is on the left wall of the End Chamber in Chauvet, practically the deepest point in the cave. A single horse is on the slab inside the open niche, but the rest of the animals are all clustered about it, emphasizing the horse's importance.

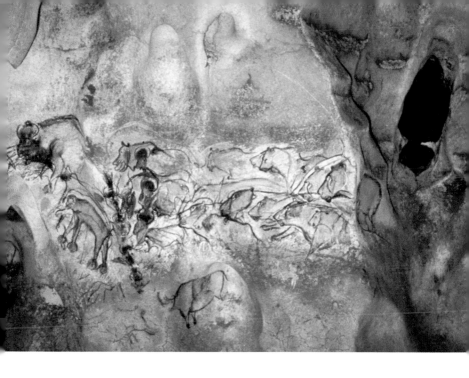

Below, right: Although there are only her legs and hips, this is the oldest painting of a woman ever discovered. It's on a hanging rock in Chauvet. Next to her is a leering man-bison. This probably illustrated some ancient myth, especially since man-bison figures appear in other caves as well.

Opposite: This cave bear skull placed on a rock in Chauvet has the appearance of an altar for a cave bear cult, especially since other cave bear skulls were clustered around it. Dates from charcoal on the rock prove that the skull was put there more than 30,000 years ago.

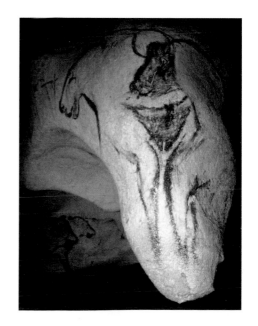

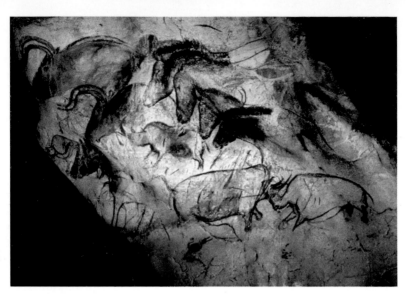

An archaeologist named Gilles Tosello has carefully analyzed this panel in Chauvet in order to show the exact sequence the painter used in creating each figure. He proved that the artist had planned the composition of the four horses from the beginning.

These comical lions and beautiful horses from Chauvet seem randomly located at first, but close examination shows that the two horses are pictured intentionally both inside and outside one lion's body. One horse's muzzle hangs over the lion's belly and the artist left a space in the belly's line to accommodate it.

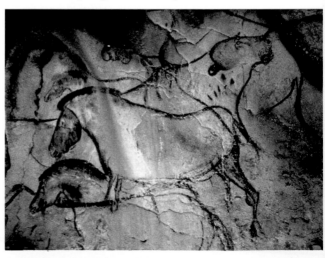

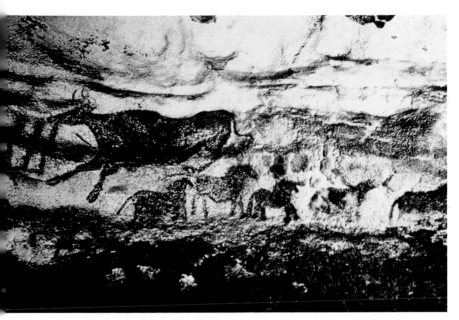

The Falling Cow (top) from the Axial Gallery in Lascaux and the Great Black Cow (bottom) from the Nave both appear near groups of horses and their hooves are near gridlike signs. These similarities could mean that they are illustrations of the same scene from a myth or a historical event dating back to the mists of time.

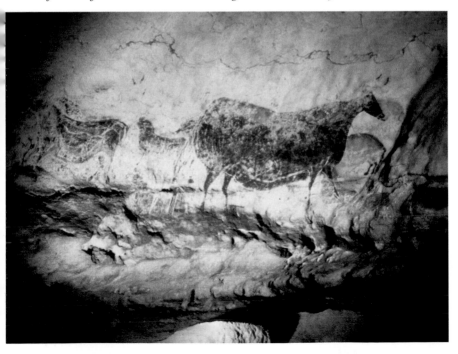

The Hall of Bulls is the first room in Lascaux. Easily accessible, open, dry, and covered with brilliantly white calcite, it was the perfect canvas for the cave painters. They rose to the occasion by creating the greatest masterpiece of prehistoric art.

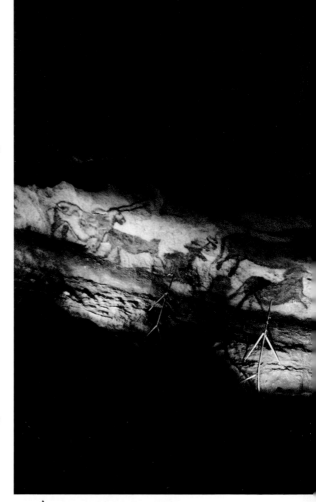

Below: The Crossed Bison are in the Nave in Lascaux along the same wall as the Great Black Cow. The hind legs show a mastery of perspective that was lost in western art until Paolo Uccello in the fifteenth century.

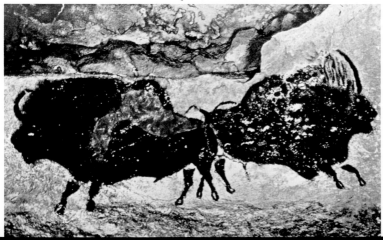

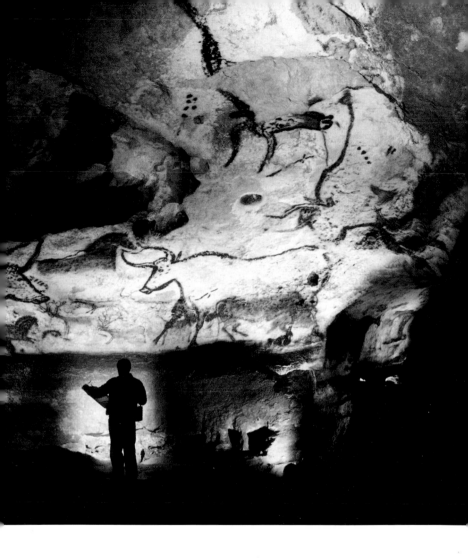

This image is from the right wall of the
Hall of Bulls in Lascaux. His horns and
hooves are in what Breuil called "twisted
perspective," and he has the unguinly but
conventional black slash for ears. The
rows of dots and intersecting straight
lines around the bull are enigmatic signs
that occur throughout the cave.

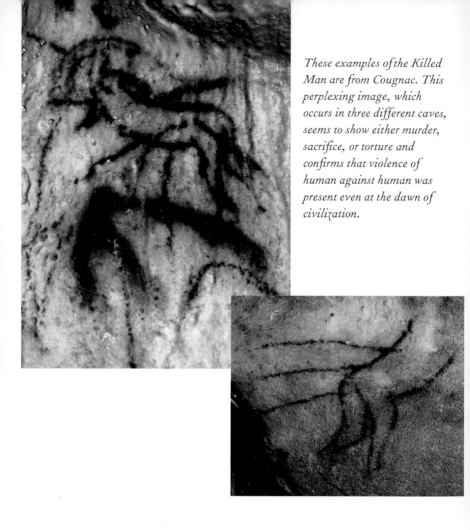

These examples of the Killed Man are from Cougnac. This perplexing image, which occurs in three different caves, seems to show either murder, sacrifice, or torture and confirms that violence of human against human was present even at the dawn of civilization.

These images from Cosquer were painted by blowing paint around a hand that was pressed against the wall with some of its fingers curled down. That made the hand appear to have missing fingers, which was likely either a code or a signal of affiliation with family, clan, or some other group.

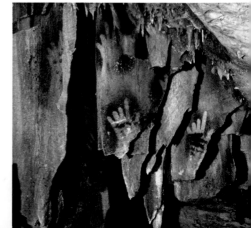

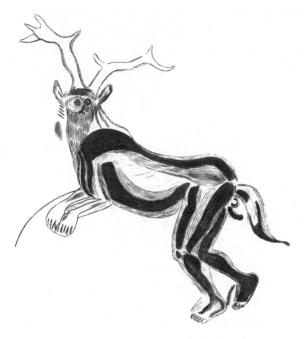

Breuil's rendering of the Sorcerer of Les Trois-Frères. He is near the ceiling of the cave, about fifteen feet above the cave floor. He looks down over everything in the room from a place that looks impossible for anyone to climb to.

through layer upon layer at a dig. I turned to Robert. "The history of the tribes?" I asked.

He smiled exactly as he had in the Chapel of the Lioness and shrugged the same way, too. "Perhaps," he said, "but we don't know."

We got back to our feet, and Robert led me to a spot a few yards back from where we had been lying. He pointed his light at a place on the wall near the ceiling. He didn't say anything. He just waited. I looked at the wall, then at him, then back at the wall. "Oh, my God," I said as I finally made out the figure, "there it is."

Breuil and Count Henri named him the Sorcerer in the first
moments after they saw him, although Breuil later came to believe
he was "the 'God' of the Trois-Frères." Not that he is particularly
large. He is about thirty inches high and eighteen inches wide. He
is engraved, but parts of him are painted black, and thus he is the
only painted figure among the many hundreds of engravings in the
Sanctuary. His eyes are two black circles with black, round pupils
looking straight ahead. His nose is a single line between them that
ends in a small arc. A long, pointed beard that reaches to his chest
covers the rest of his face. He even seems to have a thick handlebar
mustache that turns up at the ends. He has the ears of a stag. They
are pricked up and turned forward as if something has caught his
attention. Two stag's antlers sprout from the top of his head. He
has the long body of a horse, outlined with thick stripes of black
paint, and a horse's tail that is also partially painted. His arms are
more human than not. He's holding them together in front of him.
They end in what appear to be five long fingers but no thumb. His
sizable penis, while not erect, sticks out beneath his tail. He has
muscular human legs bent at the knee. They, too, are colored in
with black paint. He has lifted one foot as if he is walking, pranc-
ing, or dancing. He is a moving, bearded man-stag-horse who
knows we are here and has suddenly turned to look right at us.

The Sorcerer is near the ceiling, about fifteen feet above the
cave floor and next to a large round fissure in the wall. As he looks
down over everything below, his power is amplified by the fact that
it appears impossible for anyone to climb up there to paint him. He
seems to stand alone, generated by his own power. In fact, there
are convenient outcroppings, most of them concealed by turns in
the rock, which the artist probably climbed. Breuil rediscovered
them and used them to get in position to make his copy. He was
also able to climb up into the fissure next to the Sorcerer, where he
found a few more engravings. His often difficult scrambling

around on the rocks led him to a perceptive supposition: "All these complicated hidden passages lent themselves to extraordinary effects which would be inexplicable to uninitiated novices, who must have been deeply impressed. I will not try to revive these ancient ceremonies. The effect of songs, cries or other noises, or mysterious objects thrown from no one knows where, was easy to arrange in such a place."

There were many more engravings, including a large phallus carved out of the rock. The larger engravings, like the bison in Le Tréfonds, tend to use features in the wall to enhance their effects. Here in the Sanctuary a small dome on a flat area of rock becomes the hump of a large bison below and to the left of the Sorcerer. Two bovine legs bridge a cavity suggesting a female and her sex. Another bison has turned its head to look behind it. The head is carved on a part of the rock that bends back on itself. These larger animals on the walls below the Sorcerer are seldom carved over; it is as if they were permanent symbols with honored places on the walls that played their part over and over again in whatever happened here. As part of the ceremony some people must have lain at the foot of the wall as Robert and I had and engraved over the same area again and again, making new animals over old ones, until for reasons known to them, and not to us, they deemed that the space was full and moved a short way down the wall to a fresh spot and began again. Or maybe there were many who lined up along the wall, all furiously engraving at once.

Robert and I left the cave then. It was twilight when we emerged. After he had locked the doors, we got back into his peculiar little truck and bounced along the road. In a few minutes we arrived at a stone building down the hill from the château that serves both as Robert's office and a private museum. As I was taking off my boots and coveralls, which were caked everywhere with gray mud from the cave, Robert disappeared, but he returned in a

few moments with some glasses and a bottle of wine. His office is lined with bookshelves and has a comfortable sitting area in front of a large wooden desk. Eric, Robert's son, joined us along with his exuberant big dog and a couple of young archaeologists who were studying at the caves.

After a few moments of quiet talk, Robert asked me to write something about my visit in a large bound ledger where every visitor to the caves enters his or her impressions. I took the book to Robert's desk and opened it to the last entry. I drew a line beneath it and wrote the date. Then I stared at the blank space on the page. I was so overflowing and overcharged with impressions and also so convinced that I had been as close as I would ever be—physically close—to The Truth that I could hardly think. The few words that came to me seemed to be insignificant by comparison, like bits of dust.

A Passage Underwater;
The Skull on a Rock

"Oh, I know just what you mean," Jean Clottes said two days later. "The same thing happens at Chauvet. I mean even to professional, experienced people who've been in hundreds of caves. They're completely overcome. It's just so much. We don't expect any work out of them until the next day or even the day after that."

"I ended up just writing something stupid," I said. "I don't even know what it was."

"Well, that's it," Jean said. "That's just what happens."

We were riding in his car through the low Pyrenees to the west of Foix. It was Sunday afternoon. Here and there groups of local farmworkers and their wives sat in clusters rather solemnly. The men frequently had rifles near at hand. "They're trying to shoot wild boar," Jean said. "There are beaters down in the trees trying to flush them out. The peasants have an elaborate system for deciding who gets what cut of meat depending on who shot the boar, who saw it first, and so on."

Jean Clottes is six feet tall, slender and athletic. At seventy-two, he is officially retired, although retirement in his case does

Jean Clottes in his study in his home in Foix. Talent and hard work took him from English teacher in a provincial high school to an international authority on prehistoric art.

not mean he has stopped working. He works constantly. Retirement means only that he no longer holds any official position in the French archaeological bureaucracy as he had for so many years. (And yes, in France there is a bureaucracy that controls archaeology.)

He's lived all his life around Foix, a lovely provincial town about forty miles from the border with Spain. After beginning his career as an English teacher in a local high school, Jean rose to international eminence in prehistory, a virtually impossible climb. He did it by intelligence, by charisma, but above all by hard, concentrated labor over many years.

In 1959, when he was thirty and teaching in the high school, he began studying archaeology, commuting between Foix and the

university in Toulouse. In those days he was concentrating on dolmens, Neolithic structures with two upright stones supporting a third stone across the top. Dolmens are rather like the megaliths at Stonehenge except that they are smaller and stand alone. They dot the landscape across France and Great Britain. Clottes's doctoral thesis was an inventory of more than five hundred dolmens in the Lot region of France. At that time he was really nothing more than an older-than-average graduate student, but his talent and energy were already apparent. On January 1, 1971, twelve years after he had begun his studies, he was appointed director of prehistoric antiquities for the Midi-Pyrenees, an area larger than Switzerland. The post was more prestigious than lucrative. He received only three hundred francs a month as an indemnity, which was not enough to permit him to quit teaching English at the high school.

Nevertheless, that appointment determined the rest of his life. In his new position he discovered to his surprise that other government agencies and elected officials assumed he was an expert on all prehistoric remains including painted caves, which he was not. When new caves were discovered, as they were, and when issues arose concerning how to preserve the caves and their art, which they did, he was the one whom local officials turned to for answers, decisions, and, most daunting of all, direction.

Not exactly in a panic, but certainly in a hurry, Jean began to learn what he could. He made friends among archaeologists working in the caves, attended conferences, and worked on some archaeological surveys of particular caves. He finished his thesis on the dolmens in 1974, and after that he was able to quit the high school and devote himself entirely to the caves.

That's when his prodigious output of scientific work really began. By now his bibliography is almost absurdly long. It contains over three hundred articles and more than twenty books. In particular he wrote an extensive study of Niaux, one of Breuil's six

most important caves. Along with Robert Bégouën and several others, he did extensive research on the Volp system of caves, and at one time he thought of devoting the rest of his career to their study. Beginning in 1988 he spent years directing excavations at a cave named Le Placard, where his team discovered more than six hundred engraved rocks. The research team was able to date the oldest engraving to more than 20,000 years ago and to show that signs like those on the rocks in Le Placard appeared in other caves spread across a wide region of France. During that time he trained and encouraged a whole generation of prehistorians. In 1992 he became general inspector for archaeology at the Ministry of Culture and a year later the scientific adviser for prehistoric art for the Ministry. He held that post until 1999, when he turned sixty-six and was required to retire. During the 1990s it seemed that whenever an important new cave was discovered, it was Jean Clottes who got to direct the research and to determine who would have access and who would not.

Although Jean is forceful and demanding when it comes to work, he is not a difficult personality. On the contrary, he is charming and easy to get along with. He once arrived in the United States for a lecture tour that was to last two weeks with just one large leather pouch slung over his shoulder. He endured the inevitable string of nightly dinners with strangers and the shuffling from airport to hotel to lecture hall with patience and good humor. But his success in a bureaucracy like French archaeology, where for him to receive a plum inevitably meant that someone else lost out, created resentment in some quarters as well as the notion that it would be nice sometime just to see him take a fall. With the discovery of a cave named Cosquer in the cliffs near Marseilles in 1991, and with Jean Clottes constantly in the media explaining the new discovery, this faction thought the moment for that fall had arrived.

Marseilles is the center of undersea diving in France, and Henri Cosquer was the director of a diving school nearby. The cliffs along the shore contain networks of underwater caves. Cosquer and divers like him took every opportunity to explore them, despite—or perhaps because of—the great danger they present. In September 1985 Cosquer noticed a small hole in the rock that was the entrance to a tunnel 130 feet under the surface. Over the next several days, he slowly worked his way through the tunnel until he finally emerged into a cave filled with forests of beautifully colored stalagmites and aragonite crystals in bizarre shapes. He returned several times that fall but didn't tell anyone else about the cave. It was his secret place.

After that fall, six years passed before Cosquer could return to his cave. In July 1991 he made his way through the tunnel again and this time saw something even more spectacular than the stalagmites and crystals: a human hand stenciled in red on a wall. Here was a discovery he couldn't keep secret. At various times that summer he led five or six friends through the tunnel into the cave and they soon found most of the paintings and engravings that have made Cosquer one of the two greatest discoveries in France since Lascaux.

Cosquer took photographs and videos of all the art, but he wasn't sure what to do with them or how to handle his great discovery. As he pondered, a tragedy occurred that affected his thinking. On September 1, four divers visiting from Grenoble happened on the entrance to the tunnel and tried to follow it even though they lacked a safety line and other basic cave-diving equipment. The divers lost their way and panicked. Only one made it out alive. As it happened, Henri Cosquer was part of the hastily formed rescue team that found the three bodies. Two days later, on September 3, 1991, he took his photographs and videos and revealed his discovery to the Naval Affairs Headquarters in Mar-

seilles. The navy officials sent the news upstream to Paris, where it quickly reached Jean Clottes at the Division of Archaeology at the Ministry of Culture.

Obviously the first step was to determine if the paintings and engravings were authentic. A panel quickly formed, with Jean Clottes as the scientific adviser who examined the photographs and video Cosquer had taken to substantiate his claims. The photographs showed clearly that the paintings were often covered with calcite, which was a sign of their antiquity. Still, an expedition led by Jean Courtin, a prehistorian who was also an experienced scuba diver, entered the cave on September 18. They took more photographs, examined many of the paintings closely, and brought out samples of charcoal that still remained on the cave floor. Courtin reported that the paintings and engravings had tiny crystallizations that proved their authenticity to him. Radiocarbon dating demonstrated that the charcoal from the floor, which also had an antique patina, was over 18,000 years old. That didn't mean that the paintings were the same age but did establish that people had entered the cave during that era. Clottes and Courtin were satisfied that this and other evidence Courtin had gathered proved that the cave was genuine. The entrance was underwater now, but at that time the Mediterranean had been about three hundred feet lower than it is today.

The scientists were able to accomplish this work while the existence of the cave was still a secret from the general public. But in mid-October, just weeks after Cosquer revealed his discovery to the naval officials, the news was leaked to two local papers. One, *Le Méridional*, published the story under the inspired headline "Twenty Thousand Years Beneath the Sea." Suddenly Jean Clottes found himself besieged by radio, television, newspapers, and magazines from all around the world. His position was delicate. On one hand, he hadn't himself been inside the cave; more-

over, the demands of the media were distracting him and the other scientists from their work. On the other hand, in the bureaucratic wars for funding archaeology in France, public interest and support for certain projects can be important. Favorable news stories can help as well. So despite the inconvenience they caused, the media had to be courted.

A separate danger worried Clottes as well. In the past, publicity about new discoveries had attracted thieves and vandals, who could destroy the find. The news also attracted the merely curious, who without meaning to could damage the art and archaeological evidence on the floor of a cave. The result was that at a press conference in Paris the minister of culture decreed that he would protect the cave immediately as a historical monument.

That was the moment when the reaction began. It's not clear exactly why. Perhaps it was simple jealousy, since the cave was now closed and Jean had become the chairman of the official committee in charge of preserving and studying it. Whatever the reason for the reaction, in the following weeks various prehistorians began to question the authenticity of the cave. In particular Denis Vialou, a professor at the natural history museum in Paris and a well-known prehistorian, declared in November in a newspaper interview, "I am absolutely convinced that it's a fake." He repeated this assertion in television and radio broadcasts. Soon Arlette Leroi-Gourhan, the widow of André Leroi-Gourhan, joined the chorus, as did Paul Bahn, a British prehistorian. Bahn wrote an article in the *Independent on Sunday* that explained the arguments on both sides but concluded by saying, "doubts persist." In February 1992 a contentious article appeared in *Science et Vie,* a national magazine for the general public, under the title "A Shadowy Cave." "Denis Vialou remains skeptical," the article said. "Some other important specialists in the painted caves like Gilles and Brigitte Delluc, as well as Arlette Leroi-Gourhan, share

his doubts. They evoke the fact that no scientific dossier has been transmitted to them and deplore the temporary closing of the cave since it was classified as a historical monument." The article continued in an arch and superior tone about one engraving it called the "Provençal penguin," about the "almost childlike mediocrity" of other figures, and about paintings it called "unskilled copies." Even the calcite deposits were suspect: "The calcite deposits on the figures do not prove their age: many calcium deposits can be found in the tunnels of the Paris Metro." Besides, "it is possible to make calcite artificially."

Jean Clottes and Jean Courtin took these articles as personal attacks on their judgment and integrity. While remaining stoical in public, Clottes ground his teeth in private. He made his response in July 1992 in an article he coauthored in the *Bulletin de la Société Préhistorique Française*. He concludes his argument with one grand paragraph: "For this collection to be false, the forger would have had to be extremely knowledgeable about Paleolithic art so as to commit no error in the choice of themes and techniques, while at the same time introducing spectacular innovations that were still plausible. He would have had to be an excellent diver and an equally fine artist. He would have had to succeed in reconstituting an ancient type of calcite coating not only on the paintings but also on the ceilings and the neighboring walls. He would have had to patinate the engravings, procure an abundance of charcoal 18,500 years old belonging to a species of tree growing in a cold climate, and construct hearths and coat them with calcite even beneath the water. Finally, he would have had to work very discreetly (at night?) in order not to draw attention to repeated dives in a very busy location, as well as leave no trace of his activities in the cave."

Nevertheless a few die-hards like Denis Vialou persisted in their doubts. Finally, just a few months later, Jean Clottes and var-

ious collaborators published another article in the *Bulletin* concerning radiocarbon dates from Cosquer. The carbon samples used in the dating had been collected by Jean Courtin and came from charcoal left on the floor and from minute specks of organic pigment chipped from various paintings. One of the charcoal samples had already yielded a date about 18,500 years ago. Five pigment samples taken from paintings of animals proved to be between 19,000 and 18,500 years old. Obviously the charcoal and the paintings were contemporaneous, and the paintings were genuine. Two other pigment samples came from hand stencils and incomplete figures. One figure was more than 26,000 years old and one hand stencil was more than 27,000 years old. Two charcoal samples came from fires that were just as old. The dates showed that there had been two periods of activity in Cosquer, and at last these dates proved the authenticity of the paintings beyond any doubt. More important, 27,000 years was, as Clottes wrote, "presently the oldest date obtained directly from the pigment of a wall painting"—and here he could not resist a brief moment of nonscientific, triumphant glee—"*in the whole world.*" (Italics are those of Clottes et al.)

Jean Clottes was fifty-eight in 1991 when Cosquer was discovered. Since the entrance was underwater, he would have to learn to scuba dive in order to see the cave for himself. So, despite his age, he did. The entrance through a tunnel was a challenging technical feat even for an experienced diver. The first time Jean attempted it he got stuck and barely managed to wedge himself through with the help of the professional divers who accompanied him. Nevertheless, he persisted. In all he made twenty-four dives into Cosquer.

Since the cave contained the remains of hearths, which contain

the remains of burnt Scottish pine, and since some of the paintings used charcoal for black pigment, Cosquer was a perfect cave for radiocarbon dating. Of the two periods represented in the cave, the older, from about 27,000 years ago, consists entirely of finger tracings on the walls and stencils of hands. The paintings of animals, in which horses predominate but which include three great auks and some seals, date to 18,000 years ago. There are no signs of habitation during either occupation. Perhaps the opening was lost or became covered over only to be rediscovered 9,000 or 10,000 years later.

The hands are especially interesting because just under a third of them have missing fingers. There are 65 hands in all, 44 stenciled in black in a chamber at the farthest reaches of the cave and 21 stenciled in red on one wall closer to the entrance. Of the total, 43 are left hands and 22 right.

At least a dozen caves have stenciled hands—Les Trois-Frères and Font-de-Gaume each have 5—and the hands in a few, particularly a cave named Gargas in the Pyrenees, similarly have fingers missing. Gargas has 231 hands, but only 124 are clear enough to read with confidence. Of those just 10 are complete, leaving 114 with missing fingers. Gargas was discovered at the beginning of the twentieth century and precipitated nearly a century of bitter disputes. Some scholars maintained that the missing fingers were evidence of ritual mutilation. Others thought hunters had lost fingers because of extreme frostbite, while still others blamed debilitating diseases or extreme malnutrition. Those theories have few adherents today. For one thing, thumbs are never missing—and why would frostbite or disease always spare the thumb? But, more simply, subsequent experiments have shown that bending down one or more fingers before blowing the paint on produces the same effect. It's more likely that holding down this or that finger was a code. Leroi-Gourhan wrote an entertaining paper showing how

such a code might have worked, although he made no claim to having cracked the one at Gargas.

Gargas is more than 250 miles across mountainous territory from Cosquer, which suggests how much contact there was and how unified culture could be across a wide area, even 27,000 years ago. Of course, there were regional differences. In Gargas over half the "mutilated" hands have all four fingers held down with just the thumb remaining. At Cosquer the most common position for mutilated hands was with the ring and little fingers held down; only two hands show all four fingers held down. That could mean that the hand signals used one code at Gargas and a different one at Cosquer. Or it could be that the same code was used in both caves but the messages are quite different.

And Cosquer contained a surprise: a "killed man." It was a simple drawing similar to a drawing that had come to light in 1922 with the discovery of a cave named Pech-Merle. One slab of rock in the cave at Pech-Merle had the peculiar image of a man outlined in red. He's standing but his legs are much shorter than his body; his arms are short too, and he has an odd, swollen head. All this gives him the appearance of a precocious infant. Strangest of all, his body is pierced by eight lines, four on his front and four on his back. Thirty years later Cougnac was discovered about seventy miles northwest of Pech-Merle. It had two figures that were similar, although more bent at the waist. Lines pierced their bodies. Although other explanations have been offered, the men appeared to have been killed by spears, perhaps even tormented by thrusts of spears until they died.

Those two caves are two hundred miles northwest of Cosquer, but they date to 20,000 years ago, roughly the same era as Cosquer's second period. And now Cosquer had revealed yet another killed man. He has the same odd body and short legs and arms, but here he has pathetically fallen on his back. A long line, presumably

a spear, has rammed through his back, burst from his chest, and taken part of his head with it.

The meaning of these four killed men, all so similar but in widely separated caves, is anyone's guess. Was it the image of some great narrative? The commemoration of a past tragedy or the just punishment of a transgressor? Or something else entirely? Certainly the killed men, along with the scenes of men confronting bisons in Lascaux and Villars, show that the Ice Age hunters lived in a civilization replete with classic stories. The killed man shows that the world of the hunters was not an innocent Eden. At least one of those classic stories concerned the violence of man against man.

Cosquer was the first of three crises that entangled Jean Clottes during the 1990s. They arrived in rather quick succession and each one fed into the next so that each succeeding crisis was bigger than the last. The second crisis was Jean's involvement in Chauvet, a cave that proved to be even older and more spectacular than Cosquer. The third occurred when Jean turned from description, dating, and classification—his great strengths as a lifelong dirt archaeologist—and attempted to reveal the meaning behind the art.

Jean first heard of Chauvet through a telephone call to his home in Foix on December 28, 1994. Interrupting a long-planned Christmas family holiday, he left that very day to drive east for two to three hours through the mountains to Vallon-Pont-d'Arc, the site of the discovery. There he met Jean-Marie Chauvet, Eliette Brunel-Deschamps, and Christian Hillaire, the three spelunkers who had made the discovery. The next day they led him into the cave. Eliette had brought red wine from her own vineyard for them to drink in celebration of the new discovery after they had returned from their descent.

"Oh, but I'm here to verify the authenticity of the paintings," Jean Clottes said. "I'm expecting to see some fakes."

But Eliette promised him that they would be in the mood to drink the wine. And they were. In their book about the discovery, *Dawn of Art: The Chauvet Cave,* the three spelunkers say, "We saw that he was profoundly moved by the extraordinary beauty of the paintings and engravings." Evidently Jean had been speaking from his own experience when he told me of the overwhelming effect seeing a cave like Les Trois-Frères or Chauvet for the first time can have on even experienced prehistorians.

He had seen almost immediately that the paintings were genuine. The floor of the cave was littered with the bones of cave bears, their footprints, and even traces of their claws. Thanks to the precautions the spelunkers had taken from the first, the floor of the cave had no shoe prints, which fakers could not have avoided making, especially in front of the painted panels. Examining the paintings with a magnifier, he saw that apparently solid lines often had small gaps caused by erosion while others, like the paintings in Cosquer, were covered with mineral deposits or calcite. All of that, and much other evidence besides, convinced him that they could drink Eliette's wine with clear consciences.

The cave is in a mountainous region in south-central France called the Ardèche. The entrance, near the top of a cliff, overlooks the Pont d'Arc, a natural stone arch over the Ardèche River that attracts hordes of vacationers each summer. The three discoverers had been a spelunking team for many years and had already discovered a few minor painted caves. Their leader, Jean-Marie Chauvet, was a park ranger and had just a year before been named the custodian of the known painted caves in the region.

On December 18 they had been exploring along the crest of the cliff when at the end of a declivity they felt a draft of cool air, often the sign of a cave. They pulled away rocks until Eliette, the smallest of the three, could squeeze partially through. She found herself

looking down from the roof of a large chamber. She shouted and the echo seemed to return from endless depths. They dug out the hole some more and descended thirty feet by a chain ladder. Once on the floor of the cave, they began moving forward slowly. Eliette suddenly let out a cry. "They have been here," she said, and pointed to the two lines of red ochre illuminated in the beam of the lamp on her helmet. Slowly, following in one another's footsteps so as to disrupt the floor as little as possible, they passed through chamber after chamber whose walls were covered with magnificent paintings and engravings. They found human footprints as well and a bear skull placed on a rock like an altar.

When they emerged three hours later, it was midnight. They blocked the entrance as best they could and walked down the cliff in silence, absorbed in their thoughts. Back home they finally relaxed and broke out some champagne. They had just experienced their greatest day in twenty years of exploring caves.

On December 24 they returned with three friends with whom they had decided to share their secret. Jean-Marie Chauvet brought rolls of plastic to lay on the floor to protect it. They discovered more galleries, including the one leading to the most important chamber, the Salle du Fond, with its powerful paintings of lions and rhinos. Finally, having run out of plastic, they crawled just to the entrance of a vestibule where they could see three red bears painted at the back. But the floor was covered with bones and they turned back and left the cave after spending seven hours underground. They returned again the day after Christmas with more plastic and then on December 28 announced their discovery to the regional Administration of Cultural Affairs. That was when Jean Clottes got his call.

Upon seeing Chauvet, Jean confessed later, he was struck "like a thunderbolt" with the determination to be the one who directed the study of the cave, and he began his campaign to get that

appointment. First of all, since he was the one who authenticated the cave for the Ministry of Culture, he wanted to avoid any problems like those that had plagued the study of Cosquer. He suggested to the minister of culture that some dozen or so specialists in cave art be invited immediately to see the cave. Jean sent a list of names with that of Denis Vialou, his main antagonist from Cosquer, at the top and included several others who had joined Vialou in the ruckus. These visits all occurred on February 7, 1995, and resolved any doubts there may have been. In fact, Vialou was so impressed with the cave that he tried to take it away from Clottes. He requested that the right to make the scientific study of the cave be awarded by a competition. After months of preparation, both Vialou and Clottes presented their proposals to an international jury of nine archaeologists, who then retired to consider. On May 31, 1996, they reported that they had voted nine to nothing in favor of Jean Clottes.

Jean led the study of the cave from 1998 until 2001, when Jean-Michel Geneste took over. He had always been part of the team studying Chauvet and had previously been the administrator of Lascaux. The basic plan and procedures that Jean Clottes proposed in 1995 were still in place when I stayed with the team for a few days in the fall of 2004.

Fortunately, the cave is located not far from a rustic athletic camp that is overrun in summer but often empty in spring and fall when the team meets to go into the cave. The camp has cement dormitories with spartan rooms that contain four cots. Each room opens onto an outdoor walkway. Toilets and showers are clustered here and there along the walkway. We ate at a long table in an immense common room, and the meals, prepared by a wiry, tough-looking chef, were spectacular. One night we had boar's head stew.

One of the great agonies of archaeology is that you cannot both

excavate a site and preserve it. Excavation is destruction. That is why there is such anger toward archaeologists who excavate a site and then delay publishing their results for years. The site is ruined and now the information from it has been reburied in some professor's filing cabinet. That's also why there has been only one very limited test excavation at Chauvet. There will not be another for many years. Jean Clottes's plan was based on methods for studying the cave that would yield results yet still preserve it in nearly perfect condition for the future. First, that meant preserving the climate inside Chauvet by studying the cave for only two weeks in May and October. Limiting the time people were in the cave would allow the climate to reassert itself during the long months Chauvet remains empty. Also, the floors were to be preserved at all costs. Before work could begin the technicians working for the Ministry of Culture installed metal grids along the exact route the three spelunkers had laid out with their rolls of plastic. Large areas of the cave remain unstudied, although they look very interesting from a distance, because the protective grids on the floor don't yet extend that far.

The main work being done, which will take many more years to complete, sounds simple enough—listing, recording, and reproducing all the art on the walls of Chauvet. Leroi-Gourhan's punch cards are long gone, but their spirit endures in inventory forms that must be completed for each piece of art on every wall, whether it is an animal painted in full figure in the midst of a herd or a faint line on an otherwise empty wall. The inventory includes the location, the size, the height from the floor, the theme ("animal, sign, trace, human, composite, undetermined"); the species of animal ("horse, bison, aurochs, ibex, red deer, reindeer, megaceros, feline, bear, mammoth, rhinoceros, undetermined"); the "technology" ("painting, drawing, stumping [that is, making a series of dots with a wad of moss or hide], engraving, scraping, fin-

ger tracing"); the nearest figure; the signs of deterioration ("calcite film, superimposition, obliterated, eroded, corroded, other"); the color ("black, red, yellow, brown, other"); orientation; profile ("left, full face, right"); and various other details. All this information goes into a computer database.

But the inventory is merely the beginning. The art needs to be copied as well. Making copies is a long, often tedious process. In that way it is very much like an archaeological dig. And, like a dig, it is absolutely essential because, strange as it sounds, it is impossible to see the art merely by looking at the wall. The intense concentration copying requires reveals signs and images that were invisible before. Michel Lorblanchet, a distinguished prehistorian with considerable artistic talent, made copies in a cave named Pergouset. He had visited the cave more than twenty times, often with colleagues, and thought he knew it well. But when he began to make his copies, he discovered numerous animals and signs that hadn't been seen before, including a vulva some eighteen inches across that, once seen, becomes the first thing anyone notices on the wall. Lorblanchet worked in the cave for three years making copies. His copies show twelve horses, three reindeer, three mountain goats, one stag, a bison, an auroch, four undetermined animals, sixteen signs, the vulva mentioned above, and twelve undetermined traces. Years earlier, when Leroi-Gourhan visited the cave, he saw only an isolated mountain goat, a horse, and a bison. What Lorblanchet was able to see compared to what Leroi-Gourhan saw is the difference between copying and merely looking.

Copying the art in the caves began with Breuil making paintings and tracings. The tracings in particular remain important resources for prehistorians and appear frequently in books and papers. It is far easier to decipher the art, especially when there are many works overlaying each other, by studying tracings rather

than the cave wall itself. However, when Breuil made mistakes, as in drawing a second tail for the lion in Les Trois-Frères instead of a human arm and hand, an unfortunate amount of erroneous scholarship has appeared because of it.

Breuil made his copies by putting tracing paper directly on the cave wall, a method that would horrify a modern scientist, who would touch a wall only for a special purpose such as extracting a sample of paint for radiocarbon dating. Jean Clottes's proposal specifically said, "The tracings are planned so that there will be no direct contact with the wall." And today the reasons for making copies have grown more complex. The goal is not only to reproduce the art but also to analyze the component parts of the piece, to study the techniques of the artist, and to learn, when possible, how the painting or engraving was made stroke by stroke. It was this method that permitted Norbert Aujoulat in his book on Lascaux to determine the unvarying order of strokes by which the artists painted a horse.

Several members of the team at Chauvet are both trained archaeologists and gifted artists. One, Gilles Tosello, might be the equal of Breuil. The method of making copies at Chauvet begins with a photographic print that is precisely the same size as the art itself. The copyist takes the photograph and sheets of clear plastic into the cave. Usually he or she sets up a tripod with a clamp to hold a drawing board and a lamp, then works standing directly in front of the cave wall, often for hours on end. After covering the photograph with a plastic sheet, the copyist looks at the wall and begins to draw just one part of what is there. It could be just the color red in the painting or just the black. The features of the wall itself are copied as well, so some plastic sheets will show bear scratches if there are any, or only the bumps and hollows in the wall, or just the cracks. Although the clear sheet is on the photograph, the photograph is really only a template. The copyist is trying to reproduce what is on the wall, not just color in, say, all the

red in the photograph. There could be some dozen or more plastic sheets before the copy is finished.

Through the use of Photoshop, which many archaeologists at Chauvet can manipulate like wizards, the plastic sheets are entered into Macs connected to oversize screens. Now the images of the painting and the wall behind it can be manipulated any way a researcher needs. For example, isolating the various elements of the painting can reveal the order of the steps the artist took to produce it. Also, when there are superimpositions of one painting on another, the paintings can be studied individually or together and in either case stroke by stroke. The superimpositions look random, but this careful study turned up one case in Chauvet where the superimposition was planned. The artist had left a gap in the line marking the belly of one animal. The line showing the neck of the superimposed animal goes right through that gap.

The study of another, more complex painting produced even richer results. One of the most beautiful paintings in Chauvet shows four horses that seem to be running behind a strange herd of aurochs and rhinos. Just below the horses, two large rhinos face each other. This whole creation, though beautiful, is confusing, too. Why are these animals all together? Were they put there just by chance or is there some hidden order guiding the choices? The technique of carefully copying layer by layer has revealed the steps by which this painting was created.

First, a cave bear made scratches on a blank wall. Nevertheless, this space was chosen for painting. Then an artist or artists engraved a rhino facing left in front of a mammoth facing right. The rhino's haunches are right over the bear scratchings. These engravings are more than eight feet from the floor and have little detail. Presumably they were made with a pointed stick or bone or some other extended tool that enabled the artist to reach eight feet but did not allow any fine work.

The lower parts of these engravings were effaced when an

artist—the same one? another?—scraped the soft surface of the rock away to create a clear, hard, white area for painting. The scraped area bent around a corner in the wall so that a small part was almost at forty-five degrees to the major portion. The artist now painted five small animals—two rhinos, a deer, and two mammoths—in black on the major portion of the wall. Next, lower on the wall, came the two great rhinos facing each other on either side of the curve in the wall. Whether these are two males fighting or a male and a female in a courting ritual isn't clear.

Then an artist, perhaps a different one from the one who painted the five small animals and the facing rhinos, painted three magnificent large aurochs on the major part of the scraped area. They face left and have imposing curved horns that sweep forward. Last, the same artist who painted the aurochs painted the four horses. They also face left but are on the part of the wall around the corner from the aurochs.

The paintings of the four horses developed in at least two steps. The artist painted two horses one behind the other and then paused to scrape the wall below the outermost horse's neck. This pause is provocative. Does it mean the artist began with the idea of painting only two horses, then had the inspiration to add a third and fourth? Or did the artist, thinking of four horses from the beginning, have second thoughts for a moment before proceeding? In any event, the artist painted the third horse, then again scraped away the rock surface below its neck before painting the fourth and final animal.

The aurochs and horses, while similar, are each individuals as well. They have different expressions, different eyes and ears, different proportions of their heads and necks, and different postures. The whole force of the painting moves from right to left around the corner and across the wall connecting the leftward rush of the horses with the similar leftward movement of the aurochs. The

step-by-step copies have revealed that what at first appeared to be a random assemblage of animals was in fact a planned composition, at least as far as the horses and aurochs are concerned. Although the horses were the final animals painted, the artist had reserved space for them from the beginning. And the analysis also reveals the artist's stops, starts, and pauses as the composition developed.

The Chauvet team work in an outbuilding built especially for them near several outdoor basketball courts. After breakfast each day they are there, bent over the large screens of their Macs as they consult with one another about how to proceed with the day's work. A hard rain the first morning I was there caused much discussion about who was going to the cave and who wasn't. I couldn't understand what difference the rain made, since it wouldn't be raining inside the cave. All but one chose to remain at camp and work on the computer renderings.

A day later, when I climbed up to the entrance of the cave, I understood. From the nearest parking area, it's a brief walk through a vineyard to the base of the cliff. Then it is a long, hard hike along a narrow path of mud and stones through a forest up the cliff. Rain would make this trek uncomfortable and perhaps even dangerous, since the path is narrow and slick, and the drop-off is often sheer. While some tools like tripods can be left in the cave, the archaeologists carry everything else—art supplies, cameras, and most especially food, water, and wine—back and forth in backpacks each day. From the parking lot by the vineyard the trek up the cliff takes about thirty minutes.

The path ends at the tiny Cave of the Winch. It got its name because shepherds used to put up sheep there for the night and installed a winch to bring up hay. A row of metal bars like a prison

cell spans the cave's broad opening. Some scientific equipment as well as two microwaves and some other kitchen equipment and supplies are stored behind the bars. In front there's a long picnic table on a patio where the team eat at midday. From here you can see the Pont d'Arc far below. It is a large, natural stone bridge that looks elegant as it arches over the river. Science can explain how natural forces created this unusual formation, but it remains affecting. It's easy to think of it as something created by a great and mysterious power, which I suppose the forces of nature are. Perhaps the ancient hunters chose to paint in Chauvet because the cave offered a sight line to this rare feature on the landscape.

Whenever the scientists descend into the cave, a state guide must be present as well. He remains outside to make sure that no unauthorized person goes in. The entrance to the cave lies at the end of a stone walkway built around the side of the cliff. A thick metal door that requires two keys bars the entrance. The state guide has one key and the scientists have the other, so no one, authorized or not, can enter surreptitiously. Since Chauvet was discovered, its ownership has been the subject of many enervating lawsuits involving the various owners of the land, the nation of France, and the discoverers, particularly Jean-Marie Chauvet. Although the cave is named for him, he has found more frustration and disappointment than joy in the aftermath of his discovery.

But the care of those first explorers, the strict security that has been imposed from the beginning, and the precautions that were at the core of Jean Clottes's plan for studying and exploring the cave have preserved it in the state in which it was found. And what a cave it is! Just as Breuil's Battle of the Aurignacian upset the accepted prehistoric chronology of that day, the discovery of Chauvet has upset the chronologies of both Breuil and Leroi-Gourhan as well as a host of other time-honored assumptions about the nature and development of prehistoric art. Various labo-

ratories have done radiocarbon dating on some forty-five samples taken from different places throughout the cave. The results show that there were two or perhaps three periods when people entered the cave. One sample was 22,800 years old, but that date is the only one from that era and is therefore uncertain. Seven dates fall between 27,000 and 26,000 years ago, although no paintings date to this period. Twenty-two of the radiocarbon dates come from 32,000 to 30,000 years ago. Some of these come from carbon on the ground, but others come directly from paintings where the artists used charcoal pigment for black, proving that the art was as old as the remains on the floor. (Three samples came from the two confronting rhinos below the panel of horses.) A cave named La Grande Grotte at Arcy-sur-Cure has paintings that date to 28,000 years ago. It is the next-oldest cave after Chauvet. Some of the art in Cosquer is, as I have said, 27,000 years old. The next-oldest after that, which is 25,000 years old, is in caves Cougnac and Pech-Merle, both far to the north in central France. So the art in Chauvet is at least 4,000 years older than any other known cave art.

But the art in Chauvet is not only old, it is also just as sophisticated as any of the art that appeared later, including that in Lascaux, which was painted 14,000 years after Chauvet. This, as I've mentioned, upsets the theory that art had crude beginnings and became more sophisticated over time, a theory that had prevailed since scholars began to recognize prehistoric art for what it was, and that had been the foundation of intricate chronologies of different styles by Breuil and Leroi-Gourhan. The paintings in Chauvet show a mastery of line and coloring and of perspective that is the equal of any art in caves or, in truth, of any art anywhere in the world. Also, there is a sense of drama, of motion, of *action*—lions on the hunt with gleaming eyes, horses at the gallop—that is superior even to Lascaux. Craig Packer, a specialist on African lions of today, told Jean Clottes he had often seen the same expression in

the eyes of lions living in Tanzania. In order for the ancient hunters to have seen that expression and record it so perfectly, Packer said, they must have gotten as close to the lions as he, Packer, had been. "But the difference," he said, "is that myself, I was inside my four-by-four."

Yet, old as it is, and impressive as the art is, Chauvet is also similar to the caves that came after it. It has themes found in all the caves. There are hands, dots, and geometric signs; there are human figures that are rather abstract; and there are animals including the standard menagerie of horses, bison, rhinos, mammoths, and cattle. Chauvet stands at the beginning—the sudden, seemingly spontaneous beginning—of a tradition that lasted for the next 20,000 years.

The tradition endured, but Chauvet shows that its details changed. There are more than 420 animals painted or engraved on the walls of the cave, but only 345 have been positively identified. Of these, 81 percent are dangerous animals like lions, mammoths, rhinos, and bears that the Stone Age people seldom hunted for food. At Lascaux there are just seven lions, one rhino, one bear, and no mammoths. Perhaps, as I suggested earlier, the ancient hunters successfully reduced the number of dangerous animals so that they became less of a threat. That would mean, inevitably, that the myths of these prehistoric societies would change as well. At least some of the stories based on dangerous animals would drop away and new ones based on different species would take their place, and the kinds of animals prevalent in the art in the caves would change as well.

Three features of Chauvet need special mention. The famous bear skull found carefully placed upon a rock is just as astonishing as the art because the arrangement has every appearance of being an altar. It is located in a room with a rather low ceiling. The floor is lowest in the center and moves up from there gradually, almost

in tiers, until it meets the walls. All in all, the chamber looks rather like an amphitheater with the rock and skull at center stage.

Sometime in the dimness of the past, the rock fell from the ceiling of the cave and broke into several pieces. A Paleolithic hunter placed the skull at the edge of the largest piece of rock. The lower jaw is missing, but the upper jaw with its long canine teeth sticks out over the edge of the rock. Pieces of charcoal under the skull show that someone had built a fire on the rock. The pieces of charcoal have a radiocarbon date of more than 30,000 years ago. The skull, which shows no sign of flames, was placed there after the fire had gone out.

There are lots of cave bear bones throughout the cave, including more than 190 skulls. It is possible that someone picked up a skull at random and put it on the rock for no reason in particular, perhaps even someone who wandered in after Paleolithic times. But there are other remains near the rock that make it almost certain that the skull was put there not at random but on purpose. A second bear skull lies on the floor only inches from the rock. More than 45 other bear skulls are close to the rock. Most of them lie within six yards of it. They are not in any discernible pattern, but still they are there and people must have brought them there. It's true that running water and scavenging animals can move bones in a cave. But if that were the case here, why are there only skulls and not a wide variety of bones? And one of the skulls has two black lines, apparently from the burnt end of a torch. That means it was already a skull marked with lines when it was brought here, not a head with the flesh still on it. Somehow, some way, this room was a shrine to cave bears, which were honored in unknowable rituals.

In another part of the cave two bear bones—humeri, in fact—were stuck upright into the cave floor, each one near a bear skull. Two bear teeth were put in small hollows in a rock. The bones stuck into the floor and small objects placed in cracks and hollows

make Chauvet similar to many other caves, including Les Trois-Frères. No other cave has a bear skull on a rock or a collection of bear skulls brought into a room. But the bones in the floor and crevices show a similarity of beliefs across a wide area and through many millennia.

There is no complete human figure in Chauvet, but there are six human elements. They all appear in the End Chamber, the deepest part of the cave, and they form a strange collection—five vulvas and one thin arm ending in thin, stick fingers. Three of the vulvas are right at the entrance to the End Chamber and two near the rear; all of them are nearly six feet from the floor. Three are engraved and two are painted in black, but in form they are nearly identical. A horizontal arc lies across the top of two lines that meet in a V. These three lines form a triangle. Then there is a single vertical line where the two sides of the V meet. Four of the vulvas are isolated on the wall. The fifth one, however, along with the thin arm and fingers, is part of a scene that could be from an ancient myth, a myth that first appears here in Chauvet, then reappears in classical mythology, and survives even today.

This mysterious scene is part of one of the most intense and animated compositions in all of cave art. It streams across the left wall of the End Chamber, where it is centered on an opening in the wall shaped roughly like an upside-down V. A slab inside the opening has a painting of a horse. All the animals, including the horse, are facing left. The ones to the right of the opening—a pack of lions that seem to be in a frenzied hunt for the herd of bison just before them and a strange mammoth with round feet—all appear to be rushing toward the upside-down V. Those on the left of the opening, rhinos mostly and more lions, appear to be rushing out of it.

Well to the right of this masterpiece and entirely separate from it, a large rock formation hangs from the ceiling. It ends in a pen-

dant that could hardly be more phallic. It is painted with various figures all around it, but the view from the entrance to the chamber shows a curious scene. A bison, or at least something with the head of a bison, appears crouched over a vulva painted with black lines in the standard triangular shape. Here, however, the interior of the triangle is filled in with black shading. Also painted in black lines are two legs, one on either side of the triangle. Each leg has a fat thigh and a knee, but below the knee the legs narrow and end in a point rather than feet. This is clearly the painting of a woman. Her upper half either never existed or was erased so that the artist could draw the bison's head. The head is shaded in with black as well and has an intense, leering white eye. There is a black line for the bison's hump. But just at his neck another black line, rather fainter than the others, suggests a thin arm that, like the arms of the Sorcerer in Les Trois-Frères, ends in a human hand.

The painting of the woman has never been seen except in photographs. The walkways that protect the floor of the cave do not extend very far into the End Chamber. From the point at which they end, only the beast is visible. Then an inventive archaeologist named Yanik Le Guillou attached a digital camera to a collapsible metal arm and succeeded in taking pictures around the entire surface of the pendant. The photographs revealed for the first time that the bison-man was beside a woman.

Of course, even though it is a bison and not a bull, this painting makes one think of the myth of Zeus in the form of a bull carrying Europa to Crete and raping her. Minos, who became ruler of Crete, was conceived in that rape. An angered god later made Minos' own wife become enamored of a bull. She gave birth to the Minotaur, part bull and part man, who lived in the Labyrinth, which is a kind of cave. And the art on the walls of the ruined palaces of the ancient civilization on Crete shows young men leaping over the back of a charging bull in some sort of public specta-

cle. Today in Arles and the surrounding countryside, just slightly to the west of Chauvet, young men dressed in white enter circular arenas where they try to snatch knitted balls off the tips of the horns of a charging bull and then run to safety. And across southern France and northern Spain, where painted caves are concentrated, traditional bloody bullfights endure, which end usually when the matador plunges a sword into the base of the bull's neck and down into its heart.

All these associations are so close and fit so well that it is difficult not to believe that they are proof of a direct heritage. But that heritage may not be there after all. Yanik Le Guillou, the archaeologist who put the camera on the end of a pole, is a thin, dark man, erudite and contemplative. He sent me a letter with a persuasive warning against assuming too much. "This kind of arm and fingers," he wrote, "is similar to what we know about Upper Paleolithic human hand and arm drawings. But in those cases we don't have a bull with a human hand, but a human with a bison mask or head. Be careful, this has nothing to do with Picasso or with the Minotaur." He has shrewd reasons for saying this. He continued: "The Minotaur is a bull because the bull was the principal symbol of strength and the principal dangerous animal in (Late) Neolithic times. Besides that, the bull could be domesticated, so eventually you have the possibility of taking power over him. But in Paleolithic times the principal dangerous animals are lions, mammoths, cave bears, and rhinoceroses. In Paleolithic times there is no domestication or even the beginnings of pre-domestication. The bull doesn't contain the strength of nature. The power in animals, like the power in nature, is not through the bull. The Minotaurisation of our bull is a snap judgment. There is no filiation. Except in the mind of people who desperately look for original filiations."

I guess I could be one of those people. "Just let your mind go,

but never in contradiction with the facts," he said later in the letter. "That's the archaeologist's way and the way I try to look at these drawings." But when I let my mind go, it goes straight to the Minotaur, although I know that Yanik's warning is prudent. I'm sure I should heed it more than I will in the following sentences. European culture began somewhere. Why not right here, where someone painted a woman and a bison-man on a stone pendant 32,000 years ago? That coupling of human and beast is embedded so deeply in our psyche that it has endured in myth and spectacle ever since.

We can see by traces left on the floor and by a few lines or dots painted even in the farthest depths of Chauvet that the ancient people went everywhere in the cave no matter how difficult the passage became. To explore a small passage beyond the End Chamber, someone went thirteen feet straight down using the wall as support, and then slid through some narrow openings before climbing more than six feet to gain a small overhang. After pushing into every last corner of the cave, the artists chose only certain walls for their paintings, ignoring others that would appear to be equally suitable. They made the paintings in Chauvet quickly, and once done, the paintings were seldom visited again.

In fact, it could be that they were *never* visited again. Perhaps cultural reasons prevented it or perhaps a landslide or some other natural event had covered the entrance. The hunters made a fire in the End Chamber in front of the pendant with the woman and the bull. Its purpose was probably to produce charcoal to use in making the paintings. Today the floor in the chamber is littered with charcoal fragments. If there had been even a single later visit, those fragments would have been trampled into dust. At Chauvet, as opposed to caves like Les Trois-Frères and Lascaux, there are no

large walls with hundreds of engravings, one superimposed on another. To make that many engravings required repeated visits by a number of different individuals. But at Chauvet there are so few human traces left in the cave other than the art—some hearths and charcoal, a few flint blades, the bear skull on the rock, some rocks piled intentionally here and there, and a trail of footprints—that the number of people who came into the cave must have been few and the number of entries few indeed. Whatever purpose the paintings served apparently lasted for generation after generation without the paintings needing to be visited, worshiped, or even so much as seen. Nor did the paintings need to be re-created in cave after cave. If that had been the case, the 20,000 years the cave-painting culture lasted would have produced far more caves than there are, even assuming there are twice or three times as many caves as we presently know still undiscovered. Evidently, once a cave was painted, it remained potent for eons.

There was, however, at least one visitor who explored Chauvet about 27,000 years ago, long after the paintings were finished. Judging by the size of the footprints and by two prints left on the walls by a clay-stained hand, the visitor was about ten years old. The child carried a torch and touched it to the wall regularly, leaving a series of charcoal marks. These brushes against the stone served two purposes. They knocked off the ash that forms at the top of a torch just as it does on the end of a cigarette. The marks also described a path so the child could find the way out of the cave. The torch proves that the child wasn't lost, but had entered the cave prepared to explore it. There are no other tracks; the child was there alone. What was happening? Was it just an adventurous and inquisitive kid or was it some special ritual where for some reason a child was sent into the cave alone once every few thousand years? Either way, that child was the last visitor to Chauvet until Jean-Marie Chauvet and his two friends let them-

selves down through a hole in the ceiling late one December afternoon in 1994.

After Cosquer and Chauvet, Jean Clottes never suspected that the third great controversy of his career would last so long or turn so personal. In fact, he had no premonition that it was even coming and he remains bewildered and frustrated by it to this day—especially since the onslaught followed what he thought was one of the most fruitful, even joyous, periods in his career.

The problems began in September 1996 when he and David Lewis-Williams, a South African anthropologist, published a book called *Les chamanes de la préhistoire: Trans et magie dans les grottes ornées* (*The Shamans of Prehistory: Trance and Magic in the Painted Caves*). This was a major attempt by two leading figures to interpret prehistoric art. The two risked this approach even though interpretation had become less and less common since Leroi-Gourhan's spectacular attempt had eventually collapsed under its own weight. Clottes and Lewis-Williams proposed that often—not always, but often—the art had been created by tribal shamans who were trying to reproduce the visions they saw while in a magic trance. They said that the shamans could have induced their trances by many different methods, including drugs.

When *Shamans* appeared, Jean Clottes was part of a group of about a dozen specialists doing research in the caves in the Pyrenees. From time to time they would meet for two days in Toulouse in order to discuss their work. During those meetings, there was never a single discussion concerning the interpretation of the art nor, by extension, of Jean's new book and its thesis. At Chauvet in 1998, while Jean was directing the first archaeological investigation of the cave, the seven specialists in Paleolithic art who were part of the team, all of them longtime friends and associates, never

mentioned the book during the month they were there except—and this was worse than not mentioning it at all—in a kidding manner. The most aggravating slight came from a guide at a cave named Isturitz-Oxocelhaya in the western part of the Pyrenees. The small store at the cave had all the other books by Jean Clottes but not *Shamans*. Why not? "Oh," the guide said, "it's not scientific. It's just a crazy notion." The reviews of the book were about equally mixed—favorable, unfavorable, and neutral—but the unfavorable reviews were often virulent and mocking. One had a title that has become notorious: "Membrane and Numb Brain. A Close Look at a Recent Claim for Shamanism in Paleolithic Art."

What caused all these strident reactions? It certainly wasn't the book itself—or was it? Although neither Jean Clottes nor David Lewis-Williams knew it at the time, the idea for *Shamans* was hatched in June 1994 when the two men, who had been acquainted for many years, met again during a major colloquium on rock art in Flagstaff, Arizona. Jean Clottes had been pondering the forbidden subject of interpretation and now here was Lewis-Williams, who, several years earlier, had proposed a novel but controversial interpretation.

David Lewis-Williams made his reputation with his work on rock art paintings in the Drakensberg Mountains of South Africa. These are elegant paintings by the San people created during the nineteenth century or earlier. They are complex and varied but often show herds of elongated elands with tiny heads. Some of the elands have human features. Smaller human figures sometimes float above the herds. They hold thin sticks and are riding on long, thin shapes that make the people, incongruously, appear to be skiing. Although these paintings were taken at first as mere representations of the animals and of people dancing, Lewis-Williams in 1981 published *Believing and Seeing: Symbolic Meanings in Southern San Rock Paintings,* in which he established that the paintings

were really a spiritual meditation. The paintings were especially concerned with trances, with visions seen in trances, and with shamanistic rituals. Seeing the paintings in this light, Lewis-Williams was able to construct persuasive readings that accounted both for the major figures and for smaller figures that had previously been inscrutable.

Lewis-Williams continued studying the relation between shamanism and rock art and, audaciously, in 1988 he extended his analysis to prehistoric art in Europe. He, along with a colleague named T. A. Dowson, published a paper titled "The Signs of All Times: Entoptic Phenomena in Upper Palaeolithic Art" in *Current Anthropology*, a prestigious journal with a provocative format. With each major article, *Current Anthropology* invites twelve to fifteen experts, especially experts who would be known to disagree, to write commentary that is published after the article. Then the author of the article writes a reply to the commentary. The language in these exchanges is usually scholarly and polite, but occasionally it turns cranky. The responses to "The Signs of All Times" were polite on the whole, including one by Paul Bahn, who eight years later would write the "Membrane and Numb Brain" review of *Shamans*. Bahn takes exception to this point and that, but he concludes by saying that the authors' future studies "may well take us as far as we are ever likely to get into the minds of the Palaeolithic artists."

In "The Signs of All Times," Lewis-Williams and Dowson declare that, while analogies from ethnology were flawed, they have discovered a different path, a "neurological bridge" that could take us back to the Paleolithic Age. That bridge is the human nervous system, which they claim was the same then as now. They say that when drugs, fatigue, pain, insistent rhythms, or other stimuli induce a trance, the nervous system produces a pattern of hallucinations derived from it and not from cultural clues. The

pattern is the same for all people in all cultures at all times. There-fore, Paleolithic hunters had the same pattern of hallucinations during trances that we do.

In particular the authors mean visions derived from the struc-ture of the optic system. They call such visions "entoptic phenom-ena." One example of entoptic phenomena is the jagged lines or herringbone patterns that some people see on the edge of their vision as a prelude to a migraine. Citing a considerable amount of modern research on the effects of mescaline and LSD, Lewis-Williams and Dowson identify six principal entoptic forms: a grid, parallel lines, dots, zigzags, nested curves, and filigrees. They also say that there are three stages of a hallucinatory trance, although they are not necessarily sequential or completely distinct. A sub-ject experiences the entoptic forms and only those forms in the first stage. During the second stage, the subject tries to make sense of the entoptic forms by, for example, seeing a grid as a chessboard. And in the third and final stage, which is usually accompanied by the feeling of flowing through a swirling vortex, the subject expe-riences hallucinations that are so powerful they seem real. This is the stage when a San shaman might feel he had been transformed into an eland. Lewis-Williams and Dowson exhibit several charts showing that the entoptic forms appear in both San and Paleolithic art. More than that, various images from the art of both cultures appear to apply to each of the three stages of a trance. The sorcerer at Les Trois-Frères and the other man-animal figures found in Paleolithic art would be images from the third stage of a trance.

Then the paper describes how the structure of the cave itself could have been determined by shamanism and the search for visionary trances. The smaller, difficult, out-of-the-way places that are covered with engravings are where individuals or small groups went to experience visions. The larger galleries were for rituals that many people attended. Thus people might crowd into the Hall of Bulls in Lascaux before only one or two or three went

on to the Apse to seek and engrave their visions. The communally constructed galleries "may have been vestibules where novices absorbed the power of imposing and sometimes ritually renewed depictions before venturing farther into the caves or being left alone for their personal quest." In other words, the large, communal galleries prepared those few going farther into the cave for what they were about to see in their coming visions. Then, having gone deeper into the cave to experience visions, the selected few traced the visionary images they saw on the walls of the cave in order to preserve and remember them. Thus, Lewis-Williams and Dowson say the Paleolithic artists "were merely touching and marking *what was already there.*"

Jean Clottes was familiar with this paper and with the rest of Lewis-Williams's work. He approached him at the colloquium in Flagstaff and said, "David, you are familiar with shamanism, and I have a certain knowledge of Paleolithic art in the caves." He then proposed that the two of them test the theories about shamanism in the painted caves in Europe.

Lewis-Williams replied serenely, "Nothing would give me greater pleasure."

It was more than a year before their trip together began. But finally, in October 1995, they visited twelve caves, including Les Trois-Frères and Lascaux, that were in different parts of France and of many different ages. In the course of this journey Jean became convinced "that shamanism—both the concept of the universe and the practices it engenders in so many regions of the world—responds better than any other to certain particulars of the art of the deep caves." The two men had intended to write only an article after their journey but decided to write a book instead. In fact, they decided to write a daring book. First, it would grapple with the "thorny problem of interpretation," and second, more daring still, it would do so with ethnological analogies.

"Shaman" is a word from the language of a Siberian tribe.

From the time of Marco Polo, European travelers to Siberia had been astonished by certain honored members of the tribe who would dress in animal skins and antlers, dance while beating on a drum, and eventually fall into a frenzied trance. In that condition they could converse with spirits, tell the future, heal the sick, influence game animals, and so on. Similar beliefs and practices turn up in hunter-gathering societies in North and South America, Australia, Asia, and Africa. The means of inducing the trance include dancing; chanting; pain; deprivation of water, food, or light; and eating narcotic or psychotropic plants. Often these inducements are used in combination. But the goal of the trance remains the same: to enter the spirit world. Typically, shamanistic societies think of the cosmos as having three tiers. There is the upper tier of the heavens, then the world of everyday life, and finally the depths of the earth and the world below. The spirits live in the worlds above and below. The tiers are not necessarily sharply separated but tend to blend into one another. Shamans have the ability to travel in their trances from the everyday world into the world above and the world below and commune, not necessarily comfortably, with the spirits that live in both places.

The Shamans of Prehistory consists of the theories Lewis-Williams expressed in "The Signs of All Times" buttressed and expanded by Jean Clottes's intimate knowledge of prehistoric art and life. The authors begin with the bones, shells, and flints stuck into the walls in Enlène and Les Trois-Frères as well as finger tracings and similar examples from other caves where the ancient hunters seemed to be touching the walls of the cave or trying to penetrate them in some fashion. The authors explain this behavior by turning to the shamanistic cosmos with its belief in an underworld. "Understandably enough, they [the Paleolithic people] would have believed that caves led into that subterranean tier of the cosmos. The walls, ceilings, and floors of the caves were there-

fore little more than a thin membrane between themselves and the creatures and happenings of the underworld." And the frequent use of natural features of the cave wall to suggest shape or volume in the paintings shows that the walls themselves influenced the artists who made the images. According to the theories of Annette Laming-Emperaire and André Leroi-Gourhan, the artists had an ideal plan involving the pairing of various animals and they took the plan with them into the cave. But according to Clottes and Lewis-Williams, exactly the opposite is true. It was the shape of the cave wall that imposed certain animals on the artists.

The image of the wall as a membrane between the real world and the spirit world leads Clottes and Lewis-Williams to a particularly beautiful interpretation of the presence of painted hands in so many caves. Usually, the hands were made by placing a hand and forearm against the wall. Then either that person or someone else blew or spat a number of tiny bursts of red paint until the hand and the wall around it were covered. When the hand was removed, the negative image of a hand outlined in red remained on the wall. The authors, though, don't think these hands are pictures in the usual sense. Instead, it "was the act of covering the hand and the immediately adjacent surfaces with (usually red but sometimes black) paint that was important. People were sealing their own or others' hands into the walls, causing them to disappear beneath what was probably a spiritually powerful and ritually prepared substance, rather than "paint" in our sense of the word. The moments when the hands were "invisible," rather than the prints that were left behind were what mattered most . . . Like the pieces of bone in Enlène, the hands thus reached into the spiritual realm behind the membrane of the rock, though in this case paint acted as a solvent that dissolved the rock."

This analysis, and the image of a hand covered with red melting into red-painted rock, has a combination of logic and emo-

tional power that makes it believable. In the final chapter Clottes and Lewis-Williams let their imaginations range further. Using the structure of the caves and analogies with the behavior of contemporary shamanistic societies, they try to explain what happened in the caves. They begin by recapitulating Lewis-Williams's ideas that the larger rooms with well-conceived and finished paintings were a place to prepare those seeking visions for what they were about to see. Since there is always a degree of randomness in hallucinations, this preparation reduced the amount of idiosyncrasy and "tried to discredit any originality and individuality that may have challenged the religious and political status quo." After the communal meeting in the large spaces, a few participants went on to the smaller, isolated areas of the cave. There they pursued their visions and swiftly sketched them on the walls. Or perhaps they searched the bumps and fissures in the wall afterward for vestiges of the visions and sketched in the remainder to re-create what they had seen. That done, the rite was over: "Transformed by their visions, filled with new power and insight, the questers returned through the entrails of the underworld, past the communally produced images that had prepared their minds, and out of the cave to rejoin their society in a new role, the role of shaman, seer, and intrepid penetrator of the underworld."

This whole scene is an imaginative vision itself, but it is not, as some critics claimed, a hallucination. It is consistent with the clear structure of the caves and with typical shamanistic practices around the world. And certain qualities of the paintings themselves, qualities that have puzzled researchers since the discovery of Altamira, support the ideas in *Shamans*. Why do the animals appear to be floating rather than standing on the ground? Why don't the animals appear in natural surroundings with trees, grass, rivers, and other features of the landscape? The painters didn't care at all about the relative size of the animals. A tiny mammoth

might have a huge bison looming over him. How can that be? The animals, generally speaking, don't react to one another. The horses and bison in Leroi-Gourhan's pairing aren't doing anything and don't seem even to be aware of one another. Hunting is filled with drama, blood, and death. Why don't we see that drama? For that matter, as scholars have remarked since Breuil, the animals most frequently painted on the walls are not the ones most frequently hunted. But all of these apparent anomalies make sense if the animals on the cave walls are not real animals after all, despite the realism of the art. Instead, Clottes and Lewis-Williams aver, they were animals first seen as visions in a hallucination. This theory doesn't insist that all the paintings and engravings were done during trances, although some of them probably were. Large compositions such as the Hall of Bulls in Lascaux were obviously planned and took some time to execute. But in many cases their purpose was to reproduce the experience of being in a trance.

Jean Clottes was extremely proud of *The Shamans of Prehistory* and thought that "no other explanation presently available fits and explains more hard Upper Paleolithic evidence." He thought that this shamanistic interpretation would lead future research and mean that *Shamans* was the culmination of a lifetime of work that could take its place beside Breuil's *Four Hundred Centuries of Cave Art* and Leroi-Gourhan's *Treasures of Prehistoric Art*. Clottes's own proud feelings are the reason that the reactions against the book confused, dismayed, and angered him. If the silent treatment from his colleagues had been all, that would have been bad enough. But the attacks from many sides were loud and often personal and it finally got under his skin. In 2001 a new edition of *Shamans* appeared in France, and Clottes added an afterword that responded to his critics. With notes and bibliography it runs eighty

pages. Paul Bahn's "Membrane and Numb Brain" review annoyed Clottes so much that at one point he counts the number of question marks—seven—and the number of exclamation points—fourteen—in the review in an attempt to show that Bahn was not developing a rational argument so much as frothing at the mouth.

And Bahn's review certainly was filled with contempt and ridicule. He said that "these remarkable fantasies make one wonder if the authors have themselves conjured up these visions out of an altered state of consciousness, like latter-day Edgar Cayces." Elsewhere he spoke of scholars who had contracted "shamania."

But the negative chorus included many more than just Paul Bahn. Part of the hostility came simply because, to some people, the discussion of trances and drugs suggested LSD, the excesses of the 1960s, and New Age goofiness. One critic said the book "surpasses in extravagance the psychedelic ravings of the minions of Carlos Castaneda." Then, too, many scholars believe that interpreting the paintings is impossible. "The meaning has disappeared forever," one critic said. Paul Bahn added, "A growing number of researchers have decided to abandon the vain quest for meaning." Therefore, since the meaning of the paintings is exactly what *Shamans* tries to explain, it must be foolhardy and deluded. As for the rest of the criticism, most of it is either unfairly based on misunderstandings or omissions. Some of it is simply personal hostility. It is hardly the first time that has played a role in the highest realms of French prehistory.

To be fairer to the critics than they were to Clottes and Lewis-Williams, *Shamans* does shamelessly argue from analogy by drawing on observations of shamanistic societies in the recent past and in the present and then applying them to the Paleolithic Age. Sometimes these comparisons lead to passages, such as the following, that are far more speculative than they should be: "The vari-

ous participants would have experienced a range of mental states. Those who were most intensely seeking visions may have used psychotropic drugs to induce deep trance. Others, caught up in the ritual dancing and music, believed that they could share some but not all of the insights that the leading shaman, or shamans, experienced. Still other people, on the fringe of the activity, were probably less intensely swept along by the rituals. They experienced euphoria, but did not themselves see visions." Perhaps all this happened, but the authors surely cannot know who among Paleolithic people felt some euphoria and who felt less. This is what Annett Laming-Emperaire feared prehistory might become—a historical novel.

In 2002 David Lewis-Williams published *The Mind in the Cave*, a lengthy book that elaborates the fundamental ideas he and Jean Clottes had expressed in *The Shamans of Prehistory*. But, unfortunately perhaps, the shamanistic theory has not inspired either many converts or new and productive research. Still, *Shamans* is a brave book and an important one. Despite occasional excesses, it confronted the meaning of the cave paintings head-on and argued for an interpretation that was consistent within itself and with the facts presented by the caves. Yes, that interpretation was suggested by ethnographic analogy, but that in itself doesn't mean it is wrong. *Shamans* arrived, it was vilified, and now it is generally ignored by academics. Perhaps its day will come.

CHAPTER 10

Strange, Stylized Women;
The World Below the World

From the first work by the abbé Breuil to Jean Clottes's response to critics of *The Shamans of Prehistory* is almost exactly a hundred years. Except for shamanism, which is not widely accepted, there is still no grand theory of what the cave paintings mean. That is frustrating for scientists and amateurs alike, since as works of art the paintings communicate directly and supremely well. Whatever cultural reasons prompted the ancient hunters to paint in caves, the great artists among them—and there were many—took the trouble to create paintings that had graceful lines, subtle color, precise perspective, and a physical sense of volume. The cave painters may or may not have had the idea of art as we understand it, but when they chose to draw an appealing line instead of an awkward one, they were thinking and acting like artists trying to create art in our sense of the word. That's why it's valid for us to respond to the cave paintings as art and not merely as archaeological evidence, although they are certainly that as well. The multicolored and stylized Chinese Horses in Lascaux, the pride of hunting lions with their eyes ablaze in Chauvet, and the weighty, yet delicately curving bison in Altamira and Font-de-Gaume all prove that beauty truly is eternal.

And that beauty is amplified because, against all logic, the paintings seem familiar as well, close to us in time despite being as far from us in time as any art could possibly be. How is it that they could be locked away in caves, unknown or misunderstood, for eons and yet, once discovered, fit naturally in the Western cultural tradition? The art historian Max Raphael is the only major thinker about the caves who seems much concerned with this question, even though the immediacy of the paintings despite their great antiquity and mysteriousness powerfully affects everyone who sees them. Raphael offered his own Marxist answer to this conundrum, as we've seen. But there is another answer, one that better illuminates the paintings both as art and as archaeology. The paintings speak to us so directly across the millennia because they are the conservative art of a stable society, because they have a comic rather than a tragic view of life, and because they are part of a classical tradition. In fact, they are the triumph of the first classical civilization in the world.

After their beauty, the first thing everyone notices about the cave paintings is that they are repetitive. The same animals in the same or similar poses appear again and again in cave after cave regardless of the date of the paintings. Each species is painted according to convention. The conventions change somewhat over time, but still they are there.

This consistency means that the art in the caves is fundamentally conservative. In modern times we almost demand that art attack the social order or mock it or undermine it in some way, and our art changes as the times change. Cave art, which is unvarying, could not have done that. It must have been a stalwart support of the social order. It sustained the society's beliefs by painting them as unfailing, constant, ever and always the same. And in its role as protector of society and its institutions, the art was spectacularly successful.

The culture that produced the painted caves, despite subtle dif-

ferences belonging to specific times or places, lasted almost unchanged for more than 20,000 years, far longer than any since. Western culture, assuming that it began in the eastern Mediterranean around 2000 BC, is barely 4,000 years old. Because the Paleolithic culture survived so long, it means that the people who created Chauvet 32,000 years ago are almost as far from the people who created Lascaux 18,000 years ago as the people who created Lascaux are from us. A person from the time of Lascaux would be bewildered by our world, but that same person apparently would have been able to drop into the world of Chauvet, understand it immediately, and join in. He may have had to learn to make flint tools with a slightly different shape, but the rhythms of daily life were practically identical.

To last so long that culture must have been deeply satisfying—emotionally, spiritually, intellectually, and practically. It must have engendered and supported a social system that reliably produced and distributed material needs like food, clothing, and shelter. It must have fostered and protected the basic human relations—friend to friend, man to woman, parent to child—or the society would not have been cohesive enough to survive. It must have given convincing answers to questions about the world like Why is the weather colder, then warmer, then colder again? or Why does the sun rise and set? It must have answered in a satisfying way the deep internal questions of each individual—Who am I? What is my purpose? It must have provided believable and profound answers to the great, eternal questions, such as Who created the world and why? And, perhaps most important of all, it must have allowed for an orderly daily existence where people treated one another in accepted, time-honored ways and where there were gatherings, celebrations, solemn ceremonies, and spontaneous bits of fun that soothed the pain and difficulties of their lives.

The caves are so beautiful that it's easy to forget that the rest of that complex and deeply satisfying culture has almost entirely disappeared. All that the Paleolithic people preserved by word of mouth—all the poems, songs, languages, customs, and social order—is lost and cannot be recovered. It is possible that fragments remain in our own ancient myths, but we can never know for sure. As for the visual record, the caves represent only part of all that once was there. The cliffs along the river valleys in France and Spain may once have had immense and magnificent paintings that were as important to the culture as the paintings in the caves. And the ancient hunters may have used other materials to create art that was even more important to them than the paintings in the caves or in the open air. They may have made elaborate creations from feathers or carved intricate wooden totem poles that were the center of the whole community and would cause us to marvel. They may have painted or tattooed their skin in designs we could never imagine. Perhaps, like the native tribes on the American Great Plains, they recorded their history and genealogies on hides that were the society's most precious possession. But the paintings in the open air and anything they made with organic materials such as wood or hides would have disintegrated in a relatively short time.

I don't mean to be blind to the difficulties of life in the Ice Age or to idealize that life, but many of the difficulties seem so only by comparison to our lives today. The skeletons that survive from those days show people who were generally quite healthy, who were as tall and robust as we are, and who often lived for fifty or sixty years. The climate was no colder than southern Sweden is today and food was plentiful most of the time. There was so much game and so much territory compared to so few people that we have no direct evidence of warfare or intentional violence. Even the Neanderthals might have withered away on their own. With food and shelter there for the taking and with a society that, as the

caves prove, had a rich imaginative life and was capable of regularly producing artistic geniuses—with all that, life must have seemed good. Where was any reason to want the world to change?

The art and the beliefs continued for something like a thousand generations because, during all that time, people could see with their own eyes that the world remained ever the same. When the world did change, when the herds of reindeer diminished even as the number of people increased and the weather warmed and the glaciers retreated, then painting in caves ended as well.

The second fundamental quality of the art in the caves is less immediately striking, but it fits very well with a conservative art that supports the accepted social order. The cave paintings are scenes of comedy, not tragedy.

One frustration in studying the art in the caves is that any discussion of its meaning inevitably turns toward the serious. That's because few would doubt that, in the end, the art *is* serious in the way that all great art is serious. But it's misleading—in fact, it's blinding—to think that it is *only* serious and that the ceremonies that may have gone along with it, whether they were religious or not, were necessarily solemn affairs.

The mysterious Unicorn in Lascaux that looks like a man in an animal suit has inspired many bewildering interpretations, but it is far less bewildering to think of it as comic, as some concoction that made Stone Age people smile. The lion in Les Trois-Frères with a tail in the shape of an arm and hand—well, it's funny when you think about it. And there are many more examples of what looks like playfulness in cave art, including visual puns, comic monsters, and different animals sharing the same body or, in one case, just the same nose.

The engravings of people seem particularly playful. There are all those strange, stylized, headless women with huge haunches that taper off into skinny legs without any feet. Often they are drawn pressed together with the breast of one becoming the hip

of her neighbor. They're not funny exactly—at least not to us—but they're not somber either. Leroi-Gourhan and others have assumed that they represent the female principle, but it's difficult to see them that way. The pictures of men don't seem to symbolize any grand principle either. Although the phallus of the Sorcerer of Les Trois-Frères is truly impressive, generally men are represented by cute, grinning faces. They don't give the impression of potent maleness. Their skin is often sagging with age or otherwise deformed. Though they are male, sex doesn't seem to be much of a concern for them. It may not even be within their ability. Yes, there is the lecherous man-bison next to the woman on the hanging rock in Chauvet, but on the whole, contrary to Leroi-Gourhan, the great universal, sexual drama of male and female principles apparently wasn't very much on the minds of the cave painters—at least not while they were painting. Instead they painted a benign world.

I'm not forgetting the four images of killed men, two at Cougnac and one each at Pech-Merle and Cosquer. They apparently show men killed by other people. Perhaps they even show murder or torture. Although we have no other evidence for passionate crimes like murder or for cruelty like torture, it would not be a surprise to learn one day that they existed and that Ice Age art included those themes. But it is surprising that it depicts them so rarely. The killed men are just four images out of thousands.

The cave painters did not make perfectly naturalistic images of men, women, vulvas, or penises, but paintings of hands are nearly always realistic. Their frequency and realism are an argument in favor of Max Raphael's theory of the primacy of the hand in Paleolithic thinking and of its role in leading the cave painters to base their work on the golden section. Of course, hands weren't painted as the animals were, but, as we've seen, were made by placing the hand on the wall and blowing red or black paint around it, thus leaving a negative image. Hands don't appear in every cave, but they are prominently displayed in the many caves where they do

appear. Whether or not the purpose was to cause the hand to appear to melt into the wall, as Jean Clottes declared in his book on shamanism, it is still obvious that touching the wall and leaving a record of the touch was immensely important. Maybe by touching the wall the person received some power from the animals pictured or from the wall itself. Or perhaps it was the other way around— the person transmitted power to the animals or the rock. Then again, perhaps the hands were evidence of a baptism or a genea-logical record where the bent fingers, instead of being a code in the usual sense, show family or clan affiliation. That would explain why some caves contain hands from women, men, and children. One hand from a small child is high enough on the wall that some-one older must have lifted the child and held it while someone blew enough paint around the tiny hand to leave its image on the wall. Whatever power the cave wall gave to people who pressed their hands to it, or whatever power the wall took from them, everyone in the community could share in the process.

The caves must not have been considered so very dangerous and forbidding if everyone in the community, including the small-est children, was welcome to come in and leave a mark. Often, although not often enough for archaeologists, there are ancient footprints in the caves. The footprints always include some left by children. In most cases their different sizes indicate that the chil-dren were of various ages. Sometimes adults were present, some-times not. Certain scholars have theorized that the caves were places for initiation ceremonies. The footprints contradict that the-ory, since some of the children were clearly far too young to be ini-tiates. Also, initiates would all be about the same age, not a variety of ages.

In their art the cave painters revered animals. Only animals were grand and important enough to be worth the trouble of paint-ing them across the walls of a cave. They, not men and women, had

all the leading parts in the great drama of the universe. Here again, however, that drama doesn't seem to be either sexual or tragic. Of course, it's easy to tell bulls from cows and stags from does in the paintings, but in species like horses where sexual differences are less obvious it's often hard to tell whether a painting shows a male or a female. In any case, except for rare scenes like the male reindeer in Font-de-Gaume licking a female, the animals appear indifferent to one another. They don't seem to have sex or to be born or to grow old or to die. In fact, the animals don't even seem to be hunted very often, as the lack of evidence for Breuil's hunting magic theory proves. Their unchanging existence and their muted emotions give the animals in the paintings calm, uneventful lives rather than tragic ones.

The greatest painters must have surveyed their caves in meticulous detail. They needed to find suitable walls, but more than that, they were looking for places in the cave where the walls suggested what should be painted there. Often, after I had spent several hours in a cave, or when I had visited several caves in succession in a single day, I would sometimes think I saw an animal painted or engraved on a wall; when I looked more closely, nothing was there. The contours of the wall had suggested a head or chest or horns and the play of shadows along with some colored stains from minerals had made me think I was seeing a horse or a bison.

This confusion annoyed me at first. But eventually I realized that it was inevitable in a cave because the expectation of discovering new paintings or engravings, even on cave walls that had been studied thoroughly, was perfectly sensible. At Les Combarelles a guide who had shown a particular wall to tourists hundreds of times noticed a bear's head about a foot across that no one had seen before. Jean Clottes had been in Niaux countless times and even written a book about the cave. But on a recent visit, as he regarded

a wall he thought he had studied thoroughly, he looked again at two black converging lines and realized they were the horns of an ibex. Shapes in the rock formed the body of the animal. So at last it occurred to me that seeing animals in the rock must have been desirable, perhaps even the primary purpose of the art. The paintings and engravings—maybe not all of them, but many—weren't adding animals on top of the rock but were a means of pulling out of the stone the animals that were already there. With the rock's shape as a start, the artists could begin to lay out the plan for their work.

Some caves have mostly paintings and others have mostly engravings. Some large ones like Lascaux have both, although the paintings and the engravings each seem to be relegated to their own chambers. Paintings tend to be near the front of the cave while the engravings are often far from the entrance in difficult passageways where only one or two people could fit. The painted chambers are planned. The paintings do overlap on occasion but by and large these paintings are left whole and respected. These chambers, like the Hall of Bulls and the Axial Gallery in Lascaux, must have contained the knowledge and wisdom of the culture— the stories, certainly, but also perhaps history, mythology, cosmology, and maybe genealogy. These are works of general meaning and prominent as they are it would have been expected that everyone who entered the cave saw them.

The engraved chambers are quite different. They don't seem to be planned because the engravings are made over one another in wild profusion. Here the preceding work is not purposely destroyed or defaced. It's just ignored as the next artist worked. This work is more personal and could not have been intended for everyone to see.

These two parts are somehow united. Jean Clottes and Lewis-Williams thought that the painted portions were used to prepare

individuals for the visions they would have in the private portions. That makes sense even if the shamanism is dropped out. Somehow the big rooms are the universal; they are located first in the cave. Then farther in are the private locations, where individuals engraved on the wall their own personal ideas, thoughts, visions. This art is less predictable than the paintings in the large rooms. The engravings are each the ideas of a single person, although of course they are informed by the society's shared beliefs. The paintings were the considered art of the whole society.

That means that it is possible to think of the paintings, particularly such grand an intricate compositions as the Hall of Bulls in Lascaux, as similar to other public art that expresses the unified beliefs of a whole society. In that way the cave paintings are like the bas-relief sculptures on the pediments of the Parthenon, which portray a rich unifying mythology and were executed, like the cave paintings, by the hands of anonymous artists. In fact the comparison with the Parthenon is precise since the cave painters were working in their own classical tradition, just as the Greek artists were. The qualities that define classicism—dignity, strength, grace, ease, confidence, and clarity—are also the principal qualities of the cave paintings. Above all, the essence of classical art is that it aspires to imitate nature by creating images of nature's ideal forms. In the Paleolithic era the ideal forms were not the Discus Thrower or the David. They were horses, bison, mammoths, and the other species that obsessed the early artists, all created as ideals. The horses and bison are perfect horses and bison, never old or sick or dying, and the detailed knowledge of the anatomy of the animals is repeated in the Greeks' understanding of human anatomy. Even, or perhaps especially, the unvarying conventions in the painting of these ideal animals—the poses in profile, the curving horns in twisted perspective—are themselves as much a sign of the classical sensibility as is the standing figure with one

bent leg in Greek sculpture. The cave paintings possess classical ideas, classical grace, classical confidence, and classical dignity, and that is why they feel familiar and appear to be a direct part of our heritage. We connect so closely with the cave art because the Greek and Renaissance masters have unwittingly taught us, to appreciate it.

To the Greek artists, perfecting the forms found in nature expressed the highest philosophical ideals. The same is true for the cave painters. Their beautiful but placid and repetitive art, based on perfecting the forms of animals found in nature, was not only the first great art but also the first great philosophy, the first attempt we know of to put meaningful order to the chaos of the world. How liberating, how frightening, and how seductive that must have been! No wonder then that from time to time those first rough but civilized people left the churning, fecund world above and went down into the caves, which were empty and sterile, and there, whether collectively in the great painted chambers or individually in the remote engraved tunnels, they summoned the shades of animals trapped in the rock. Then they watched as the world below the world, which their efforts had set free, flickered in the dim light of lamps burning in their hands.

ACKNOWLEDGMENTS

I could not have written this book without Jean Clottes's friendship and help. From the moment I arrived at his home in Foix, practically without introduction, he was kind, informative, and patient with me. As I pressed on with my research, often stumbling as I did, he was always there to answer questions and to offer encouragement when I needed it. He opened certain doors for me that would never have opened otherwise, and he helped me avoid numerous errors. I will be eternally grateful for his kindness and generosity.

Two friends and confidants of many years, Stephen Harrigan and William Broyles Jr., read the manuscript and made many helpful suggestions. Every writer needs friends he can trust to say the truth. Steve and Bill are mine.

I'm grateful to my editor, Ann Close, for believing in this book and helping me immeasurably with it. My agent, David McCormick, handled all business details impressively and provided excellent editorial advice as well.

By opening up Les Trois-Frères to me, Robert Bégouën not only advanced this book but also gave me one of the very best days of my life. His son Eric has also been of great help.

Laure Emperaire took time during a very busy period in her life to share with me memories of her mother, Annette Laming-Emperaire.

The warmth with which I was welcomed by archaeologists in France sustained me throughout my research and writing.

Georges Sauvet of the University of Paris was particularly generous with his time and knowledge. Brigitte and Gilles Delluc, husband-and-wife prehistorians, greeted me with friendship and extraordinary hospitality. In particular they shared their memories of André Leroi-Gourhan. Claudine Cohen of the École des Hautes Études en Sciences Sociales kindly shared with me some of her vast knowledge of the history of prehistory. During my stay with the team studying Chauvet, I was privileged to meet many talented scientists, who were without exception friendly and helpful. For that I would like to thank Norbert Aujoulat, Valérie Feruglio, Carole Fritz, Bernard Gely, Jean-Michel Geneste, Yanik Le Guillou—who also corresponded with me afterward—Gilles Tosello, and Florian Berrouet. Ludivine Moreno was gracious and informative during several tours of Niaux.

In the midst of my research I had several detailed conversations about this book with the historian H. W. Brands. His comments were especially helpful in setting me on the right path. At the beginning of my research my friend from high school Norman Yoffee, now of the anthropology department at the University of Michigan, helped me with contacts and was consistently reassuring. John Speth, also of the University of Michigan, spent a long morning with me working through various nuances of anthropology. He also read the manuscript and made extensive comments that both saved me from errors and asked incisive questions. Richard Klein of Stanford generously shared with me some of his deep understanding of human evolutionary development.

Nancy McMillen was an immense help in assembling the illustrations.

And, of course, this book would have been impossible without my children and without my wife, Tracy.

NOTES

Works cited in brief in these notes are cited in full in the bibliography. When the source of information or of a quote is clearly identified in the text, I have not repeated the reference here.

1 / The Seductive Axe; The Well-Clothed Arrivals

20–24 *profusion of animals:* Kurtén (1968, 1976), Powers and Stringer (1975), Spiess (1979), Sonneville-Bordes (1986), Gordon (1988), de Beaune (1995), Lister and Bahn (2000), Cohen (2002).

24–32 the earliest humans: Klein (1999).

27 *well-regarded scholars:* Kohn and Mithen (1999).

30 *a neurological change:* Klein with Edgar (2002).

30 *Scientists who disagree:* Zilhão (2001), Clark (2001), Wolpoff et al. (2004), and Speth (2004), among others outside this book's bibliography.

31 *infused with sentimentality:* Zilhão (2001).

31 *One scholar:* Solecki (1971).

32 *for 100,000 years:* Jordan.

33 description of the Neanderthals: Trinkaus and Shipman (1994), Mellars (1996), Tattersall (1999), Jordan (1999).

34 *one influential paper:* Berger and Trinkaus (1995).

34 *animal fat:* Cachel (1997).

35 *could speak or not:* Mellars (1996, 1998).

35 *their society remained primitive:* Stringer and Gamble (1993), Mellars (1996).

35 *buried their dead:* Mellars (1996), d'Errico (2003).

35 *rodents brought in the pollen:* Sommer (1999).

37 *One theory:* Wolpoff and Caspari (1997), Wolpoff et al. (2000), Wolpoff and Coolidge (2004).

38 *international scientific team:* Krings et al. (1997).

38 *a different international team:* Ovchinnikov et al. (2000).

38 *did not become our ancestors:* This point is not settled among scientists, or at least among some scientists. The view expressed in these pages is the

majority view by far, but Wolpoff, Speth, Zilhão, Clark, and others contest it fervently.

39 *difference in birth rate:* Zilhão (2001).

39 *large mammals:* Stewart et al. (2003).

39 *climate grew more severe:* Stringer and Gamble (1993).

40 *hunter-gatherer societies that still survive:* Gat (1999).

41 *Arcy-sur-Cure:* Mellars (1999), White (2001).

41 *wasteland in southwestern Spain:* Straus (2005).

2 / A Skeptic Admits His Error; The Passion of Miss Mary E. Boyle

44 discovery of Cro-Magnon skeletons: Camps (1991), White (2003).

45–46 nineteenth-century background: Hammond (1982), Murray (2001), Trinkaus and Shipman (1994).

46 *the brilliant Gabriel de Mortillet:* Reinach (1899), Trinkaus and Shipman (1994), Richard (1999a).

48–54 Sautuola and the discovery of Altamira: Murray (2001), Bahn (1996,1998), Bahn and Vertut (1999).

54 Chiron and his theories: Bahn and Vertut (1999).

55 discoveries at La Mouthe, Font-de-Gaume: Cartailhac (1902), Bahn and Vertut (1999).

57 Breuil's early life and his work with Cartailhac at Altamira: Breuil (1952), Broderick (1973; first published 1963), Boyle (1963), Bahn and Vertut (1999).

59 Piette: Delporte (1987).

59 *collection of prehistoric objects:* Chollot (1964).

68–72 *Battle of the Aurignacian:* Reinach (1899), Trinkaus and Shipman (1992), Richard (1999a), Cohen (1999).

72–75 Breuil's later life: Brodrick (1973; first published 1963), Boyle (1963).

74 *interview after Breuil's death:* Boyle (1963).

3 / Noble Robot, an Inquiring Dog; The Abbé's Sermons on the Mount

80–91 *On a Sunday afternoon:* The account of the discovery of Lascaux comes from Arlette Leroi-Gourhan et al. (1979), Ruspoli (1987), B. Delluc and G. Delluc (1989, 2003a, 2003b), Russot (1990).

4 / The Great Black Cow; How to Paint a Horse

92 *"What little I've learned":* B. Delluc and G. Delluc (2003b).

93 *highest point:* Personal observation.

95–120 Except when otherwise noted, the discussion of Lascaux in these pages is based on Geneste (2003) and Aujoulat (2004).

98 *"twisted perspective":* Breuil (1952).

113 *a separate entrance:* Aujoulat (2004).

113 *thousands of dots:* Clottes (2003b).

5 / A Stormy Drama Among Bison; The Golden Section

121–123 The details of Raphael's life come from the introduction to Raphael (1986).

122 *wrote in a letter:* Raphael (1986).

6 / A Lively but Unreliable Creation; Quaint, Symbolic Arrows

135 *mailed a typed manuscript:* Laming-Emperaire (1962).

136–139 *the precise image:* Details of Laming-Emperaire's life come from Lavallée (1978), André Leroi-Gourhan (1981), and correspondence and conversations with her daughter Laure Emperaire.

7 / The Trident-Shaped Cave; Pairing, not Coupling

148 *seething, divisive feud:* Françoise Audouze worked with Leroi-Gourhan, collaborated on papers with him, and is the editor of a book in his honor. Still, in 2002 she wrote in the *Journal of Archaeological Research*, "Acknowledging innovations or ideas of other prehistorians was not one of Leroi-Gourhan's traits. Bibliographic references are minimal, and he never acknowledged his debt to . . . Laming-Emperaire or Raphael." She should know better. He did not acknowledge Raphael, it's true, but he acknowledged Laming-Emperaire extensively.

In the course of my research, I heard as a solemn truth that Laming-Emperaire concentrated her work on Brazil because Leroi-Gourhan had used her ideas to become so dominant in prehistory that there wasn't any room left for her. This ignores the fact that work with her husband took her to Brazil long before *La signification* was published. Also, the photograph from 1975 reproduced in the text shows her working diligently in caves beside Leroi-Gourhan, so they maintained some kind of relationship even near the end of her life. Still, there was something between them, some resentment that was taken up by her family and that time has not soothed. When I asked Laure Emperaire what her mother thought of Leroi-Gourhan, she refused to discuss the subject at all.

149 *a cave named Le Portel:* A. Leroi-Gourhan (1967).

151 *But he did:* And both he and she acknowledged each other again and again. She had begun her thesis under a different professor. According to her preface to *La signification,* when she changed to the guidance of Leroi-Gourhan, he was already "working at that time on a monumental work on the evolution of Paleolithic art." And she is not at all resentful about his influence over her or his role in her career and the development

of her thinking. On the contrary, she has nothing but the most glowing praise for him. It was a fruitful period, she says, "a time of collaboration when André Leroi-Gourhan, with the simplicity and cordiality that are habitual with him, argued point by point the different aspects of our [that is, her] study, bringing to the discussion his suggestions and corrections, a constructive period when we had the feeling we were seeing a new and more coherent Paleolithic world reborn before our eyes."

Three years later, in 1965, Leroi-Gourhan's *Préhistoire de l'art occidental* appeared. Its foreword contained his own version of their encounters: "My new thinking first crystallized in connection with Le Portel . . . A real order seemed to me to be reflected in the arrangement of the figures—though what this might be was as yet confused in my mind. At this point both Mme. Laming-Emperaire and I realized that we were very much on the same track. After an exchange of ideas, we decided not to be influenced by each other, but to pursue our separate researches, the better to compare our eventual findings, at least until she completed *La significa-tion de l'art rupestre paléolithique,* the book she was at that time still writing. When we finally compared notes, we saw that if we had both "gone off the track," at least we had done so with the same sense of direction."

These two accounts are completely compatible and both speak of an especially warm and productive relationship.

151–155 Details of Leroi-Gourhan's life come from A. Leroi-Gourhan (1982), Cohen (1984), Delport (1987), Coudart (1999a), Bahn and Vertut (1999), and Audouze (2002).

155 *the chaîne opératoire:* Audouze (2002), A. Leroi-Gourhan (1993).

156 *another permanent contribution:* A. Leroi-Gourhan (1983, 1984), Michelson (1986).

156–160 The analysis of the finds at Pincevent is from A. Leroi-Gourhan (1984).

160 *long index cards:* Brigitte and Gilles Delluc, students of Leroi-Gourhan, showed me several sets of these cards. Brigitte Delluc is the dark-haired woman in the photograph on page 150.

161–164 *Statistics were fundamental:* A. Leroi-Gourhan (1967).

162 *"sexomaniac obsession":* Breuil and Lantier (1965).

162 *Leroi-Gourhan looked:* Clottes (2000).

164 *even Laming-Emperaire:* Laming-Emperaire (1972).

8 / Three Brothers in a Boat; The Sorcerer

169–171 *In July 1912:* Breuil (1952), Bégouën and Breuil (1958).

173 *Robert is the coauthor:* Bégouën and Clottes (1981).

184 *Breuil rediscovered them:* Breuil (1952).

9 / A Passage Underwater; The Skull on a Rock

187–190 biographical details about Jean Clottes: Clottes (1998) and personal correspondence and conversations.

190–195 account of the discovery of Cosquer and the ensuing controversy: Clottes et al. (1992), Clottes and Courtin (1996).

193 *Bahn wrote an article:* Bahn (1992).

195–198 the archaeology of Cosquer: Clottes and Courtin (1996).

196 *Leroi-Gourhan wrote:* A. Leroi-Gourhan (1983).

198–201 the discovery and authentication of Chauvet: Chauvet, Deschamps, and Hillaire (1996), Clottes et al. (2003), and personal conversations.

203 *Michel Lorblanchet:* Lorblanchet (1995).

205 *another, more complex painting:* Clottes (2003b).

209 *radiocarbon dating:* Clottes (2003b).

209 *Craig Packer, a specialist on African lions:* Clottes (2000).

210–213 *more than 420 animals:* Clottes (2003b).

214 *a persuasive warning:* (Yanik Le Guillou, pers. comm., December 16, 2004).

215–217 *traces left on the floor:* Clottes et al (2003).

217 *Jean Clottes was part of a group:* Clottes and Lewis-Williams (2001).

218 *title that has become notorious:* Bahn (1997).

218 *knew it at the time:* Clottes and Lewis-Williams (2001).

221–225 *Jean Clottes was familiar:* Clottes and Lewis-Williams (2001).

222–223 *"Understandably enough":* Clottes and Lewis-Williams (1998).

226 *Bahn's review:* Bahn (1997). The other reviews are all quoted from Clottes and Lewis-Williams (2001).

227 *"The various participants":* Clottes and Lewis-Williams (1998).

BIBLIOGRAPHY

Adovasio, J. M., et al. "Upper Palaeolithic Fibre Technology." *Antiquity* 70 (1996): 526–524.

Airvaux, J. "Découverte d'une grotte ornée, le réseau Guy Martin à Lussac-les-Châteaux (Vienne), et application d'une méthodologie structurale pour l'étude de l'art préhistorique." *L'Anthropologie* 102, no. 4 (1998): 495–521.

Allemand, L. "Qui sauvera Lascaux?" *La Recherche* 363 (April 2003): 26–33.

Amormino, V. "L'art paléolithique et le carbone 14." *L'Anthropologie* 104, no. 3 (2000): 373–381.

Anati, E. *La religion des origines.* Paris: Hachette, 1999.

Archambeau, M., and C. Archambeau. *Les Combarelles.* Périgueux: Pierre Fanlac, 1989.

———. "Les figurations humaines pariétales de la grotte des Combarelles." *Gallia Préhistoire* 33: (1991): 53–81.

Arsuaga, J. L. *The Neanderthal's Necklace.* New York: Four Walls Eight Windows, 2002.

Audouze, F. "New Advances in French Prehistory." *Antiquity* 73, no. 79 (1999): 167–175.

———. "Leroi-Gourhan, a Philosopher of Technique and Evolution." *Journal of Archaeological Research* 10, no. 4 (2002): 277–306.

Audouze, F., and André Leroi-Gourhan. "France: A Continental Insularity." *World Archaeology* 13, no. 2 (1981): 170–189.

Aujoulat, N. "L'espace Suggére." *Les dossiers d'archéologie* 152 (1990): 12–23.

———. *Lascaux: Le geste, l'espace et le temps.* Paris: Seuil, 2004.

Aujoulat, N., et al. "La grotte ornée de Cussac." *Bulletin de la Société Préhistorique Française* 99 (2002): 129–137.

———. et al. *La Vézère des origines.* Paris: Ministère de la Culture, 1991.

———. et al. "The Decorated Cave of Cussac: First Observations." *Paleo* 13 (2001).

Bachechi, L., et al. "An Arrow-Caused Lesion in a Late Upper Palaeolithic Human Pelvis." *Current Anthropology* 38, no. 1 (1997): 135–140.

Bahn, P. G. "Water Mythology and the Distribution of Palaeolithic Parietal Art." *Proceedings of the Prehistoric Society* (London) 44 (1978): 125–134.

———. "Inter-Site and Inter-Regional Links During the Upper Palaeolithic: The Pyrenean Evidence." *Oxford Journal of Archaeology* 1, no. 3 (1982): 247–268.

———. "Prehistoric Wonder or Mammoth Red Herring?" *Independent on Sunday,* January 12, 1992.

———, ed. *The Cambridge Illustrated History of Archaeology.* Cambridge: Cambridge University Press, 1996.

———. "Membrane and Numb Brain: A Close Look at a Recent Claim for Shamanism in Paleolithic Art." *Rock Art Research* 14, no. 1 (1997): 62–68.

———, ed. *The Cambridge Illustrated History of Prehistoric Art.* Cambridge: Cambridge University Press, 1998.

Bahn, P. G., and J. Vertut. *Journey Through the Ice Age.* Berkeley: University of California Press, 1997; London: Seven Dials, 1999.

Barrière, C., and M. Suères. "Les mains des Gargas." *Les dossiers d'archéologie* 178 (1993): 46–55.

Barton, C. M., et al. "Art as Information: Explaining Upper Palaeolithic Art in Western Europe." *World Archaeology* 26, no. 2 (1994): 185–207.

Bar-Yosef, O. "The Upper Paleolithic Revolution." *Annual Review of Anthropology* 31 (2002): 363–393.

Bataille, G. *Lascaux, or The Birth of Art,* translated by A. Wainhouse. Lausanne: Skira, 1955.

———. *The Tears of Eros,* translated by P. Connor. San Francisco: City Lights, 1989.

———. *The Cradle of Humanity: Prehistoric Art and Culture,* edited by S. Kendall; translated by M. Kendall and S. Kendall. New York: Zone Books, 2005.

Beaune, S. A. de. "Palaeolithic Lamps and Their Specialization: A Hypothesis." *Current Anthropology* 28, no. 4 (1987): 569–577.

———. "Nonflint Stone Tools of the Early Upper Paleolithic." In *Before Lascaux: The Complex Record of the Early Upper Paleolithic,* edited by H. Knecht, A. Pike-Tay, and R. White, 163–191. Boca Raton, FL: CRC Press, 1993.

———. *Les hommes au temps de Lascaux.* Paris: Hachette, 1995.

———. "Chamanisme et préhistoire." *L'Homme* 147 (1998): 203–219.

Beaune, S. A. de., and R. White. "Ice Age Lamps." *Scientific American,* March 1993, 108–113.

Bibliography

Bednarik, R. G. "Le cas des lions hermaphrodites." *L'Anthropologie* 96, nos. 2/3 (1992): 609–612.

——. "Art Origins." *Anthropos* 89 (1994): 169–180.

——. "A Taphonomy of Palaeoart." *Antiquity* 68, no. 258 (1994): 68–75.

——. "Concept-Mediated Marking in the Lower Palaeolithic." *Current Anthropology* 36, no. 4 (1995): 605–634.

Bégouën, H. "The Magic Origin of Prehistoric Art." *Antiquity* 3 (1929): 5–19.

Bégouën, H., and H. Breuil. *Les cavernes du Volp.* Paris: Arts et Métiers Graphiques, 1958.

Bégouën, R., and J. Clottes. "Apports mobiliers dans les cavernes du Volp." Altamira Symposium, Madrid-Asturias-Santander, 1981.

——. "Grotte des Trois Frères." In *L'art des cavernes.* Paris: Ministère de la Culture—Imprimerie nationale, 1984.

——. "Les Trois Frères After Breuil." *Antiquity* 61 (1987): 180–187.

——. "Portable and Wall Art in the Volp Caves, Montesquieu-Avantès (Ariège)." *Proceedings of the Prehistoric Society* (London) 57, pt. 1 (1991): 65–79.

Beltran, A., ed. *The Cave of Altamira.* New York: Abrams, 1998.

Berger, T. D., and E. Trinkaus. "Patterns of Trauma among the Neandertals." *Journal of Archaeological Science* 22 (1995): 841–852.

Berghaus, G., ed. *New Perspectives on Prehistoric Art.* Westport, CT: Praeger, 2004.

Bisson, M. S. "Nineteenth-Century Tools for Twenty-First-Century Archaeology? Why the Middle Paleolithic Typology of François Bordes Must Be Replaced." *Journal of Archaeological Method and Theory* 7, no. 1 (2000): 1–48.

Bocquet-Appel, J.-P., and P.-Y. Demars. "Neanderthal Contraction and Modern Human Colonization of Europe." *Antiquity* 74 (2000): 544–552.

——. "Population Kinetics in the Upper Palaeolithic in Western Europe." *Journal of Archaeological Science* 27 (2000): 551–570.

Boule, M. "Émile Cartailhac." *L'Anthropologie* 31, nos. 5/6 (1921): 587–608.

Boyle, M. "Recollections of the Abbé Breuil." *Antiquity* 37, no. 145 (1963): 12–18.

Breuil, H. "Essai de stratigraphie des dépôts de l'Âge du Renne." Périgueux: Première Congrès Préhistorique de France, 1905.

——. *Beyond the Bounds of History.* London: Gawthorn, 1949.

——. *Four Hundred Centuries of Cave Art,* translated by M. E. Boyle. Montignac: Dordogne Centre d'études et de documentation préhistoriques, 1952.

Bibliography

Breuil, H., and Raymond Lantier. *The Men of the Old Stone Age (Paleolithic & Mesolithic)*, translated by B. B. Rafter. New York: St. Martin's Press, 1965.

Brodrick, A. H. *Father of Prehistory: The Abbé Breuil*. Westport, CT: Greenwood Press, 1973. First published 1963 by Morrow.

Byrne, R. Introduction to Part 1, *Creativity in Human Evolution and Prehistory*, edited by S. Mithen. London: Routledge, 1998.

Cachel, S. "Dietary Shifts and the European Upper Palaeolithic Transition." *Current Anthropology* 38, no. 4 (1997): 579–603.

Camps, G. "Cro-Magnon: Une découverte en perpétuel devenir." *Les dossiers d'archéologie* 156 (1991): 4–13.

Capitan, L., and Jean Bouyssonie. *Limeuil: Son gisement à gravures sur pierres de l'Age du Renne*. Paris: Librairie Émile Nourry, 1924.

Cartailhac, É. *L'Age de Pierre dans les souvenirs et les superstitions populaires*. Paris:1877.

———. *Les Ages préhistoriques de l'Espagne et du Portugal*. Paris: Reinwald, 1886.

———. "Les cavernes ornées de dessins. La grotte d'Altamira, Espagne. 'Mea culpa' d'un sceptique." *L'Anthropologie* 13, no. 1 (1902): 348–354.

Cartailhac, É., and H. Breuil. *La Caverne d'Altamira à Santillane près Santander (Espagne)*. Monaco: 1906.

Chase, P. G., and April Nowell. "Taphonomy of a Suggested Middle Paleolithic Bone Flute from Slovenia." *Current Anthropology* 39, no. 4 (1998): 549–553.

Chauvet, J.-M., E. B. Deschamps, and C. Hillaire. *Dawn of Art: The Chauvet Cave*. New York: Abrams, 1996.

Chippindale, C. "Current Issues in the Study of Paleolithic Images." *American Journal of Archaeology* 103, no. 1 (1999): 113–117.

———. "Studying Ancient Pictures as Pictures." In *Handbook of Rock Art Research*, edited by D. S. Whitley, 247–272. Walnut Creek, CA: AltaMira Press, 2001.

Chollot, M. Catalog, *Collection Piette*, by Musée des antiquités nationales. Paris: Éditions des Musées nationaux, 1964.

Christensen, J. "Heaven and Earth in Ice Age Art: Topography and Iconography at Lascaux." *Mankind Quarterly* 36, no. 3/4 (1996): 247–259.

Churchill, S. E., and F. Smith. "Makers of the Early Aurignacian of Europe." *Yearbook of Physical Anthropology* 43 (2000): 61–115.

Clark, G. A. "Migration as an Explanatory Concept in Paleolithic Archaeology." *Journal of Archaeological Method and Theory* 1, no. 4 (1994): 305–343.

———. "The Logic of Inference in Transition Research." In *Questioning the*

Bibliography

Answers: Re-solving Fundamental Problems of the Early Upper Paleolithic, edited by M. A. Hays and P. T. Thacker. Oxford: Archaeopress, 2001, 39–47.

Cleuziou, S., et al. "The Use of Theory in French Archaeology." In *Archaeological Theory in Europe,* edited by I. Hodder, 91–128. London: Routledge, 1991.

Clottes, J. "The Parietal Art of the Late Magdalenian." *Antiquity* 64, no. 244 (1990): 527–548.

——. "Paint Analyses from Several Magdalenian Caves in the Ariège Region of France." *Journal of Archaeological Science* 20 (1993): 223–235.

——. *Les Cavernes de Niaux: Art préhistorique en Ariège.* Paris: Seuil, 1995.

——. "Perspectives and Traditions in Paleolithic Rock Art Research in France." In *Perceiving Rock Art: Social and Political Perspectives; ACRA, The Alta Conference on Rock Art,* edited by K. Helskog and B. Olsen. Oslo: Novus forlag, 1995.

——. "Rhinos and Lions and Bear (Oh, MY!)." *Natural History,* May 19, 1995: 30–34.

——. "Thematic Changes in Upper Paleolithic Art: A View from the Grotte Chauvet." *Antiquity* 70 (1996): 276–288.

——. "Art of the Light and Art of the Depths." In *Beyond Art: Pleistocene Image and Symbol,* edited by M. Conkey et al. 203–216. San Francisco: California Academy of Sciences, 1997.

——. *Voyage en préhistoire.* Paris: Maison des roches, 1998.

——. *La vie et l'art des Magdaléniens en Ariège.* Paris: Maison des roches, 1999.

——. *Grandes girafes et fourmis vertes.* Paris: Maison des roches, 2000.

——. "Paleolithic Europe." In *Handbook of Rock Art Research,* edited by D. S. Whitley, 459–481. Walnut Creek, Ca: AltaMira Press, 2001.

——. "Caves as Landscapes." *Det Kongelige Norske Videnskabers Selskab* 4 (2003a): 11–30.

——. *Passion Préhistoire.* Paris: Maison des roches, 2003.

Clottes, J., and J. Courtin. *The Cave Beneath the Sea: Paleolithic Images at Cosquer,* translated by M. Garner. New York, Abrams, 1996.

Clottes, J., and D. Lewis-Williams. *Les chamanes de la préhistoire: Trans e magie dans les grottes.* Paris: Seuil, 1996.

——. *The Shamans of Prehistory: Trance and Magic in the Painted Caves,* translated by S. Hawkes. New York: Abrams, 1998.

——. *Les chamanes de la préhistoire: texte intégral, polémique et réponses.* Paris: Maison des roches, 2001.

Clottes, J., et al. "La grotte Cosquer." *Bulletin de la Société Préhistorique Française* 89, no. 4 (1992): 98–128.

Clottes, J., et al. *Chauvet Cave: The Art of Earliest Times*, translated by P. G. Bahn. Salt Lake City: University of Utah Press, 2003.

Cohen, C. "André Leroi-Gourhan, chasseur de préhistoire." *Critique* 15, no. 444 (1984): 384–403.

———. "Abbé Henri Breuil." In Murray, *Encyclopedia of Archaeology: The Great Archaeologists* (1999), 1:301–312.

———. *The Fate of the Mammoth: Fossils, Myth, and History*, translated by W. Rodamor. Chicago: University of Chicago Press, 2002.

———. *La femme des origines*. Paris: Belin-Herscher, 2003.

Cole, S. C. "The Middle to Upper Paleolithic Transition in Southwest France." *Athena Review* 2, no. 4 (2001): 47–52.

Conard, N. J., and M. Bolus "Radiocarbon Dating the Appearance of Modern Humans and Timing of Cultural Innovations in Europe: New Results and New Challenges." *Journal of Human Evolution* 44 (2003): 331–371.

Conkey, M. W. "On the Origins of Paleolithic Art." In *The Mousterian Legacy: Human Biological Change in the Upper Pleistocene*, edited by E. Trinkaus. B.A.R. International Series 164:201–227. Oxford: B.A.R., 1983.

———. "New Approaches in the Search for Meaning? A Review of Research in 'Paleolithic Art.'" *Journal of Field Archaeology* 14, no. 4 (1987): 413–430.

———. "Humans as Materialists and Symbolists: Image Making in the Upper Paleolithic." In *The Origin and Evolution of Humans and Humanness*, edited by D. T. Rasmussen, 95–118. Boston: Jones & Bartlett, 1993.

———. "Structural and Semiotic Approaches." In *Handbook of Rock Art Research*, edited by D. S. Whitley, 273–310. Walnut Creek, CA: AltaMira Press, 2001.

Coudart, A. "André Leroi-Gourhan." In Murray, *Encyclopedia of Archaeology: The Great Archaeologists* (1999). 1: 653–664.

———. "France." In Murray, *Encyclopedia of Archaeology: The Great Archaeologists* (1999), 2: 522–534.

Couraud, C. "Pigments utilisent en préhistoire: Provenance, préparation, mode d'utilisation." *L'Anthropologie* 92, no. 1 (1988): 17–28.

Coye, N. *La préhistoire en parole et en acte*. Paris: L'Harmattan, 1997.

Cremades, M. "La représentation des variations saisonnières dans l'art paléolithique." *L'Anthropologie* 101, no. 1 (1997): 36–82.

Bibliography

Currat, M., and L. Excoffier. "Modern Humans Did Not Admix with Nean-
derthals During Their Range Expansion into Europe." *PLoS Biology* 2, no.
12 (2004): 2264–2274.

Dams, L. "Preliminary Findings at the 'Organ' Sanctuary in the Cave of Nerja,
Málaga, Spain." *Oxford Journal of Archaeology* 3 (1984): 1–15.

———. "Paleolithic Lithophones: Descriptions and Comparisons." *Oxford
Journal of Archaeology* 4, no. 1 (1985): 31–46.

Daubisse, P., et al. *The Font-de-Gaume Cave*, translated by Alain Spiquel.
Périgueux: Fanlac, 1994.

Dauvos, M. "Son et Musique Paléolithiques." *Les dossiers d'archéologie* 142
(November 1989): 2–11.

Davenport, D., and M. Jochim. "The Scene in the Shaft at Lascaux." *Antiquity*
62 (1988): 558–562.

Davidson, I. "The Power of Pictures." In *Beyond Art: Pleistocene Image and
Symbol*, edited by M. Conkey, et al., 125–159. San Francisco: California
Academy of Sciences, 1997.

Davidson, I., and W. Noble. "The Archaeology of Perception." *Current Anthro-
pology* 30, no. 2 (1989): 125–155.

———. "Why the First Colonisation of the Australian Region is the Earliest
Evidence of Modern Human Behavior." *Archaeology in Oceania* 27, no. 3
(1992): 113–119.

Davies, W. "A Very Model of a Modern Human Industry: New Perspectives on
the Origins and Spread of the Aurignacian in Europe." *Proceedings of the
Prehistoric Society* (London) 67 (2001): 195–217.

Davies, W., et al. "The Human Presence in Europe During the Last Glacial
Period III." In *Neanderthals and Modern Humans in the European Landscape
During the Last Glaciation*, edited by T. H. van Andel and W. Davies,
191–220. Cambridge, England: McDonald Institute for Archaeological
Research, Oxford, dist. by Oxbow Books, 2003.

Davis, W. "The Origins of Image Making." *Current Anthropology* 27, no. 3
(1986): 193–215.

de Balbin Behrmann, R., and J. Alcolea Gonzalez. "Vie quotidienne et vie
religieuse: Les sanctuaires dans l'art paléolithique." *L'Anthropologie* 103, no.
1 (1999): 23–49.

Delluc, B., and G. Delluc. *Connaître Lascaux*. Bordeaux: Sud-Ouest, 1989.

———. "Images de la main dans notre Préhistoire." *Les dossiers d'archéologie*
178 (1993): 32–45.

————. "Les figures féminines schématiques du Périgord." *L'Anthropologie* 99, nos. 2/3 (1995): 236–257.

————. *Lascaux Retrouvé.* Périgueux: Pilote 24, 2003.

————. "Marcel Ravidat, inventeur de Lascaux." *Bulletin de la Société historique et archéologique du Périgord* 133 (2003): 491–510.

Delluc, B., G. Delluc, and F. Guichard. "La grotte ornée de Saint-Cirq (Dordogne)." *Bulletin de la Société Préhistorique Française* 84, nos. 10–12 (1987): 364–393.

Delluc, G., with B. Delluc. "Le Sang, la souffrance et la mort dans l'art paléolithique." *L'Anthropologie* 93, no. 2 (1989): 389–406.

Delluc, G., with B. Delluc and M. Rogues. *La nutrition préhistorique.* Périgueux: Pilote 24, 1995.

Delporte, H. *L'image de la femme dans l'art préhistorique.* Paris: Picard, 1979.

————. *Piette, pionnier de la préhistoire.* Paris: Picard, 1987.

Delporte, H., and L. Mons. "Hommage de la S.P.F. à André Leroi-Gourhan." *Bulletin de la Société Préhistorique Française* 84, nos. 10–12 (1987): 324–327.

Demars, P.-Y. "Circulation des silex dans le nord de l'Aquitaine au Paléolithique Supérieur." *Gallia Préhistoire* 40 (1998): 1–28.

d'Errico, F. "Technology, Motion, and the Meaning of Epipaleolithic Art." *Current Anthropology* 33, no. 1 (1992): 94–109.

————. "Birds of the Grotte Cosquer: the Great Auk and Palaeolithic Prehistory." *Antiquity* 68, no. 258 (1994): 39–48.

————. "Notation Versus Decoration in the Upper Palaeolithic: A Case Study from Tossal de la Roca, Alicante, Spain." *Journal of Archaeological Science* 21 (1994): 185–200.

————. "A New Model and Its Implications for the Origin of Writing: The La Marche Antler Revisited." *Cambridge Archaeological Journal* 5, no. 2 (1995): 163–206.

————. "The Invisible Frontier: A Multiple Species Model for the Origin of Behavioral Modernity." *Evolutionary Anthropology* 12 (2003): 188–202.

————. "Neandertal Extinction and the Millennial Scale Climatic Variability of OIS 3." *Quaternary Science Reviews* 22 (2003): 769–788.

d'Errico, F., and P. Villa. "Holes and Grooves: The Contribution of Microscopy and Taphonomy to the Problem of Art Origins." *Journal of Human Evolution* 33 (1997): 1–31.

d'Errico, F., et al. "A Middle Paleolithic Origin of Music?" *Antiquity* 72, no. 275 (1998): 65–80.

d'Errico, F., et al. "Archaeological Evidence for the Emergence of Language, Symbolism, and Music: An Alternative Multidisciplinary Perspective." *Journal of World Prehistory* 17, no. 1 (2003): 1–70.

d'Errico, F., et al. "Neanderthal Acculturation in Western Europe?" *Current Anthropology* 39 (June 1998): S 1–S44.

Dickson, D. R. *The Dawn of Belief: Religion in the Upper Paleolithic of Southwestern Europe.* Tucson: University of Arizona Press, 1990.

Duhard, J.-P. "Images de la chasse au paléolithique." *Oxford Journal of Archaeology* 10, no. 2 (1991): 127–157.

———. "The Shape of Pleistocene Women." *Antiquity* 65 (1991): 552–562.

———. "La dichotomie sociale sexuelle dans les figurations humaines magdaléniennes." *Rock Art Research* 9, no. 2 (1992): 111–118.

———. "Les groupements humains dans l'art mobilier paléolithique français." *Bulletin de la Société Préhistorique Française* 89, no. 6 (1992): 172–183.

Eastham, A., and M. Eastham. "The Wall Art of the Franco-Cantabrian Deep Caves." *Art History* 2, no. 4 (1979): 365–387.

Elkins, J. "On the Impossibility of Close Reading." *Current Anthropology* 37, no. 4 (1996): 185–226.

Eshleman, C. *Juniper Fuse: Upper Paleolithic Imagination and the Construction of the Underworld.* Middletown, CT: Wesleyan University Press, 2003.

Forbes, A, Jr., and T. Crowder. "The Problem of Franco-Cantabrian Abstract Signs: Agenda for a New Approach." *World Archaeology* 10, no. 3 (1979): 350–366.

Formicola, V., et al. "The Upper Paleolithic Triple Burial of Dolni Vestonice: Pathology and Funerary Behavior." *American Journal of Physical Anthropology* 115 (2001): 372–379.

Franciscus, R. G., and S. E. Churchill. "The Costal Skeleton of Shanidar 3 and a Reappraisal of Neandertal Thoracic Morphology." *Journal of Human Evolution* 42 (2002): 303–356.

Freeman, L. G., et al. *Altamira Revisited, and Other Essays on Early Art.* Chicago: Institute for Prehistoric Investigations, 1987.

Fritz, C. "Towards the Reconstruction of Magdalenian Artistic Techniques: The Contribution of Microscopic Analysis of Mobiliary Art." *Cambridge Archaeological Journal* 9, no. 2 (1999): 189–208.

Gamble, C. "Interaction and Alliance in Palaeolithic Society." *Man* 17, no. 1 (1982): 92–107.

Bibliography

————. *The Palaeolithic Settlement of Europe*. Cambridge: Cambridge University Press, 1986.

————. "The Social Context for European Palaeolithic Art." *Proceedings of the Prehistoric Society* (London) 57, pt. 1 (1991): 3–15.

————. "Palaeolithic Society and the Release from Proximity: A Network Approach to Intimate Relations." *World Archaeology* 29, no. 3 (1998): 426–449.

————. *The Palaeolithic Societies of Europe*. Cambridge: Cambridge University Press, 1999.

García, M. A. "La piste de pas humains de la grotte Chauvet a Vallon-Pont-d'Arc." *International Newsletter on Rock Art* 24 (1999): 1–4.

Garcia, M. A., and H. Duday. "Les empreintes de mains dans l'argile des grottes ornées." *Les dossiers d'archéologie* 178 (1993): 56–59.

García Guinea, M. A. *Altamira: The Beginning of Art*. Madrid: 1979.

Gargett, R. H. "Grave Shortcomings: The Evidence for Neanderthal Burial." *Current Anthropology* 30 (April 1989): 157–190.

————. "Middle Palaeolithic Burial Is Not a Dead Issue." *Journal of Human Evolution* 37 (1999): 27–90.

Gat, A. "Social Organization, Group Conflict and the Demise of Neanderthals." *Mankind Quarterly* 39, no. 4 (summer 1999): 437–454.

Gaucher, G. "André Leroi-Gourhan, 1911–1986." *Bulletin de la Société Préhistorique Française* 84, nos. 10–12 (1987): 302–315.

Geneste, J.-M., et al. *Lascaux: Une oeuvre de mémoire*. Périgueux: Fanlac, 2003.

Giedion, S. *The Eternal Present: A Contribution on Constancy and Change*. New York: Bollingen Foundation, dist. by Pantheon, 1962.

Gordon, B. C. *Of Men and Reindeer Herds in French Magdalenian Prehistory*. B.A.R. International. Oxford: B.A.R., 1988.

Gould, S. J. "Up Against a Wall." *Natural History* 7 (1996): 16.

Graves, P. "New Models and Metaphors for the Neanderthal Debate." *Current Anthropology* 32 (December 1991): 513–541.

————. "Gesture and Speech." *Antiquity* 68, no. 259 (1994): 438–445.

Guy, E. "Le style des figurations paléolithiques piquetées de la vallée du Côa (Portugal): Premier essai de caractérisation." *L'Anthropologie* 104 (2000): 415–426.

————. "Esthétique et préhistoire: Pour une anthropologie du style." *L'Homme* 165 (2003): 283–290.

Hagen, E. H., and G. A. Bryant. "Music and Dance as a Coalition-Signaling System." *Human Nature* 14, no. 1 (2003): 21–51.

256

Bibliography

Halverson, J. "Art for Art's Sake in the Paleolithic." *Current Anthropology* 28, no. 1 (1987): 63–89.

Hammond, M. "The Expulsion of the Neanderthals from Human Ancestry: Marcellin Boule and the Social Context of Scientific Research." *Social Studies of Science* 12, no. 1 (1982): 1–36.

Hayden, B. "The Cultural Capacities of Neandertals: A Review and Reevaluation." *Journal of Human Evolution* 24 (1993): 113–146.

Helvenston, P. A., and P. Bahn. "Testing the 'Three Stages of Trance' Model." *Cambridge Archaeological Journal* 13, no. 2 (2003): 213–224.

Henshilwood, C. S., and C. Marean. "The Origin of Modern Human Behavior." *Current Anthropology* 44 (December 2003): 627–651.

Humphrey, N. "Cave Art, Autism, and the Evolution of the Human Mind." *Cambridge Archaeological Journal* 8, no. 2 (1998): 165–191.

Huyge, D. "The 'Venus' of Laussel in the Light of Ethnomusicology." In *Rock Art in the Old World: Papers Presented in Symposium A of the AURA Congress, Darwin, Australia, 1988*, edited by M. Lorblanchet. New Delhi: Indira Gandhi National Centre for the Arts, dist. by UBS Publishers' Distributors, 1992.

Igarashi, J. "Relations entre les représentations figuratives et les signes dans trois grottes magdaléniennes." *L'Anthropologie* 106 (2002): 491–523.

Irwin, A. "The Hooked Stick in the Lascaux Shaft Scene." *Antiquity* 74 (2000): 293–298.

Jelinek, A. J. "Hominids, Energy, Environment, and Behavior in the Late Pleistocene." In *Origins of Anatomically Modern Humans*, edited by M. H. Nitecki and Doris V. Nitecki, 67–92. New York: Plenum, 1994.

Jordan, P. *Neanderthal*. Phoenix Mill, UK: Sutton Publishing, 1999.

Keller, O. "Eléments pour une préhistoire de la géométrie." *L'Anthropologie* 105 (2001): 327–349.

Klein, R. G. *The Human Career*. 2nd ed. Chicago: University of Chicago Press, 1999.

———. "Archeology and the Evolution of Human Behavior." *Evolutionary Anthropology* 9, no. 1 (2000): 17–36.

———. "Whither the Neanderthals?" *Science* 299 (March 7, 2003): 1525–1527.

Klein, R. G., with B. Edgar. *The Dawn of Human Culture*. New York: Wiley, 2002.

Knecht, H. "Splits and Wedges: The Technique and Technology of Early Aurignacian Antler Working." In *Before Lascaux: The Complex Record of the Early Upper Paleolithic*, edited by H. Knecht, A. Pike-Tay, and R. White. Boca Raton, FL: CRC Press, 1993.

Kohn, M., and S. Mithen. "Handaxes: Products of Sexual Selection?" *Antiquity* 73, no. 281 (1999): 518–526.

Kozlowski, J. K. *L'art de la préhistoire en Europe orientale.* Paris: CNRS, 1992.

Kozlowski, J. K., and M. Otte. "La formation de l'Aurignacien en Europe." *L'Anthropologie* 104 (2000): 3–15.

Krings, M., et al. "Neandertal DNA Sequences and the Origin of Modern Humans." *Cell* 90 (July 11, 1997): 19–30.

Kurtén, B. *Pleistocene Mammals of Europe.* London: Weidenfeld & Nicolson, 1968.

————. *The Cave Bear Story: Life and Death of a Vanished Animal.* New York: Columbia University Press, 1976.

Lagrange, J., et al. *Le livre du jubilé de Lascaux, 1940–1990.* Perigeaux: Société historique et archéologique du Périgord, 1990.

Lahr, M. M., and R. Foley. "Demography, Dispersal and Human Evolution in the Last Glacial Period." In *Neanderthals and Modern Humans in the European Landscape During the Last Glaciation,* edited by T. H. van Andel and W. Davies, 241–256. Cambridge, England: McDonald Institute for Archaeological Research, Oxford, dist. by Oxbow Books, 2003.

Laming-Emperaire, A. *Lascaux: Paintings and Engravings,* translated by E. F. Armstrong. Baltimore: Penguin Books, 1959.

————. *La signification de l'art rupestre paléolithique.* Paris: Picard, 1962.

————. Prologue à l'édition espagnole, *Nomades de la mer.* Capharnaum: Serpent de Mer, 1963.

————. *Origines de l'archéologie préhistorique en France.* Paris: Picard, 1964.

————. (1972). "Art rupestre et organisation social." *Stander Symposium,* edited by M. A. Bash et al. Stunder-Madrid: no publisher given, 65–79.

Lantier, R. *Hommage a l'abbé Henri Breuil.* Paris: Henri-Martin, 1957.

Lavalee, D. "Annette Laming-Emperaire." *Journal de la société des américanistes* 65 (1978): 224–225.

Layton, R. "Shamanism, Totemism and Rock Art." *Cambridge Archaeological Journal* 10, no. 1 (2000): 169–186.

Leroi-Gourhan, A. (André). "L'Histoire sans textes." In *L'histoire et ses méthodes,* edited by C. Samaran. Encyclopédie de la Pléiade, 11: 217–249. Paris: Gallimard, 1961.

————. *Les religions de la préhistoire (Paléolithique).* Paris: Presses universitaires de France, 1964.

————. *Treasures of Prehistoric Art.* New York: Abrams, 1967.

Bibliography

————. *La France au temps des mammouths*. Paris: Hachette, 1969.

————. "Iconographie et interprétation." In *Symposium international sur les religions de la préhistoire*. Capo di Ponte, Italy: Edizioni del Centro, 1972.

————. "Préface." *Journal de la société des américanistes* 67 (1981): 21–22.

————. *The Dawn of European Art: An Introduction to Paleolithic Cave Painting*, translated by S. Champion. Cambridge: Cambridge University Press, 1982.

————. *Les racines du monde*. Paris: P. Belfond, 1982.

————. *Le fil du temps*. Paris: Fayard, 1983.

————. *Pincevent*. Paris: Ministère de la Culture, 1984.

————. *The Hunters of Prehistory*, translated by C. Jacobson. New York: Atheneum, 1989.

————. *Gesture and Speech*, translated by A. Bostock Berger. Cambridge: MIT Press, 1993.

Leroi-Gourhan, A. et al. *La Préhistoire*. Paris: Presses universitaires de France, 1966.

Leroi-Gourhan, Arl. (Arlette). "The Archaeology of Lascaux Cave." *Scientific American* (June 1972); 104–112.

————. "Les Artistes de Lascaux." *Les Dossiers d'Archéologie* 152 (1990): 24–29.

Leroi-Gourhan, Arl., et al. *Lascaux Inconnu*. Paris: Éditions du Centre national de la recherche scientifique, 1979.

Lewis-Williams, D. *The Mind in the Cave: Consciousness and the Origins of Art*. London: Thames & Hudson, 2002.

————. *Believing and Seeing: Symbolic Meanings in Southern San Rock Paintings*. London: Academic Press, 1981.

————. "Wrestling with Analogy: A Methodological Dilemma in Upper Palaeolithic Art Research." *Proceedings of the Prehistoric Society* (London) 57 (1991): 149–162.

Lewis-Williams, D., and T. A. Dowson. "The Signs of All Times: Entoptic Phenomena in Upper Palaeolithic Art." *Current Anthropology* 29, no. 2 (1988): 201–245.

Lhote, H. "À propos de la 'Lionne' des Trois-Freres." *L'Anthropologie* 92, no. 1 (1988): 371–372.

Lindley, J. M., and G. A. Clark. "Symbolism and Modern Human Origins." *Current Anthropology* 31, no. 3 (1990): 233–261.

Lister, A., and P. Bahn. *Mammoths*. London: Marshall, 2000.

Lorblanchet, M. "Finger Markings in Pech Merle and Their Place in Prehistoric

Art." In *Rock Art in the Old World: Papers Presented in Symposium A of the AURA Congress, Darwin, Australia, 1988,* edited by M. Lorblanchet. New Delhi: Indira Gandhi National Centre for the Arts, dist. by UBS Publishers' Distributors, 1992.

————. "Lascaux et l'art magdalénien." *Les dossiers d'archéologie* 152 (summer 1990): 46–61.

————. "Spitting Images: Replicating the Spotted Horses of Pech Merle." *Archaeology* (November/December 1991): 24–31.

————. *Les grottes ornées de la préhistoire: Nouveaux regards.* Paris: Errance, 1995.

————. *La Naissance de l'Art.* Paris: Errance, 1999.

Lorblanchet, M., and A. Sieveking. "The Monsters of Pergouset." *Cambridge Archaeological Journal* 7, no. 1 (1997): 37–56.

Marquer, J.-C., and M. Lorblanchet. "A Neanderthal Face? The Proto-figurine from La Roche-Cotard, Langeais (Indre-et-Loire, France)." *Antiquity* 77, no. 298 (2003): 661–670.

Marshack, A. "Methodology in the Analysis and Interpretation of Upper Palaeolithic Image." *Rock Art Research* 6, no. 1 (1989): 17–53.

————. "The Female Image: A 'Time-factored' Symbol." *Proceedings of the Prehistoric Society* (London) 57, pt. 1 (1991): 17–31.

————. *The Roots of Civilization: The Cognitive Beginnings of Man's First Art, Symbol, and Notation. rev. and expanded ed.* Mount Kisco, NY: Moyer Bell, 1991.

————. "The Tai Plaque and Calendrical Notation in the Upper Palaeolithic." *Cambridge Archaeological Journal* 1, no. 1 (1991): 25–61.

————. "The La Marche Antler Revisited." *Cambridge Archaeological Journal* 6, no. 1 (1996): 99–117.

————. "A Middle Paleolithic Symbolic Composition from the Golan Heights: The Earliest Known Depictive Image." *Current Anthropology* 37, no. 2 (1996): 357–365.

————. "The Berekhat Ram Figurine: A Late Acheulian Carving from the Middle East." *Antiquity* 71, no. 272 (1997): 327–338.

McBrearty, S., and A. Brooks. "The Revolution That Wasn't: A New Interpretation of the Origin of Modern Human Behavior." *Journal of Human Evolution* 39 (2000): 453–563.

McDermott, L. "Self-Representation in Upper Paleolithic Female Figurines." *Current Anthropology* 37, no. 2 (1996): 227–275.

Mellars, P. "The Ecological Basis of Social Complexity in the Upper Paleolithic of Southwestern France." In *Prehistoric Hunter-Gatherers: The Emergence of Cultural Complexity,* edited by T. D. Price and J. A. Brown. Orlando, FL: Academic Press, 1985.

———. "Major Issues in the Emergence of Modern Humans." *Current Anthropology* 30, no. 3 (1989): 349–385.

———. *The Neanderthal Legacy.* Princeton: Princeton University Press, 1996.

———. "Neanderthals, Modern Humans and the Archaeological Evidence for Language." In *The Origin and Diversification of Language: Third Paul L. and Phyllis Wattis Foundation Endowment Symposium (1997),* edited by N. G. Jablonski and L. C. Aiello, 89–115. San Francisco: California Academy of Sciences, dist. by University of California Press, 1998.

———. "The Neanderthal Problem Continued." *Current Anthropology* 40, no. 3 (1999): 341–364.

———. "Neanderthals and the Modern Human Colonization of Europe." *Nature* 432, (2004): 461–465.

———. "The Impossible Coincidence: A Single-Species Model for the Origins of Modern Human Behavior in Europe." *Evolutionary Anthropology* 14 (2005): 12–27.

Meroc, L., and J. Mazet. *Cougnac: Grotte peinte.* Stuttgart: W. Kohlhammer Verlag, 1956.

Michelson, A. "In Praise of Horizontality: André Leroi-Gourhan 1911–1986." *October* 37 (summer 1986): 3–5.

Miller, M. A. "Love or War? The Demise of the Neanderthals." *Athena Review* 2, no. 4 (2001): 13–20.

Mithen, S. J. "Looking and Learning: Upper Palaeolithic Art and Information Gathering." *World Archaeology* 19, no. 3 (1988): 297–327.

———. "To Hunt or to Paint: Animals and Art in the Upper Palaeolithic." *Man* 23, no. 4 (1988): 671–695.

———. *Thoughtful Foragers: A Study of Prehistoric Decision Makers.* Cambridge: Cambridge University Press, 1990.

———, ed. *Creativity in Human Evolution and Prehistory.* London: Routledge, 1998.

Murray, T., ed. *Encyclopedia of Archaeology: The Great Archaeologists.* 2 vols. Santa Barbara, CA: ABC-CLIO, 1999.

———, ed. *Encyclopedia of Archaeology: History and Discoveries.* 3 vols. Santa Barbara, CA: ABC-CLIO, 2001.

Niedhorn, U. *The Lady from Brassempouy: A Fake—A Hoax?* Frankfurt am Main: Haag und Herchen, 1990.

Olins, Alpert, B. "Des preuves de sens ludique dans l'art au Pleistocene Supérieur." *L'Anthropologie* 96, nos. 2/3 (1992): 219–244.

Olivier, L. "The Origins of French Archaeology." *Antiquity* 73 (1999): 176–183.

Otte, M. "On the Suggested Bone Flute from Slovenia." *Current Anthropology* 41, no. 2 (2000): 271–272.

Otte, M., and L. Remache. "Réhabilitation des styles paléolithiques." *L'Anthropologie* 104 (2000): 365–371.

Ovchinnikov, I., et al. "Molecular Analysis of Neanderthal DNA from the Northern Caucasus." *Nature* 404 (2000): 490–493.

Owens, D. A., and B. Hayden. "Prehistoric Rites of Passage: A Comparative Study of Transegalitarian Hunter-Gatherers." *Journal of Anthropological Archaeology* 16 (1997): 121–161.

Paglia, C. "The Magic of Images: Word and Picture in a Media Age." *Arion* 11, no. 3 (2004): 1–22.

Peterkin, G. L. "Early Upper Palaeolithic Hunting Technology and Techniques in Southwest France." In *Questioning the Answers: Re-solving Fundamental Problems of the Early Upper Paleolithic,* edited by M. A. Hays and P. T. Thacker, pp. 171–186. Oxford: Archaeopress, 2001.

Pettitt, P. "Disappearing from the World: An Archaeological Perspective on Neanderthal Extinction." *Oxford Journal of Archaeology* 18, no. 3 (1999): 217–240.

————. "Neanderthal Lifecycles: Developmental and Social Phases in the Lives of the Last Archaics." *World Archaeology* 31, no. 3 (2000): 351–366.

Pettitt, P., and P. Bahn. "Current Problems in Dating Palaeolithic Cave Art: Candamo and Chauvet." *Antiquity* 77 (March 2003): 134–141.

Piette, E. *Histoire de l'art primitif.* Paris: Picard, 1987.

Pike-Tay, A. "Hunting in the Upper Perigordian: A Matter of Strategy or Expedience?" In *Before Lascaux: The Complex Record of the Early Upper Paleolithic,* edited by H. Knecht, A. Pike-Tay, and R. White, pp. 85–99. Boca Raton, FL: CRC Press, 1993.

Plassard, J. "Réflexion sur l'art de Rouffignac." *L'Anthropologie* 96, nos. 2/3 (1992): 357–368.

Powers, R., and C. Stringer. "Palaeolithic Cave Art Fauna." *Studies in Speleology* 2 (November 1975): 266–298.

Proctor, R. N. "Three Roots of Human Recency." *Current Anthropology* 44, no. 2 (2003): 213–239.

Bibliography

Raphael, M. *Prehistoric Cave Paintings,* translated by N. Guterman. Bollingen 4. New York: Pantheon, 1945.

———. *The Demands of Art.* Princeton: Princeton University Press, for Bollingen Foundation, 1968.

———. *L'art pariétal paléolithique.* Paris: Couteau dans la plaie / Kronos, 1986.

Rappengluck, M. A. "Palaeolithic Timekeepers Looking at the Golden Gate of the Ecliptic." *Earth, Moon and Planets* 85/86 (2001): 391–404.

Reinach, S. "Gabriel de Mortillet." *Revue Historique* 69 (January–April 1899): 67–95.

———. "L'art et la magie." *L'Anthropologie* 14 (1903): 257–266.

Reverdit, A. "Stations et traces des temps préhistoriques dans le canton de Montignac-sur-Vézère." *Bulletin de la Société historique et archéologique du Périgord* 5 (1878): 384–419.

Richard, N. "Gabriel de Mortillet." In Murray, *Encyclopedia of Archaeology: The Great Archaeologists* (1999), 1: 93–107.

———. "Marcellin Boule." In Murray, *Encyclopedia of Archaeology: The Great Archaeologists* (1999), 1: 263–272.

———, ed. *L'invention de la préhistoire: Une anthologie.* Paris: Presses Pocket, 1992.

Riel-Salvatore, J., and G. Clark. "Middle and Early Upper Paleolithic Burials and the Use of Chronotypology in Contemporary Paleolithic Research." *Current Anthropology* 42 (August–October 2001): 449–479.

Rigaud, A. "Les bâtons perces." *Gallia Préhistoire* 43 (2001): 101–151.

Roper, M. K. "A Survey of the Evidence for Intrahuman Killing in the Pleistocene." *Current Anthropology* 10, no. 4, pt. 2 (1969): 427–459.

Roussot, A. "Breuil et Lascaux." *Les Dossiers d'Archéologie* 152 (1990): 62–63.

Rozoy, C., and J.-G. Rozoy. "Roc-La-Tour I, le site des Esprits: L'art du Magdalénien VI à Monthermé (Ardennes)." *L'Anthropologie* 107 (2003): 501–531.

Ruspoli, M. *The Cave of Lascaux: The Final Photographs.* New York: Abrams, 1987.

Russell, P. "Who and Why in Palaeolithic Art." *Oxford Journal of Archaeology* 8, no. 3 (1989): 237–249.

Sablin, M. V., and G. Khlopachev. "The Earliest Ice Age Dogs: Evidence from Eliseevichi I." *Current Anthropology* 43, no. 5 (2002): 795–799.

Sandgathe, D. M., and B. Hayden. "Did Neanderthals Eat Inner Bark?" *Antiquity* 77, no. 298 (2003): 709–718.

Saura Ramos, P. A. *The Cave of Altamira.* New York: Abrams, 1999.

Sauvet, G. "La communication graphique paléolithique." *L'Anthropologie* 92, no. 1 (1988): 3–16.

———. "Fonction sémiologique de l'art pariétal paléolithique," in *La Mémoire*. Paris: L'Marmalton (1989), 2:73–85.

———. *L'art mobilier non classique de la grotte magdalénienne de Bédeilhac (Ariège)*. Liege: Congres International UISPP, in press, 2001.

———. "The Paradigmatic Pendulum in Paleolithic Parietal Art." *Paleoart* (in preparation). C. Chippindale, ed.

Sauvet, G., and G. Tosello. "Le mythe paléolithique de la caverne." In *Le propre de l'homme: Psychanalyse et préhistoire*, edited by F. Sacco and G. Sauvet. Lausanne: Delachaux et Niestle, 1998, 55–90.

Sauvet, G., and A. Wlodarczyk. "Essai de sémiologie préhistorique." *Bulletin de la Societe Préhistorique Française* 74 (1977): 545–558.

———. "Structural Interpretation of Statistical Data from European Palaeolithic Cave Art." *23rd Chacmool Conference* (1990), edited by A. S. Goldsmith et al. Calgary, Canada: University of Calgary Archaeological Association, 1992.

———. "Eléments d'une grammaire formelle de l'art pariétal paléozoïque." *L'Anthropologie* 99, nos. 2/3 (1995): 193–211.

———. "L'art pariétal, miroir des sociétés paléolithiques." *Zephyrus* 53/54 (2000–2001): 215–238.

Sharpe, K., and L. Van Gelder. "Children and Paleolithic 'Art': Indications from Rouffignac Cave, France." *International Newsletter on Rock Art* 38 (2004): 9–17.

Shea, J. J. "Modern Human Origins and Neanderthal Extinction: New Evidence from the East Mediterranean Levant." *Athena Review* 2, no. 4 (2001): 21–32.

———. "Neandertals, Competition, and the Origin of Modern Human Behavior in the Levant." *Evolutionary Anthropology* 12 (2003): 173–187.

Shreeve, J. *The Neandertal Enigma: Solving the Mystery of Human Origins*. New York: Morrow, 1995.

Sieveking, A. *The Cave Artists*. London: Thames & Hudson, 1979.

———. "Style and Regional Grouping in Magdalenian Cave Art." *Institute of Archaeology Bulletin* 16 (1979): 95–109.

———. "Palaeolithic Art and Archaeology: The Mobiliary Evidence." *Proceedings of the Prehistoric Society* (London) 57, pt. 1 (1991): 33–50.

Simons, M. "French Court Battle Delays Study of Ancient Cave's Artworks." *New York Times*, December 9, 1996.

Bibliography

Smith, N. W. *An Analysis of Ice Age Art: Its Psychology and Belief System.* New York, P. Lang, 1992.

Smith, P. E. "The Abbé Henri Breuil and Prehistoric Archaeology." *Anthropologica* 4, no. 2 (1962): 199–208.

Soffer, O. "Recovering Perishable Technologies Through Use Wear on Tools: Preliminary Evidence for Upper Paleolithic Weaving and Net Making." *Current Anthropology* 45, no. 3 (2004): 407–413.

Soffer, O., et al. "Palaeolithic Perishables Made Permanent." *Antiquity* 74 (2000): 812–821.

Soffer, O., et al. "The 'Venus' Figurines: Textiles, Basketry, Gender, and Status in the Upper Paleolithic." *Current Anthropology* 41, no. 4 (2000): 511–537.

Solecki, R. S. *Shanidar, the First Flower People.* New York: Knopf, 1971.

Sommer, J. D. "The Shanidar IV 'Flower Burial': A Reevaluation of Neanderthal Burial Ritual." *Cambridge Archaeological Journal* 9, no. 1 (1999): 127–129.

Sonneville-Bordes, D. "Le bestiaire paléolithique en Périgord: Chronologie et signification." *L'Anthropologie* 90, no. 4 (1986): 613–656.

Speth, J. D. "News Flash: Negative Evidence Convicts Neanderthals of Gross Mental Incompetence." *World Archaeology* 36, no. 4 (2004): 519–526.

Spiess, A. E. *Reindeer and Caribou Hunters: An Archaeological Study.* New York: Academic Press, 1979.

Stapert, D., and L. Johanson. "Flint and Pyrite: Making Fire in the Stone Age." *Antiquity* 73 (1999): 765–777.

Stern, N., and S. Holdaway. "Leroi-Gourhan, André," in Murray, *Encyclopedia of Archaeology: The Great Archaeologists* (1999): 2: 812–824.

Stewart, J. R., et al. "Neanderthals as Part of the Broader Late Pleistocene Megafaunal Extinctions?" In *Neanderthals and Modern Humans in the European Landscape During the Last Glaciation,* edited by T. H. van Andel and W. Davies, 221–231. Cambridge, England: McDonald Institute for Archaeological Research, Oxford, dist. by Oxbow Books, 2003.

Straus, L. G. "Upper Paleolithic Ibex Hunting in Southwest Europe." *Journal of Archaeological Science* 14 (1987): 163–178.

———. "The Upper Paleolithic of Cantabrian Spain." *Evolutionary Anthropology* 14 (2005): 145–158.

Straus, L. G., et al. "The Upper Palaeolithic Settlement of Iberia: First-Generation Maps." *Antiquity* 74 (2000): 553–566.

Stringer, C. "Modern Human Origins—Distinguishing the Models." *African Archaeological Review* 18, no. 2 (2001): 67–75.

Bibliography

Stringer, C., and C. Gamble. *In Search of the Neanderthals: Solving the Puzzle of Human Origins*. New York: Thames & Hudson, 1993.

Taborin, Y. "Shells of the French Aurignacian and Perigordian." In *Before Lascaux: The Complex Record of the Early Upper Paleolithic*, edited by H. Knecht, A. Pike-Tay, and R. White, pp. 211–227. Boca Raton, FL: CRC Press, 1993.

Tattersall, I. *The Last Neanderthal: The Rise, Success, and Mysterious Extinction of Our Closest Human Relations*. rev. ed. Boulder, CO: Westview Press, 1999.

Tauxe, D. "Participation figurative et abstraite du point dans l'iconographie pariétale de Lascaux." *L'Anthropologie* 103, no. 4 (1999): 531–548.

Terberger, T., and M. Street. "Hiatus or Continuity? New Results for the Question of Pleniglacial Settlement in Central Europe." *Antiquity* 76 (2002): 691–698.

Thomas, H. *Human Origins: The Search for Our Beginnings*. New York: Abrams, 1995.

Thorne, A. G., and M. H. Wolpoff. "The Multiregional Evolution of Humans." *Scientific American Special Edition* (New Look at Human Evolution, 2003), 46–53.

Trinkaus, E., and P. Shipman. *The Neandertals*. New York: Vintage, 1994.

Tyldesley, J. A., and P. Bahn. "Use of Plants in the European Palaeolithic: A Review of the Evidence." *Quaternary Science Reviews* 2 (1983): 53–81.

Ucko, P. J., and A. Rosenfeld. *Palaeolithic Cave Art*. New York: McGraw-Hill, 1967, reprinted 1973.

Valladas, H., and J. Clottes. "Style, Chauvet and Radiocarbon." *Antiquity* 77, no. 295 (2003): 142–145.

van Andel, T., et al. "The Human Presence in Europe During the Last Glacial Period I: Human Migrations and the Changing Climate." In *Neanderthals and Modern Humans in the European Landscape During the Last Glaciation*, edited by T. H. van Andel and W. Davies, 31–56. Cambridge, England: McDonald Institute for Archaeological Research, Oxford, dist. by Oxbow Books, 2003.

Vaufrey, R. "Nécrologie–L'Abbé Henri Breuil." *L'Anthropologie* 66, nos. 1/2 (1962): 158–165.

Vialou, D. "Lascaux, architecture de l'art souterrain." *Les Dossiers d'Archéologie* 152 (1990): 38–43.

———. *Prehistoric Art and Civilization*. New York: Abrams, 1998.

Bibliography

————. *La vache sautante de Lascaux*. Paris: Scala, 2003.

Vouve, J. "Essai de caractérisation d'objets colorants découverts dans la grotte de Lascaux." *L'Anthropologie* 99, nos. 2/3 (1995): 478–483.

Waller, S. J. "Sound Reflection as an Explanation for the Content and Context of Rock Art." *Rock Art Research* 10, no. 2 (1993): 91–101.

White, R. "Les Images féminines paléolithique: Un coup d'oeil sur quelques perspectives américaines." In *La Dame de Brassempouy*, edited by H. Delporte. Liège: ERAUL, 1982.

————. *Dark Caves, Bright Visions: Life in Ice Age Europe*. New York: W. W. Norton, 1986.

————. "Husbandry and Herd Control in the Upper Paleolithic: A Critical Review of the Evidence." *Current Anthropology* 30, no. 5 (1989): 609–632.

————. "Visual Thinking in the Ice Age." *Scientific American* (July 1989): 92–99.

————. "Beyond Art: Toward an Understanding of the Origins of Material Representation in Europe." *Annual Review of Anthropology* 21 (1992): 537–564.

————. "Technological and Social Dimensions of 'Aurignacian-Age' Body Ornaments Across Europe." In *Before Lascaux: The Complex Record of the Early Upper Paleolithic*, edited by H. Knecht, A. Pike-Tay, and R. White, pp. 277–299. Boca Raton, FL: CRC Press, 1993.

————. "Les archives du Paléolithique." *La Recherche* (July 1994).

————. "Personal Ornaments from the Grotte du Renne at Arcy-sur-Cure." *Athena Review* 2, no. 4 (2001): 41–46.

————. *Prehistoric Art: The Symbolic Journey of Humankind*. New York: Abrams, 2003.

White, R., and M. Bisson. "Imagerie féminine du Paléolithique." *Gallia Préhistoire* 40 (1998): 95–132.

White, R., et al. "Upper Palaeolithic Fibre Technology." *Antiquity* 70 (1996): 526–524.

Willemont, J. *Lascaux Revisited*. Glenview, IL: Crystal Productions, 1994.

Windels, F. *The Lascaux Cave Paintings*, translated by C.F.C. Hawkes. New York: Viking, 1950.

Wolpoff, M. H., and R. Caspari. *Race and Human Evolution*. New York: Simon & Schuster, 1997.

Wolpoff, M. H., et al. "Multiregional, Not Multiple Origins." *American Journal of Physical Anthropology* 112 (2000): 129–136.

Bibliography

Wolpoff, M. H., et al. "Why Not the Neanderthals?" *World Archaeology* 36, no. 4 (2004): 527–546.

Wynn, T., and F. L. Coolidge. "The Expert Neandertal Mind." *Journal of Human Evolution* 46 (2004): 467–487.

Zilhão, J. *Anatomically Archaic, Behaviorally Modern: The Last Neanderthals and Their Destiny.* Amsterdam: J. Enschedé, 2001.

———. "The Lagar Velho Child and the Fate of the Neanderthals." *Athena Review* 2, no. 4 (2001): 33–39.

Zilhão, J., and F. d'Errico. "The Chronology and Taphonomy of the Earliest Aurignacian and Its Implications for the Understanding of Neandertal Extinction." *Journal of World Prehistory* 13, no. 1 (1999): 1–68.

INDEX

Page numbers in *italics* refer to illustrations.

Index

In-text photographs and illustrations:

Color insert: